D1233022

The North A View from the Skies

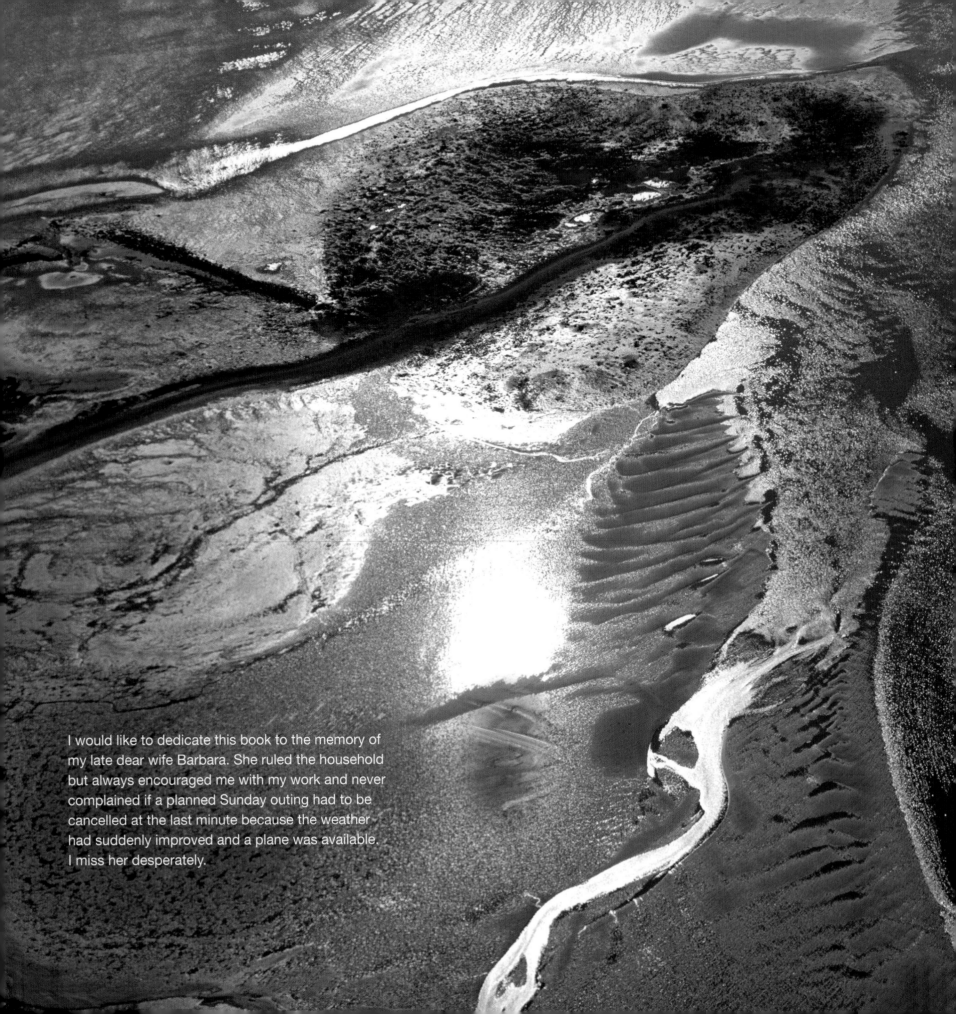

I would like to dedicate this book to the memory of my late dear wife Barbara. She ruled the household but always encouraged me with my work and never complained if a planned Sunday outing had to be cancelled at the last minute because the weather had suddenly improved and a plane was available. I miss her desperately.

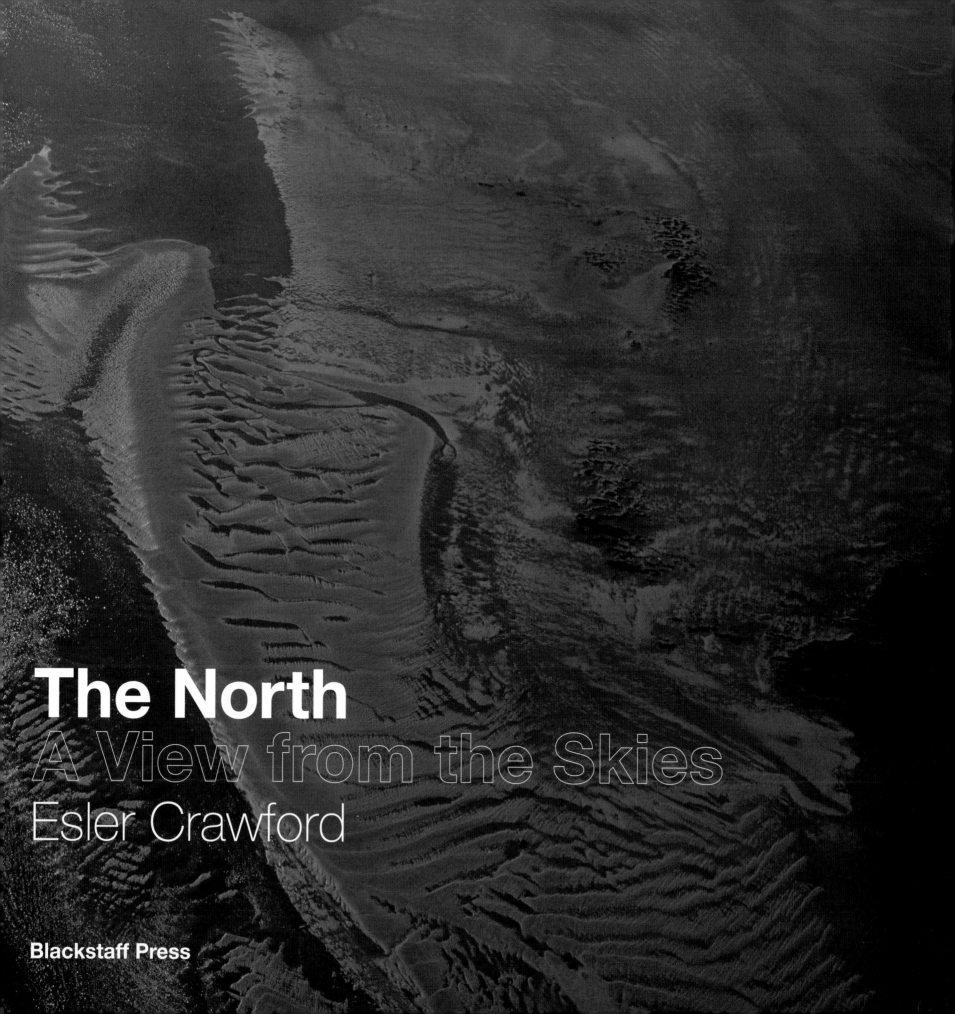

The North
A View from the Skies
Esler Crawford

Blackstaff Press

Esler Crawford

It was quite a shock to realise that it had been nearly ten years since I worked on my first book, *The North from the Air*. It was a great experience and the book turned out beautifully, even though I must confess that even I was surprised by the extent of its success. So I am delighted by the publication of *The North: A View from the Skies* – and I've been practising my book-signing technique in hope and anticipation that it will be every bit as well received!

Since my first book was published I have had the opportunity to take many more aerial photographs, enough to produce an entirely new book. The most dramatic changes over this period can be seen in the towns and cities – the dome of Belfast's recently opened Victoria Square, for example, is clearly visible from the sky – or in fields that now grow oilseed rape instead of more traditional crops. Other places have not changed so dramatically, but even in a relatively small place like Northern Ireland there is much to see, and the landscape can appear very different as the light, the time of day and the seasons change.

I have always loved spending time in Donegal and I admire its rich and varied secenery, so I seized the opportunity to include it in this book. And I must say that from the air, Donegal is a revelation: rugged hills and miles of wild, sparsely populated countryside meet golden sands, sheer cliffs and the deep blue waters of the Atlantic. As we flew towards Donegal, my pilot, an ex-commercial captain, made the wry comment that this was the first time in ten years he had flown abroad – the length of time since he had retired from his full-time job! He turned out to be an admirer of Daniel O'Donnell, and as we flew over Kincashla he regretted that we hadn't time to drop in for a cup of tea.

On another occasion, at an airport in the north-west, we were amused to hear the air traffic controller announce that he would not be available for half an hour as he was taking his coffee break! But perhaps my abiding memory of the Donegal trips is seeing the little ferry travelling from Burtonport to Aran Island, threading its way through a narrow channel and looking for all the world like something from a film set in the 1950s.

Over the last ten years my choice of equipment has not changed much. Some people may call me a Luddite but I still continue to use film cameras – a trio of Pentax 67s with lenses from 55mm up to 300mm – rather than the ubiquitous digital SLR. There are two reasons for this: firstly, I think that a 6 x 7cm colour transparency has the edge in terms of definition and overall quality; secondly, I hope that my aerial images are my photographic legacy and that they will, if carefully looked after, still be around and creating interest when CDs – and I – are long gone. My film of choice is Fuji Velvia, which gives wonderfully saturated, brilliant colours, even in poor lighting conditions. For transport we usually use a Cessna 50, which has a very low stall speed and is thus ideal for low-level, oblique aerial photography.

So the equipment has not changed. And neither has the weather. In that respect aerial photography can be immensely frustrating. But when the conditions are right, I find it to be the most rewarding form of photography; a hobby and a passion that I have been lucky enough to turn into a career.

ESLER CRAWFORD

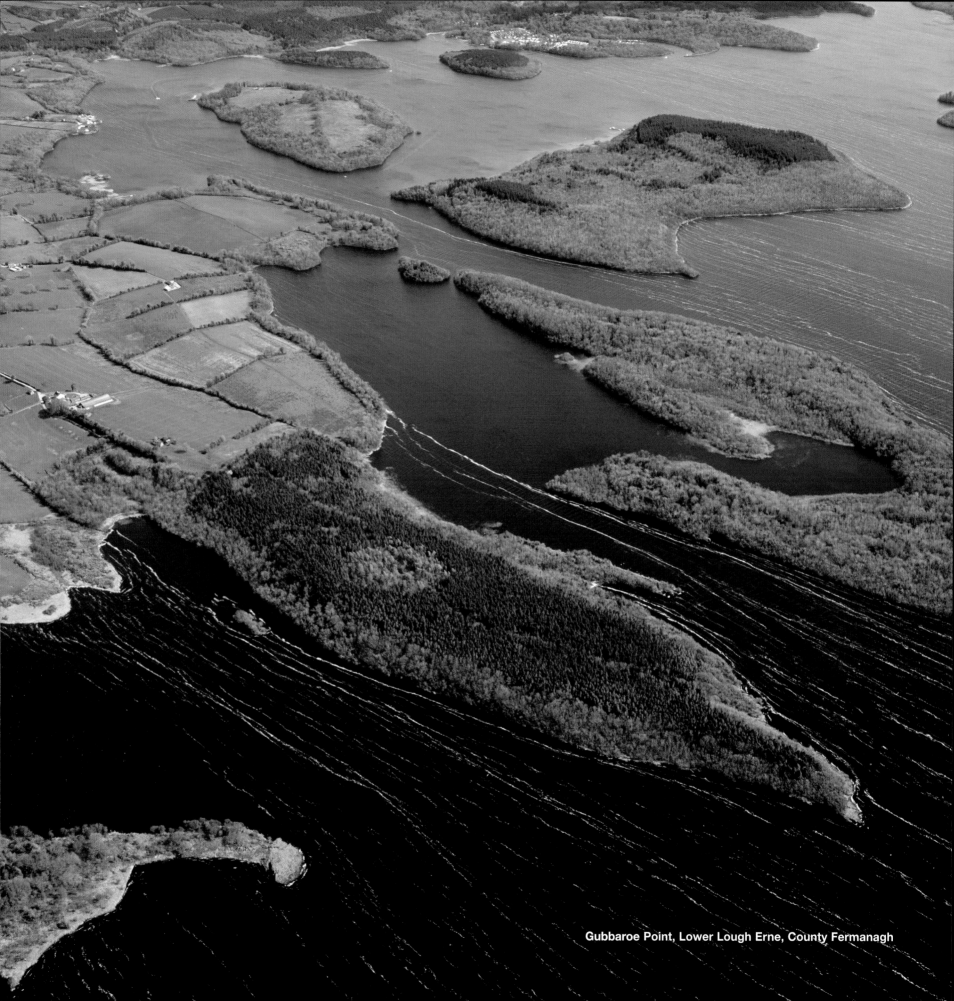

Gubbaroe Point, Lower Lough Erne, County Fermanagh

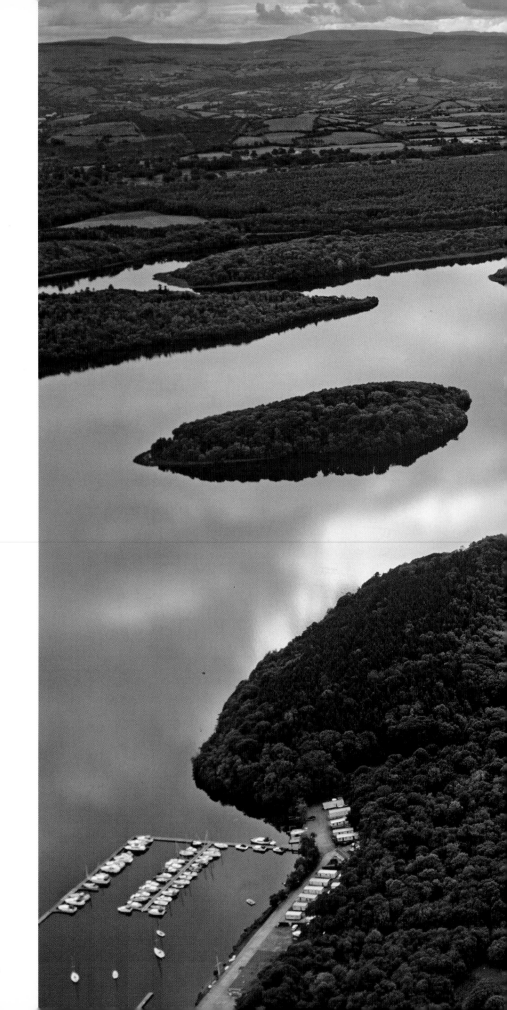

Killadeas, Lower Lough Erne

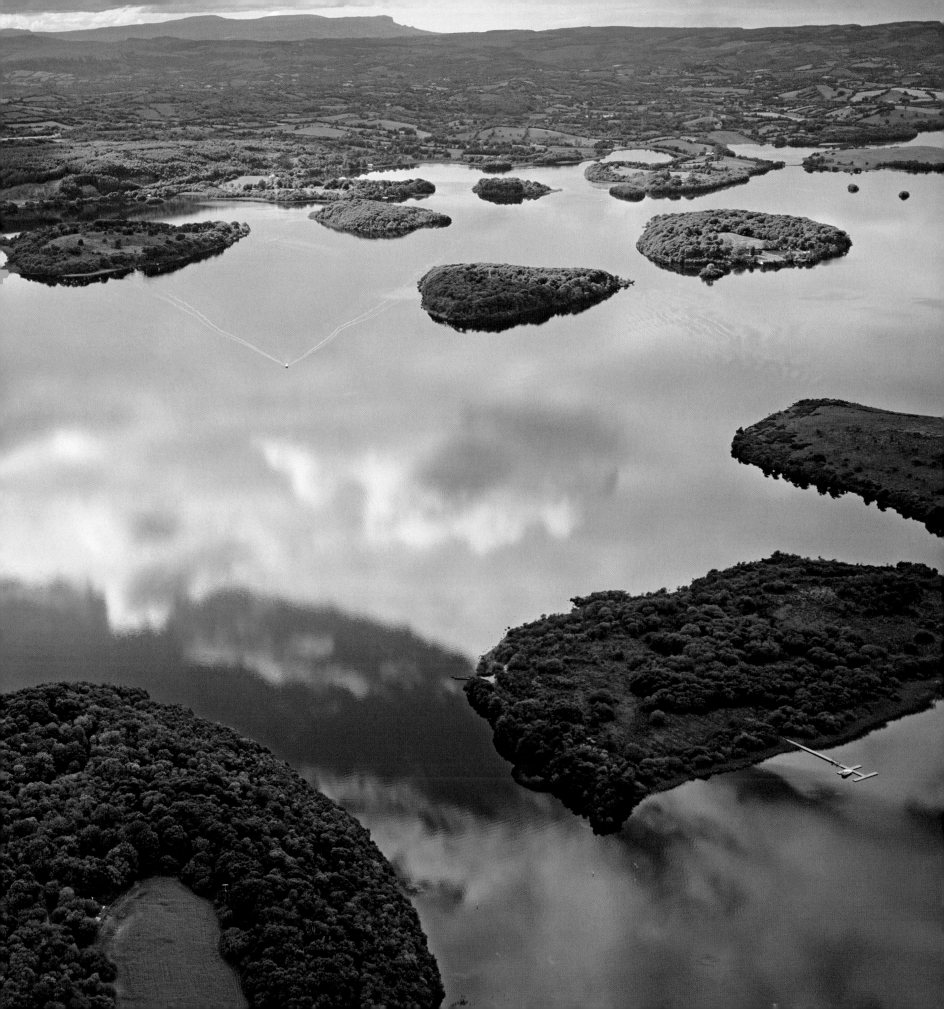

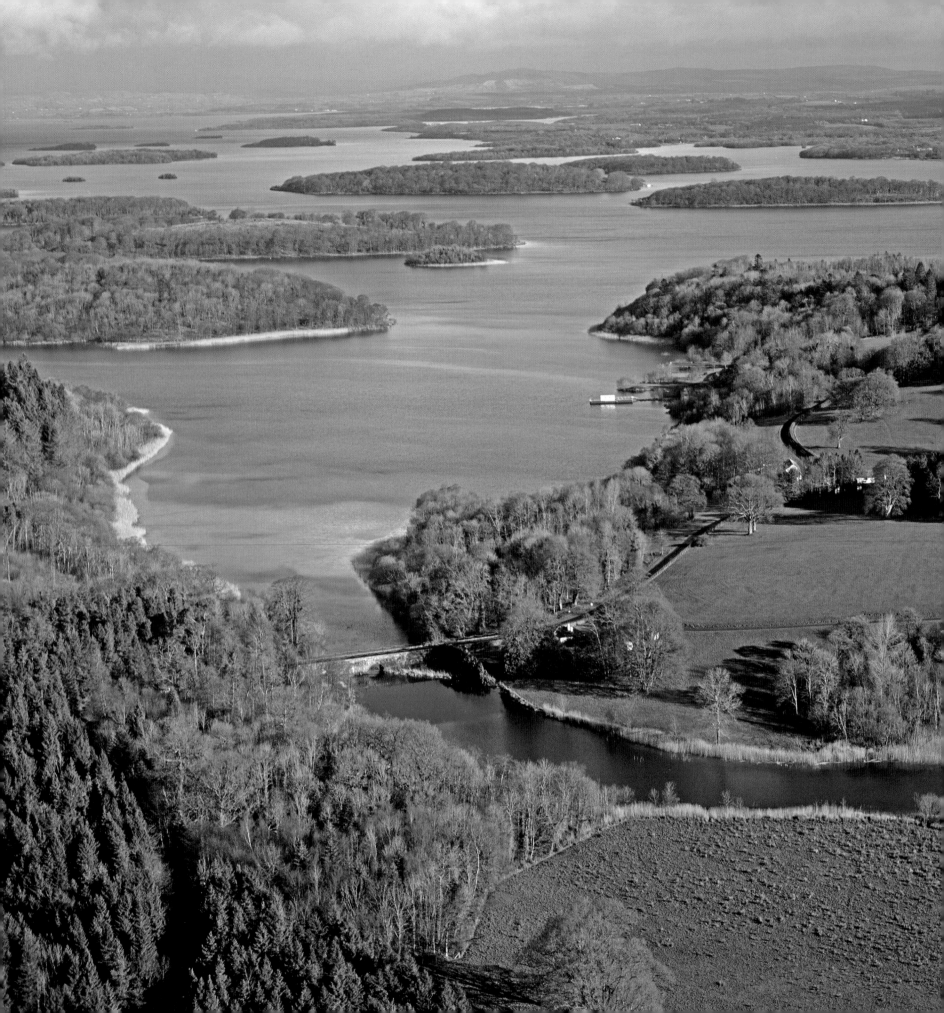

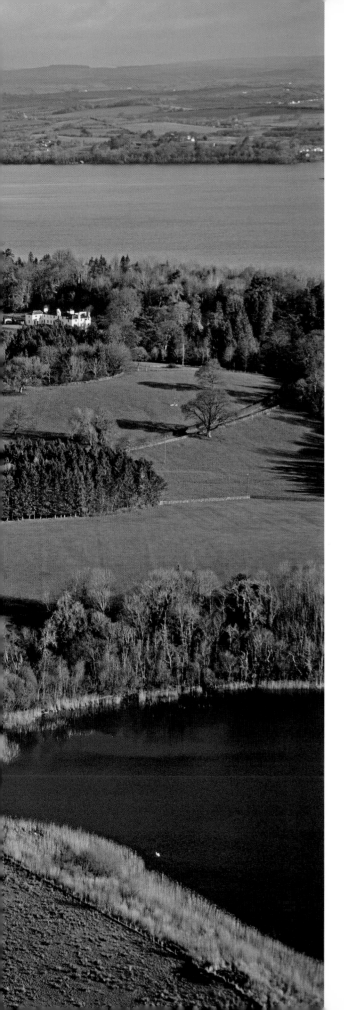

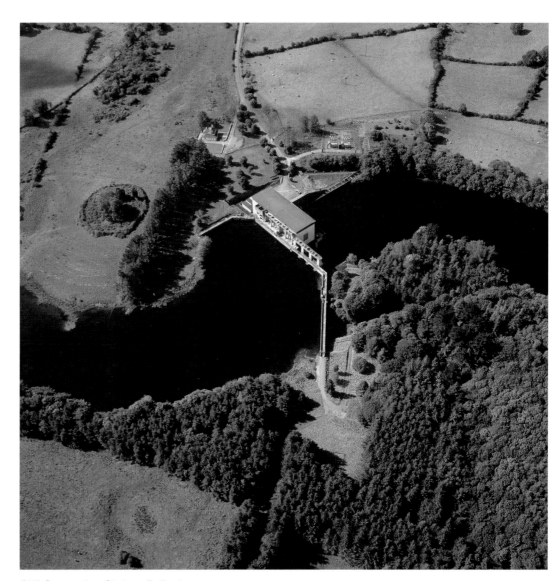

Cliff Generating Station, Belleek

Ely Lodge, Lower Lough Erne

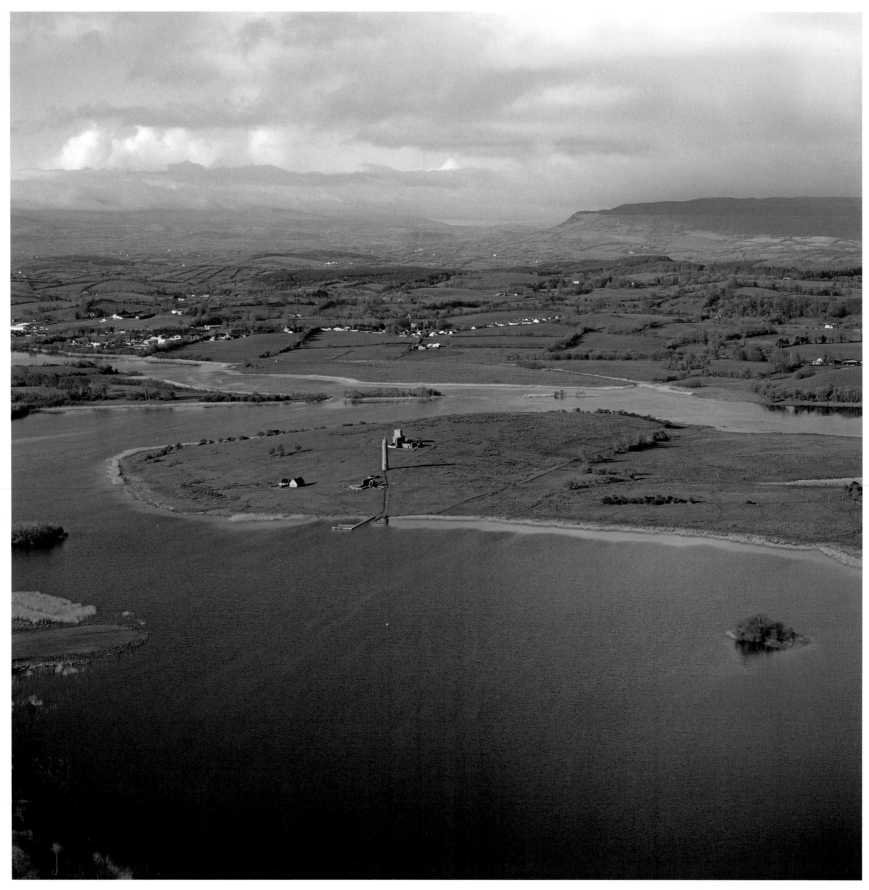

Above: Devenish Island with Belmore Mountain in the background
Opposite: The Round Tower, Abbey and churches on Devenish Island

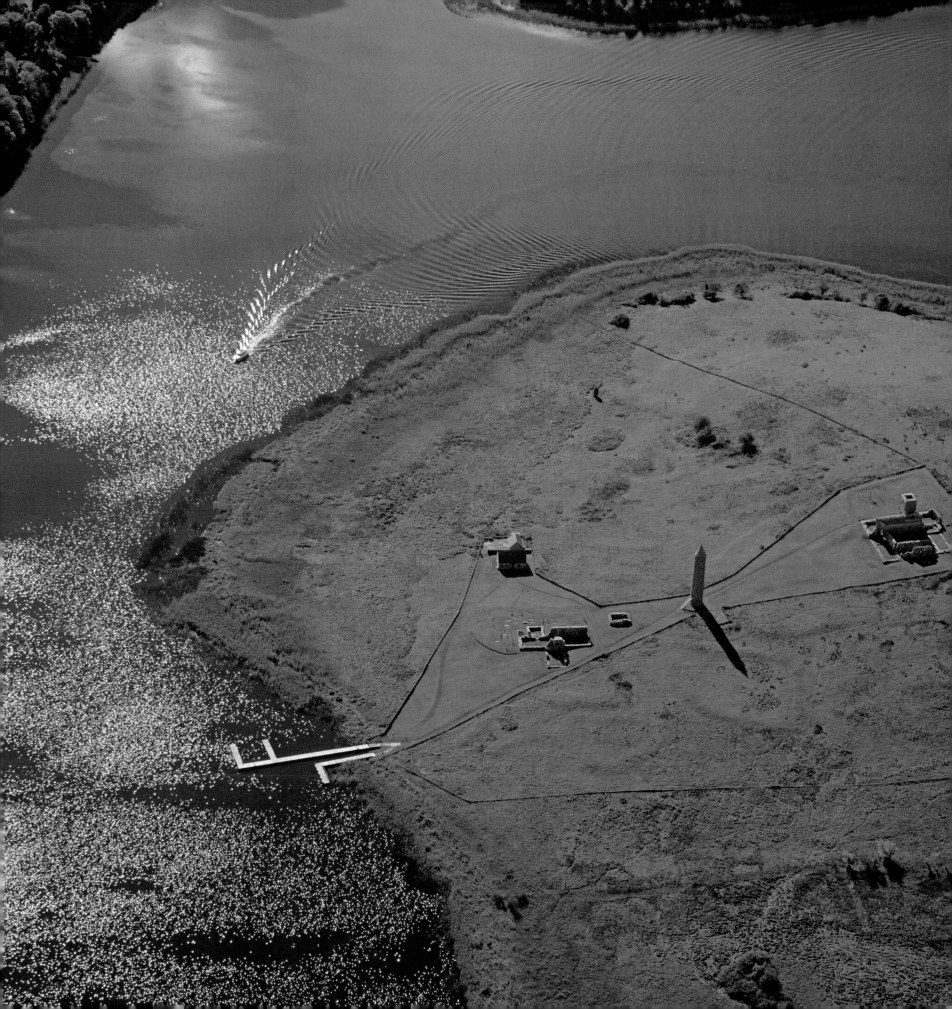

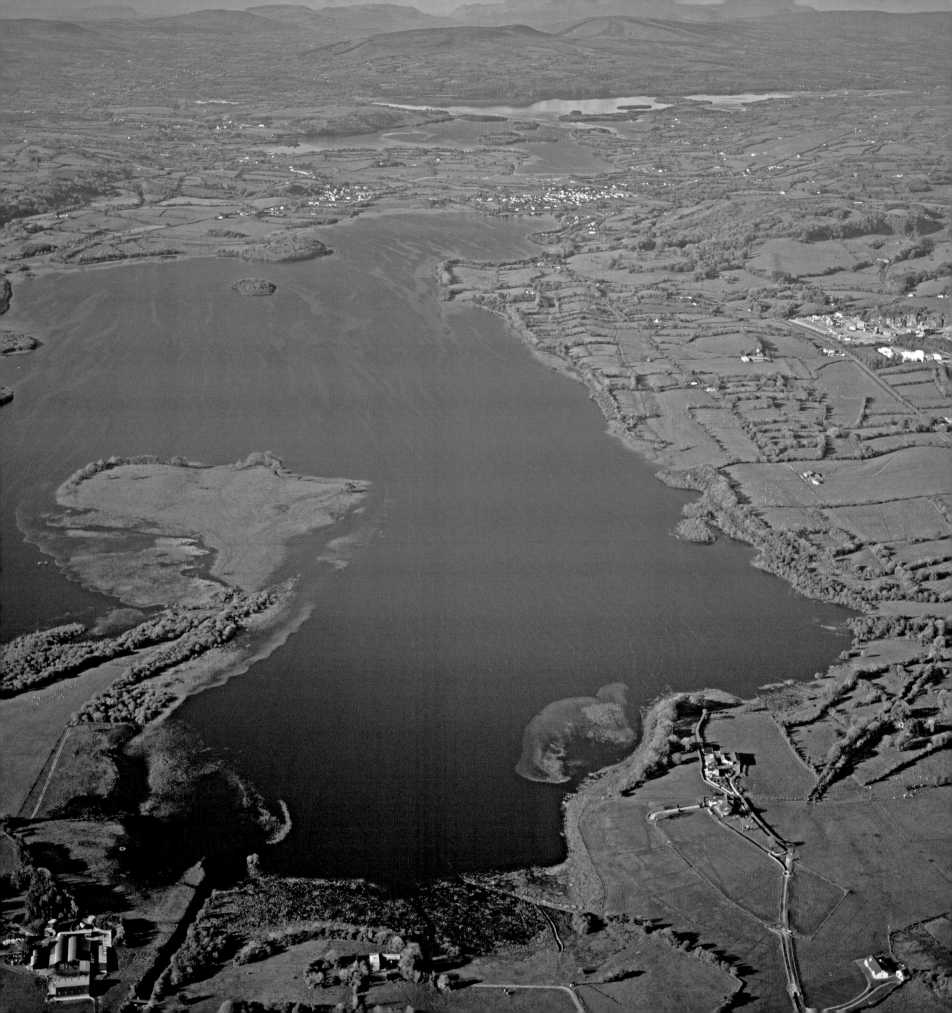

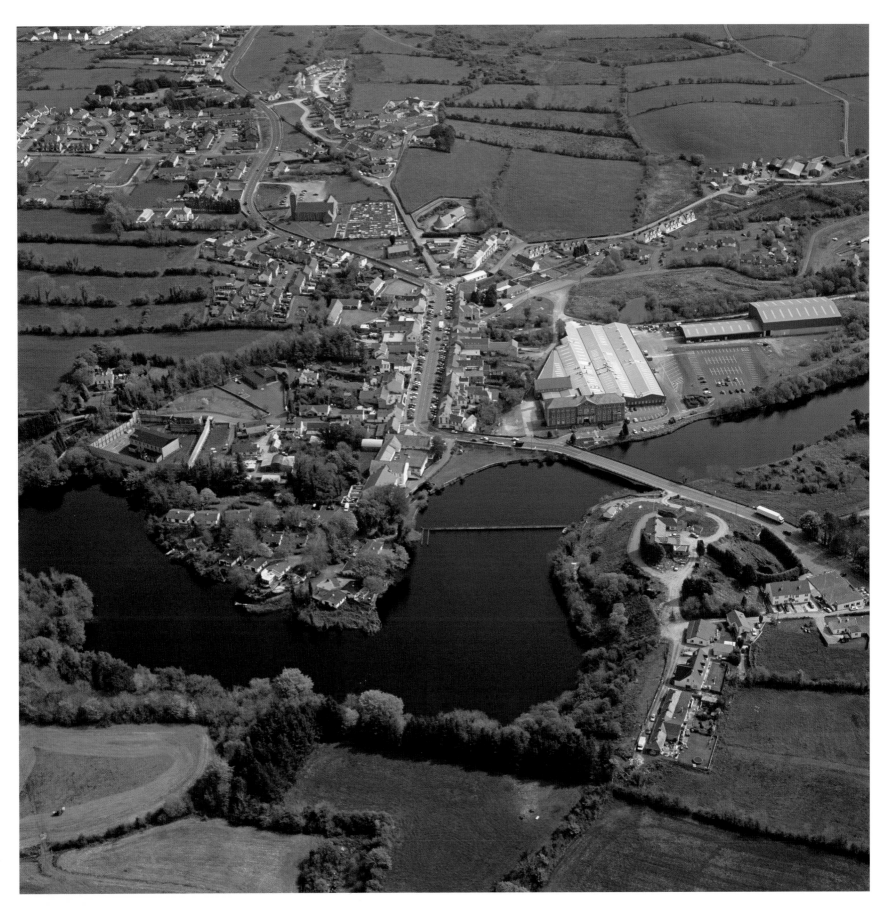

Above: Belleek
Opposite: Lough MacNean, which straddles the border between County Fermanagh and County Leitrim

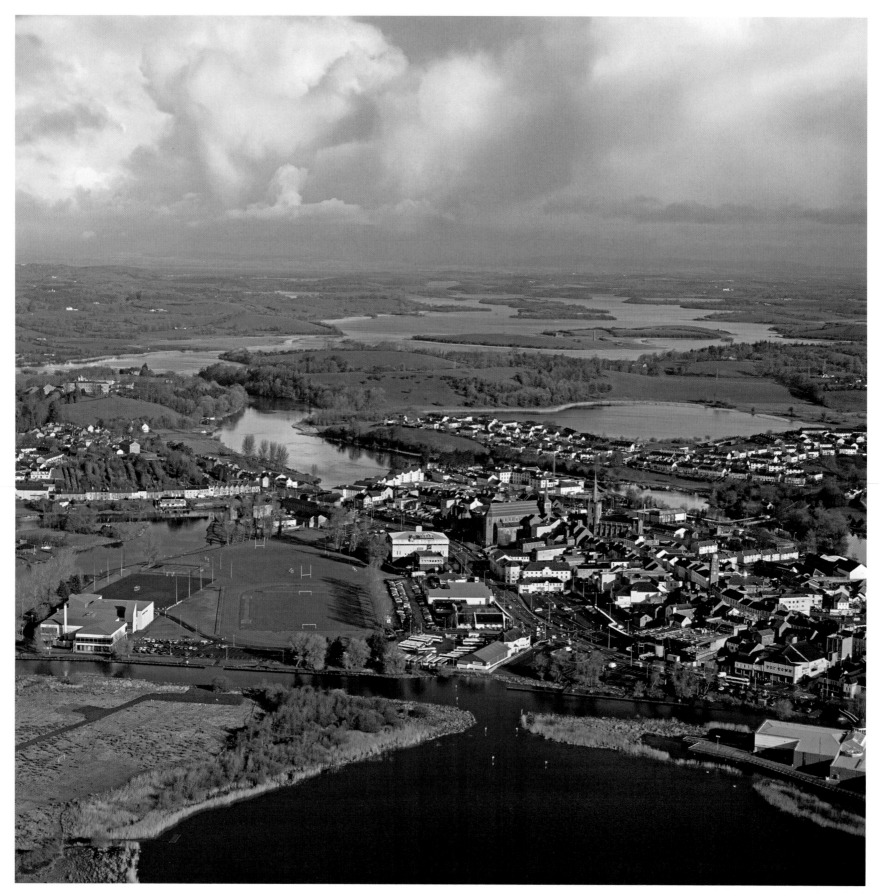

Above: Enniskillen
Opposite: Castle Coole

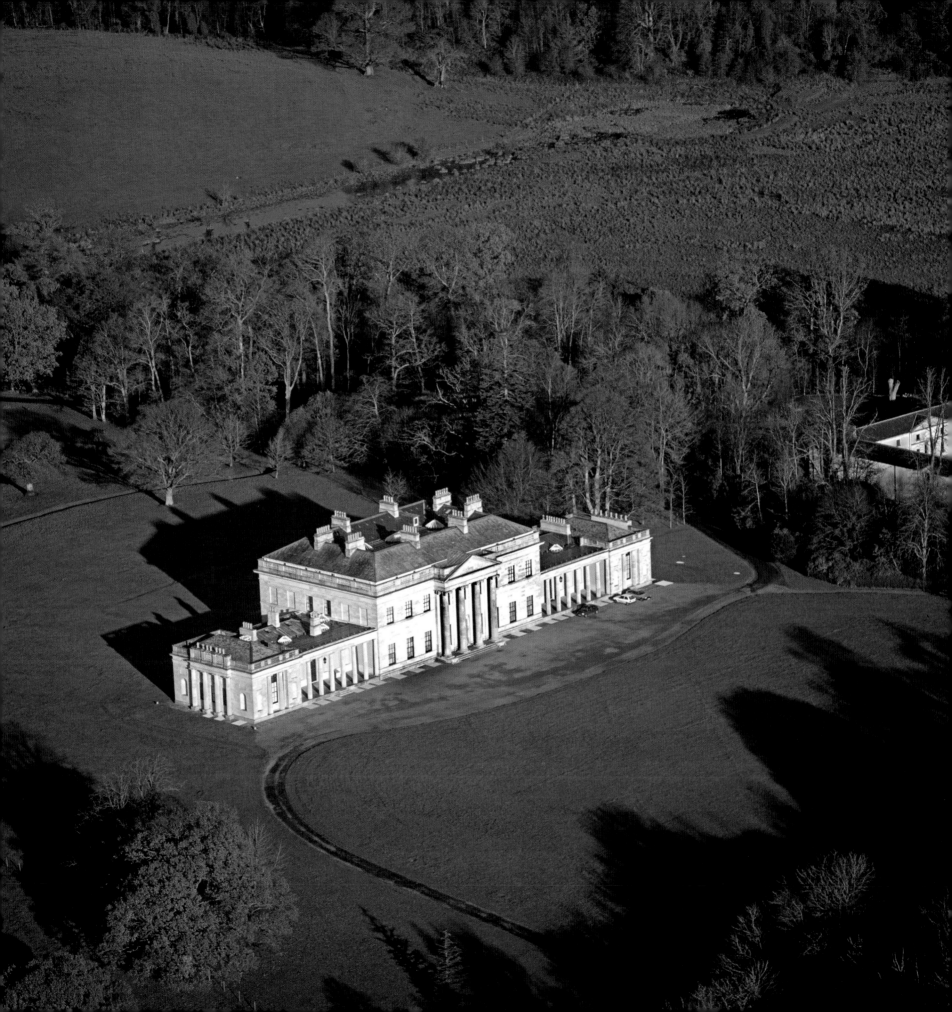

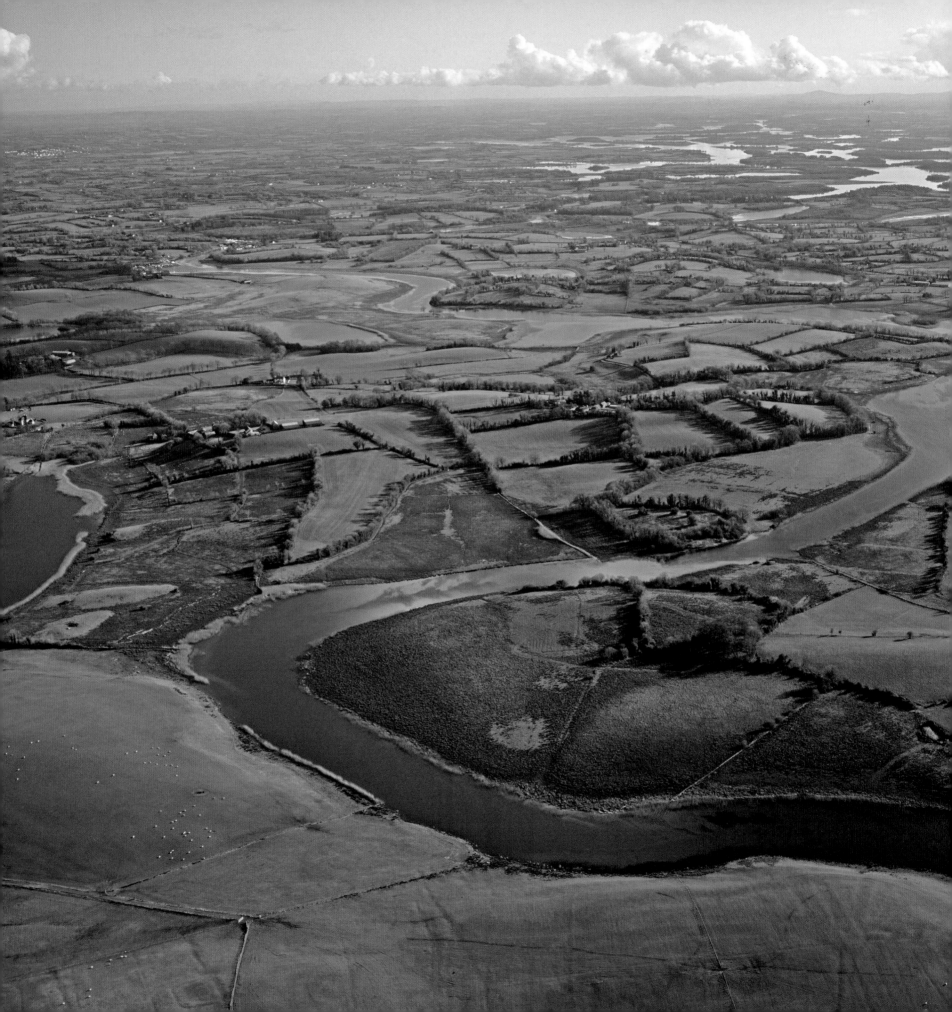

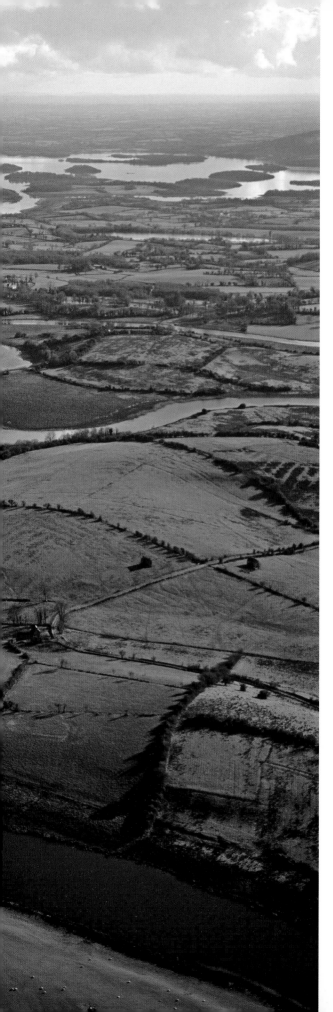

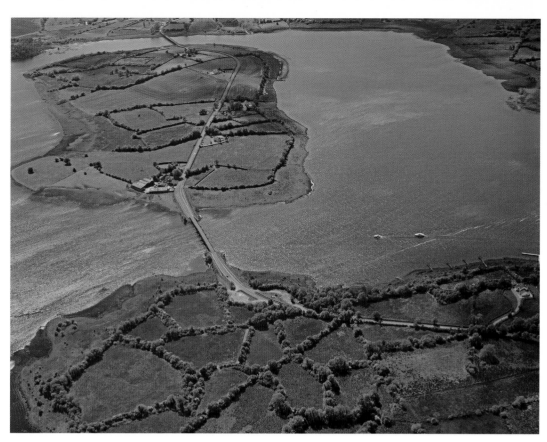

Lady Craigavon Bridge leading to Trasna Island in Upper Lough Erne

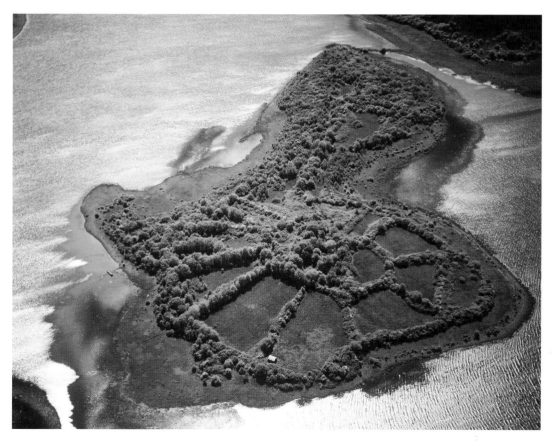

Above: Inishturk, Lower Lough Erne
Opposite: Upper Lough Erne with Cleenish in the foreground

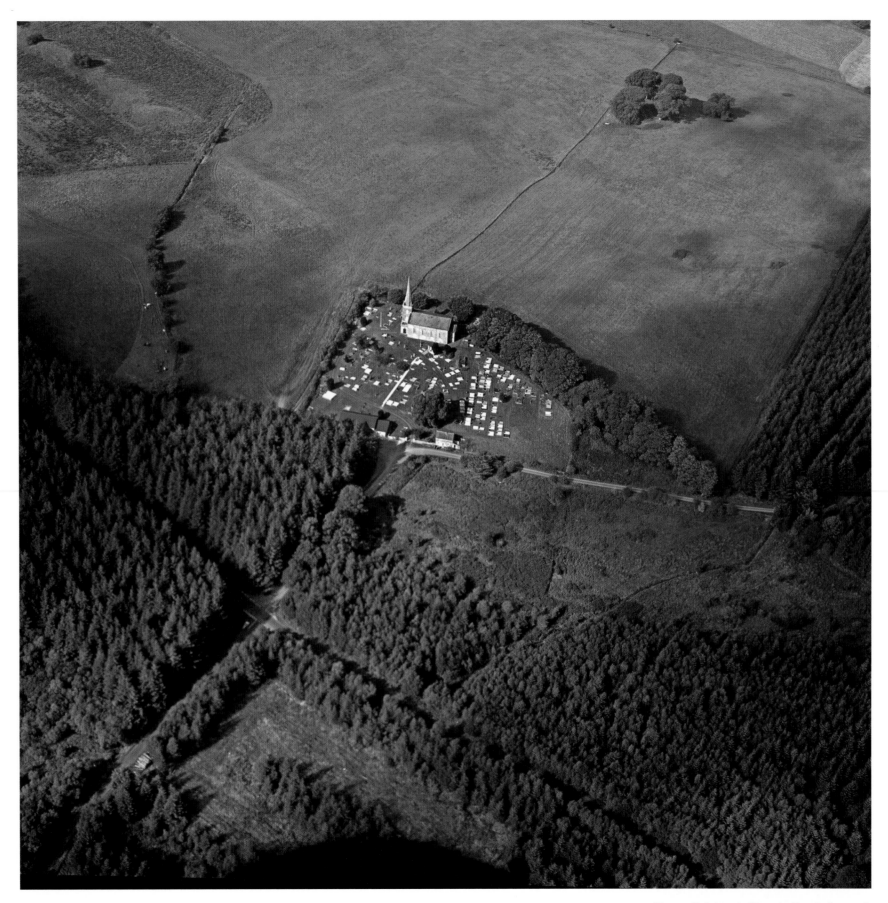

Above: Colebrook Church, Brookeborough
Opposite: Tempo Manor

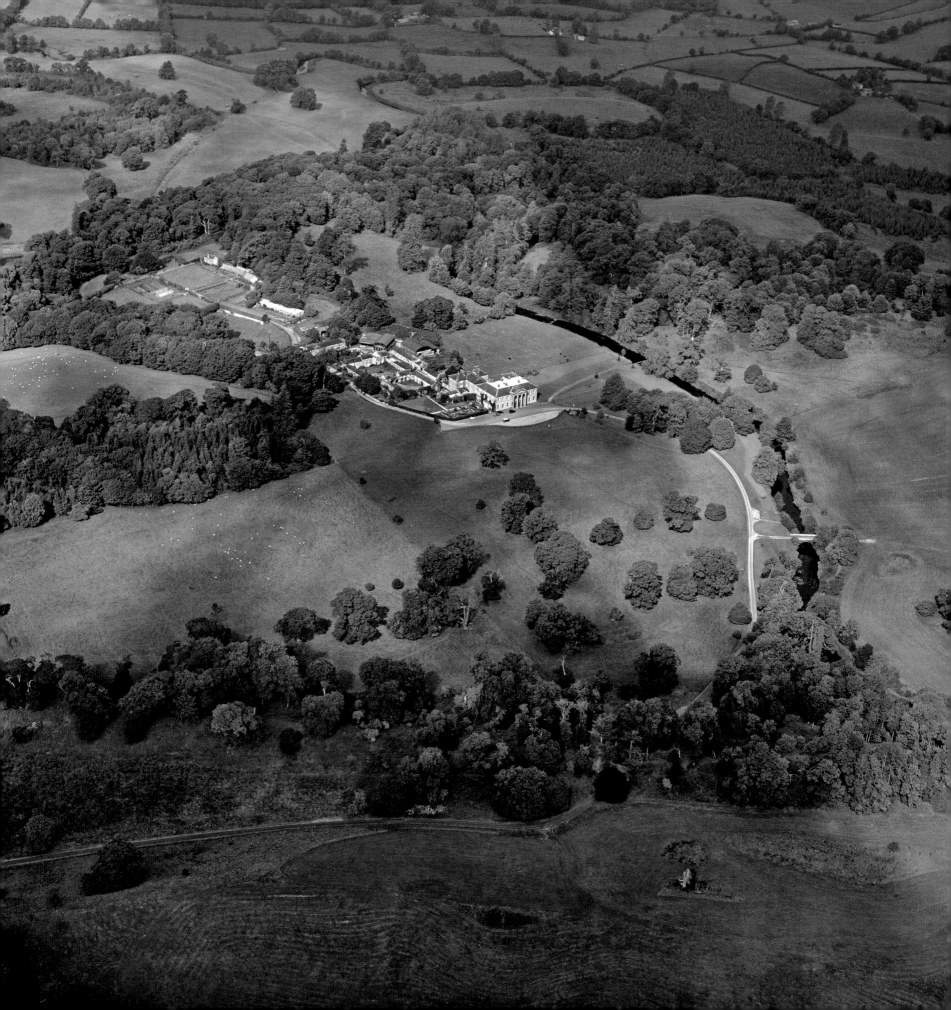

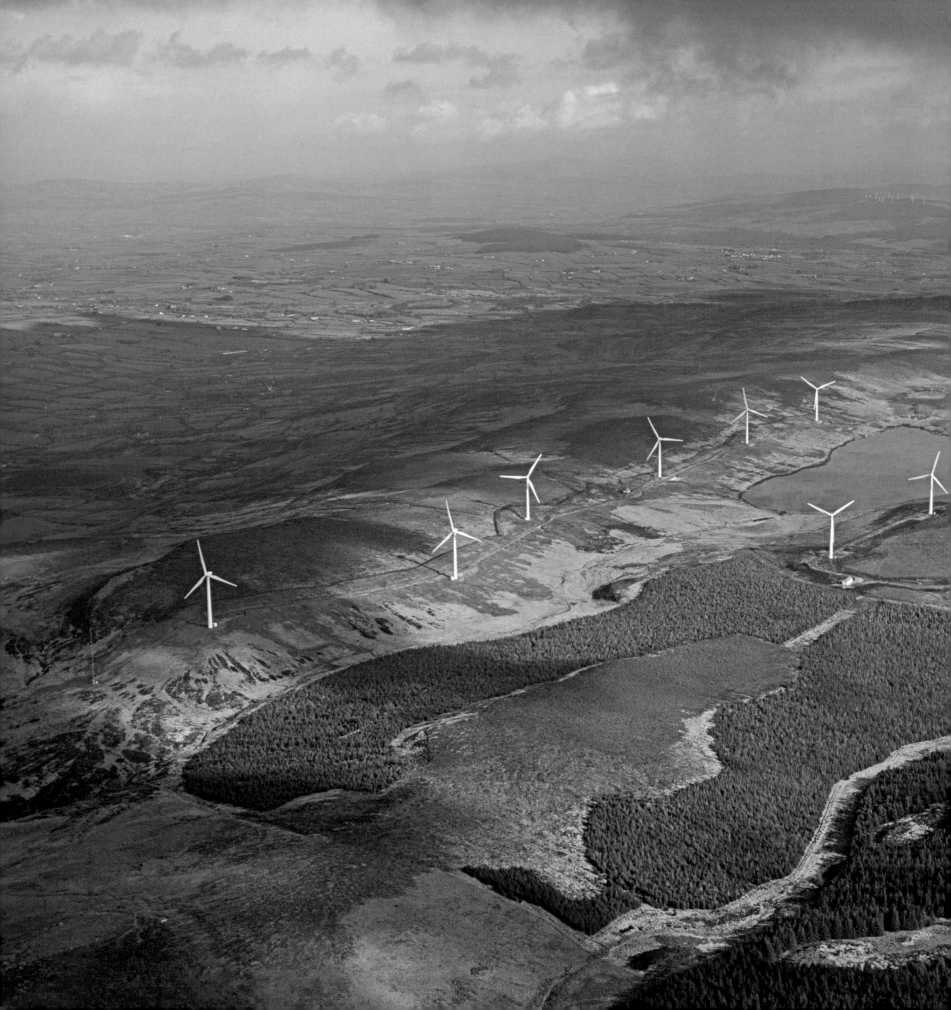

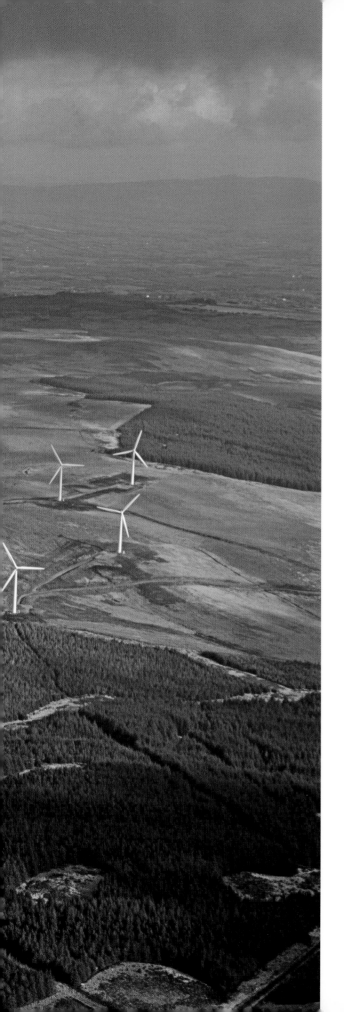

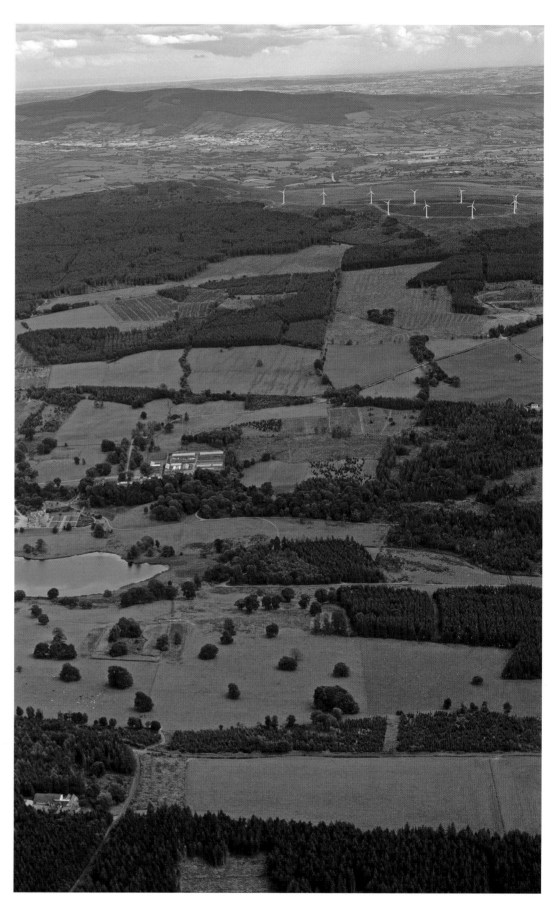

Above: Baronscourt and Bessy Bell Wind Farm, near Newtownstewart
Opposite: Bin Lough Wind Farm, County Tyrone

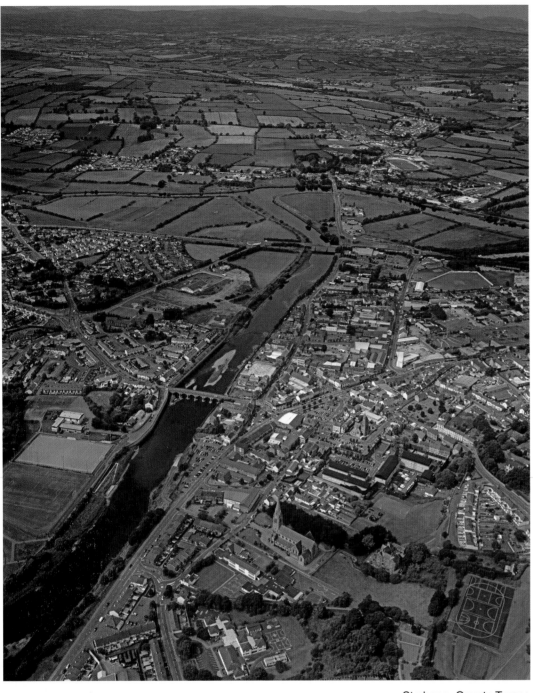

Strabane, County Tyrone

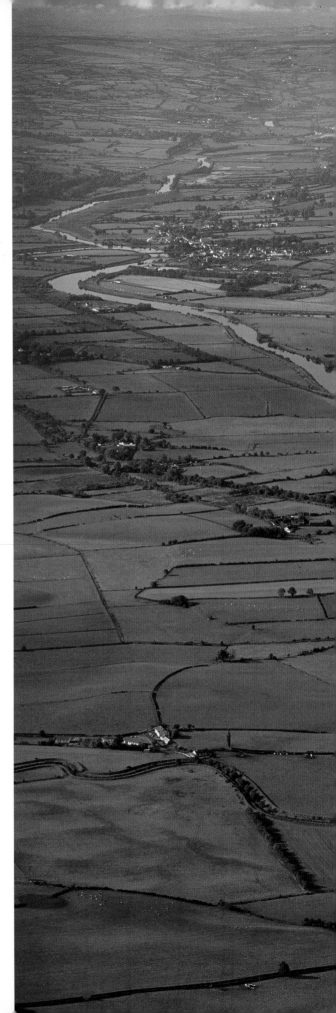

The River Foyle, north of Strabane, with the disused
Strabane Canal in the foreground

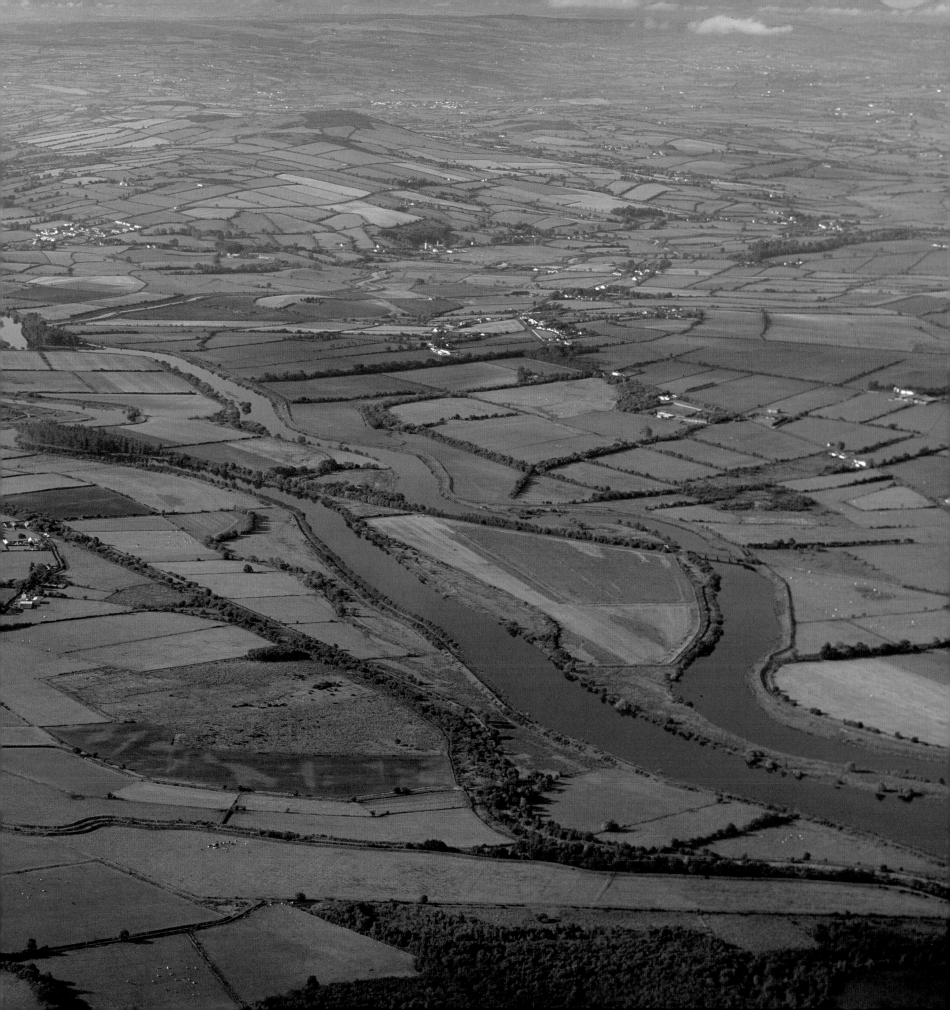

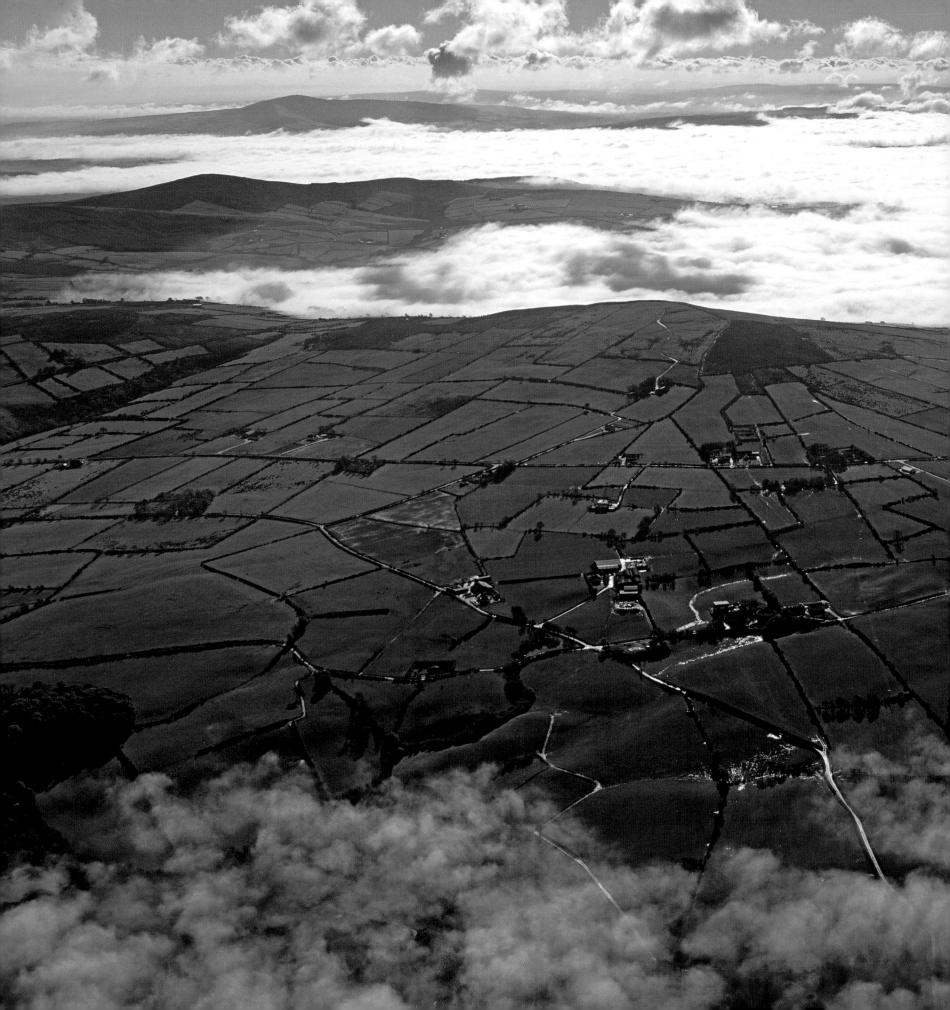

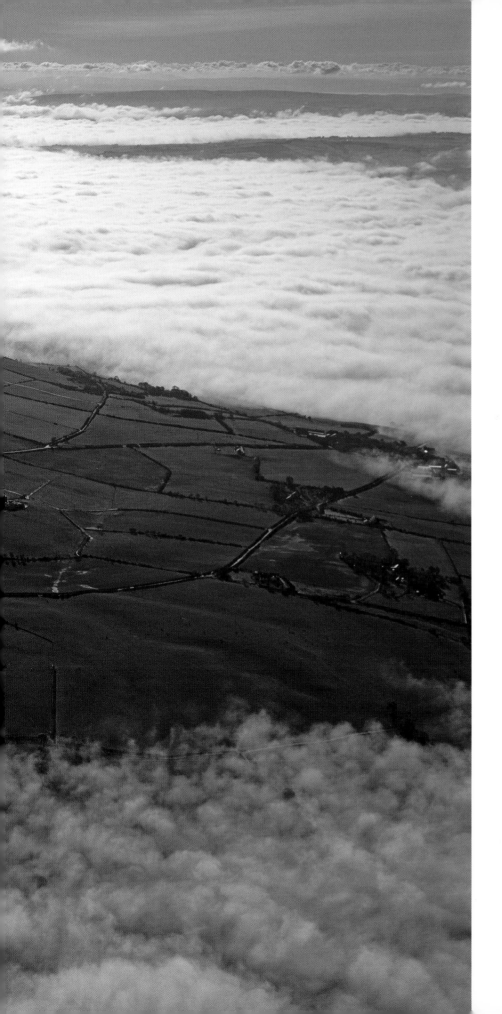

North Tyrone, looking towards Owenreagh Hill in the Sperrins

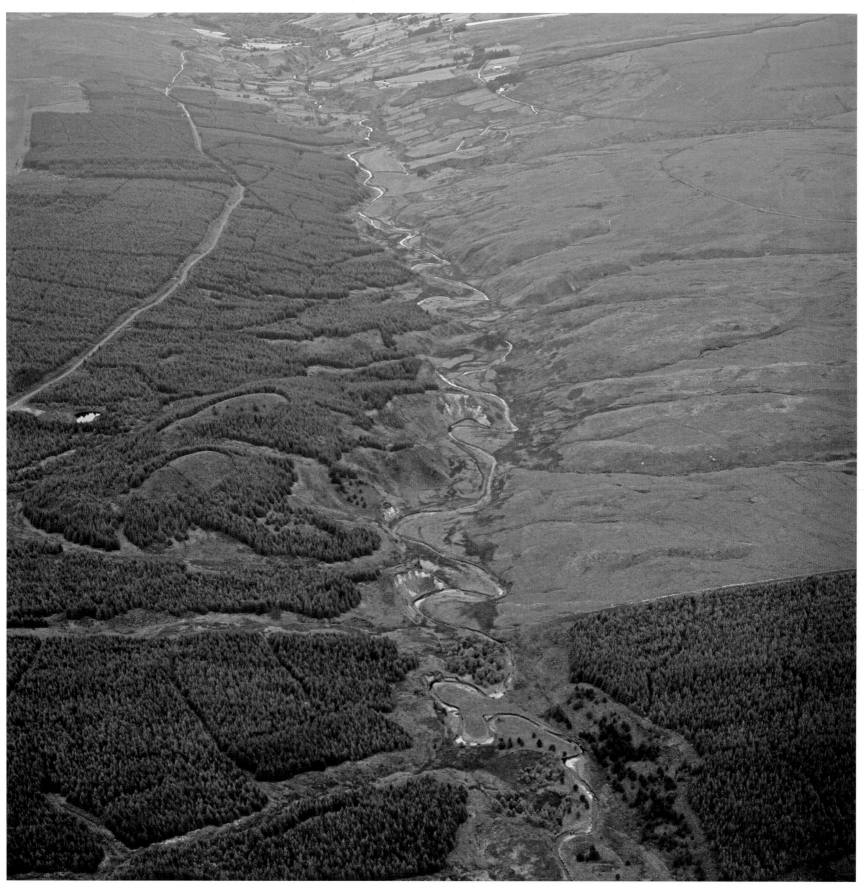

Above: Glenlark River in the Glenlark Valley, County Tyrone
Opposite: Crockmore Mountain

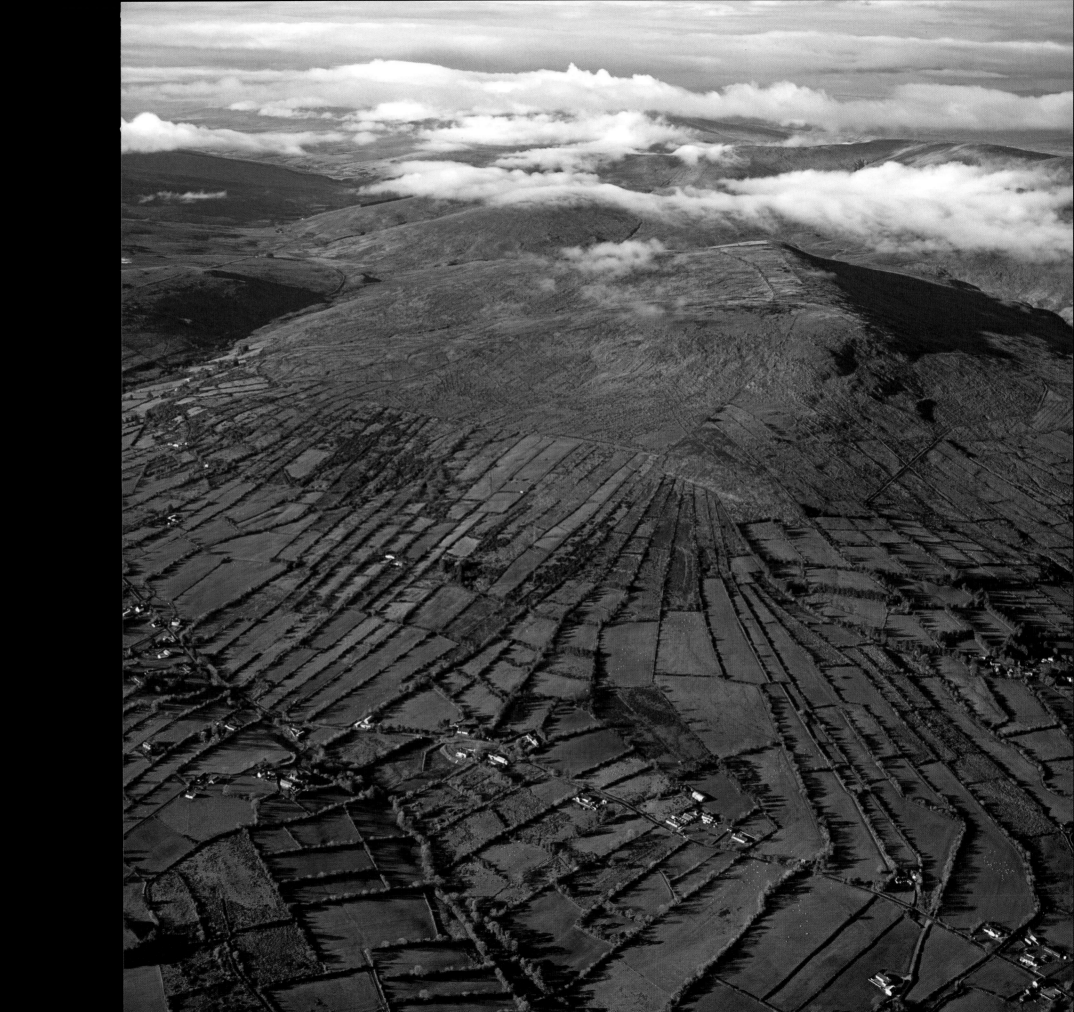

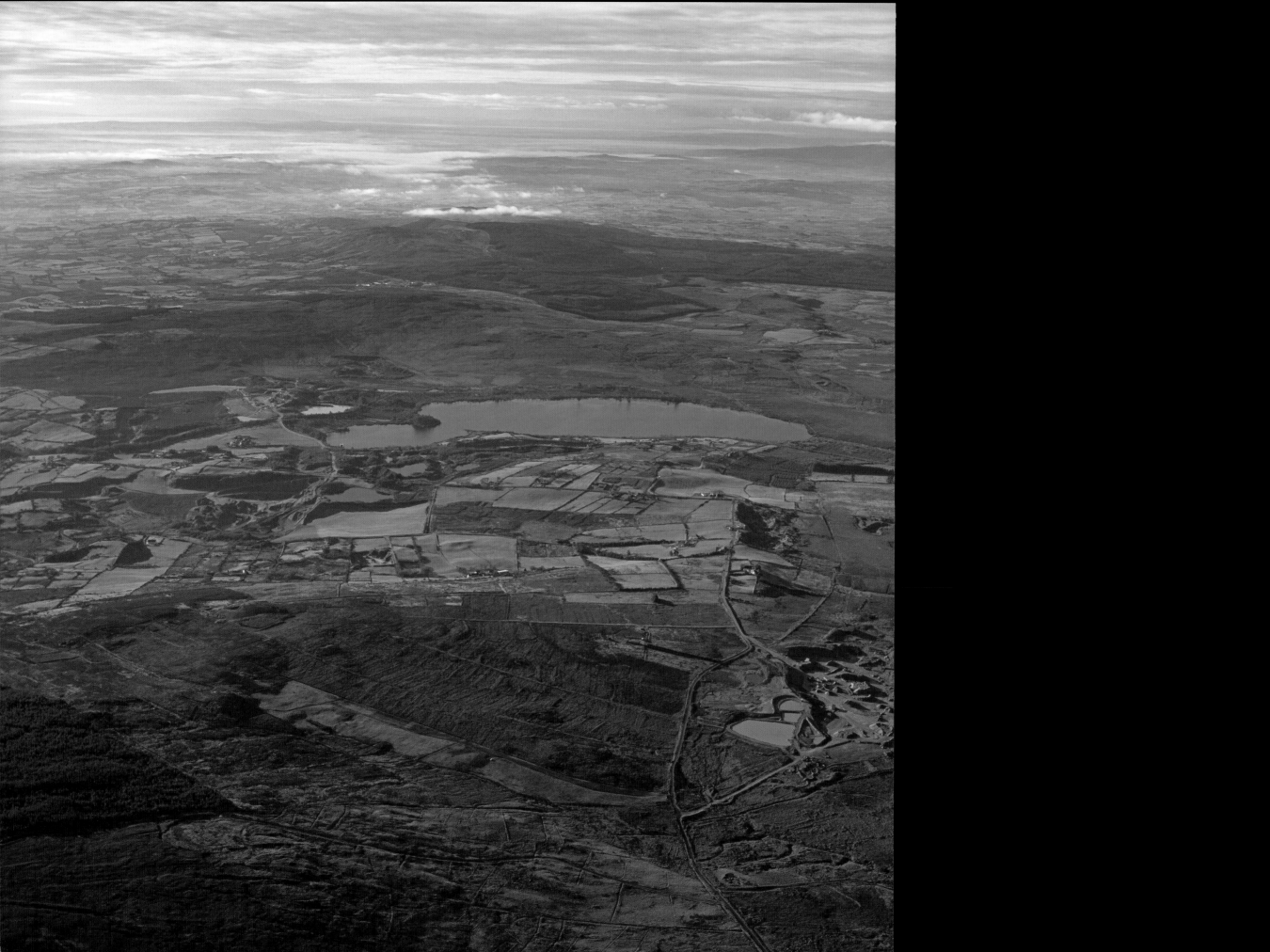

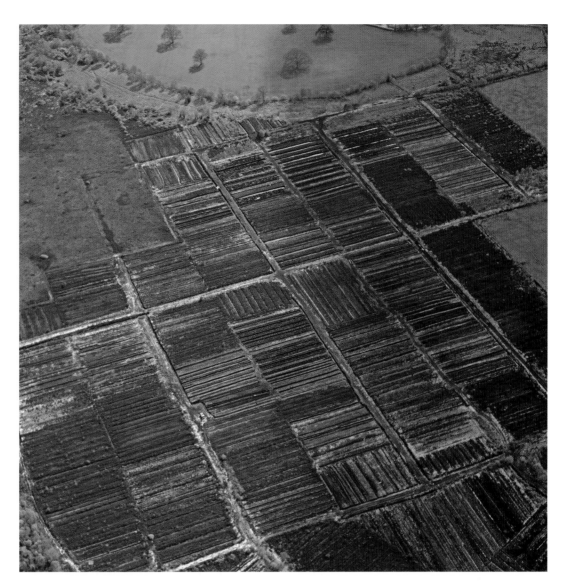

Peatland in County Tyrone

Lough Fea, on the border between County Tyrone and County Londonderry

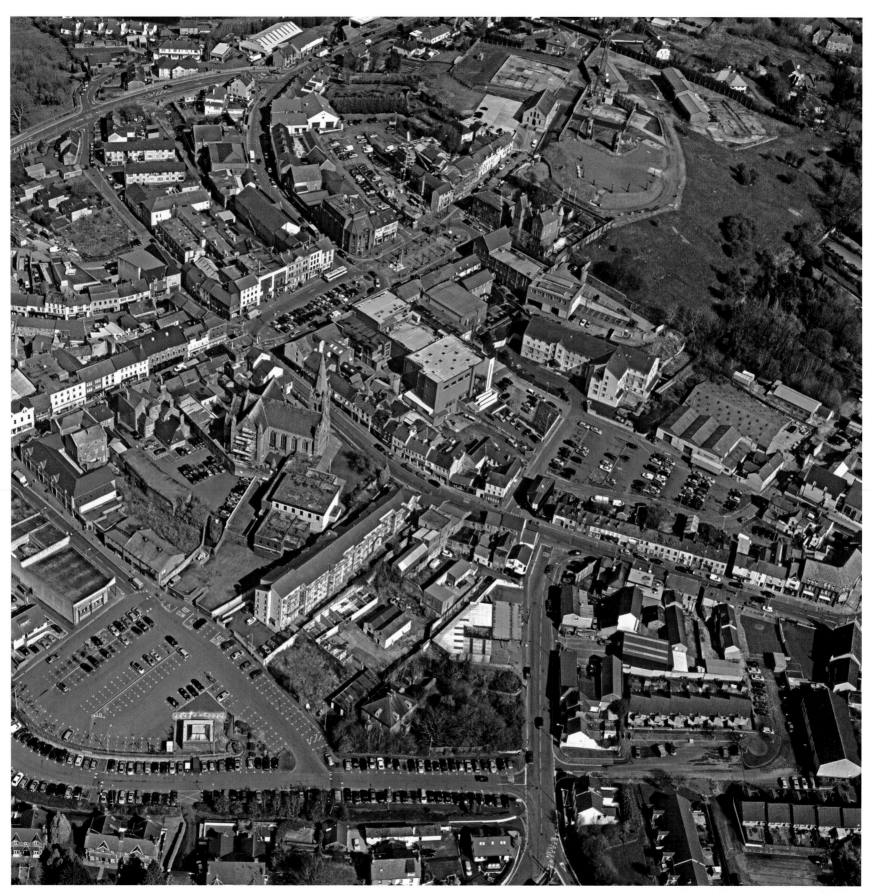

Above: Dungannon, County Tyrone
Opposite: Killymoon House, designed by John Nash, outside Cookstown

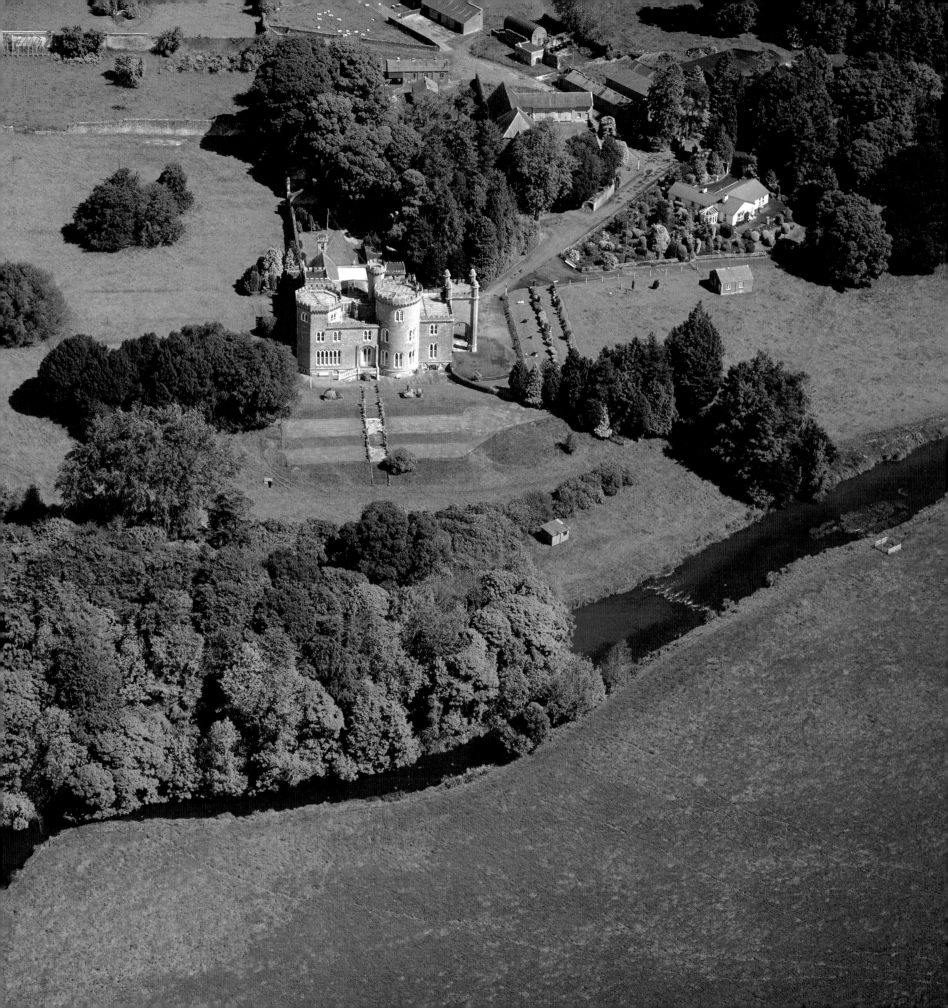

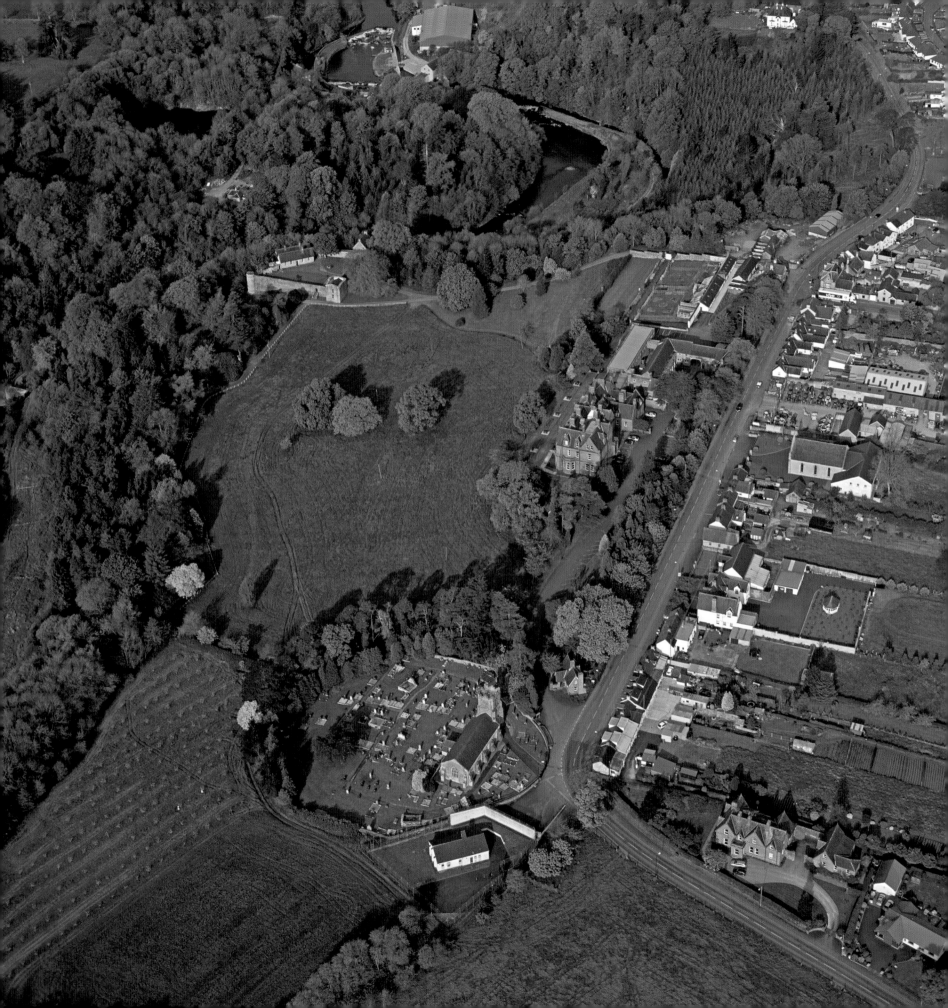

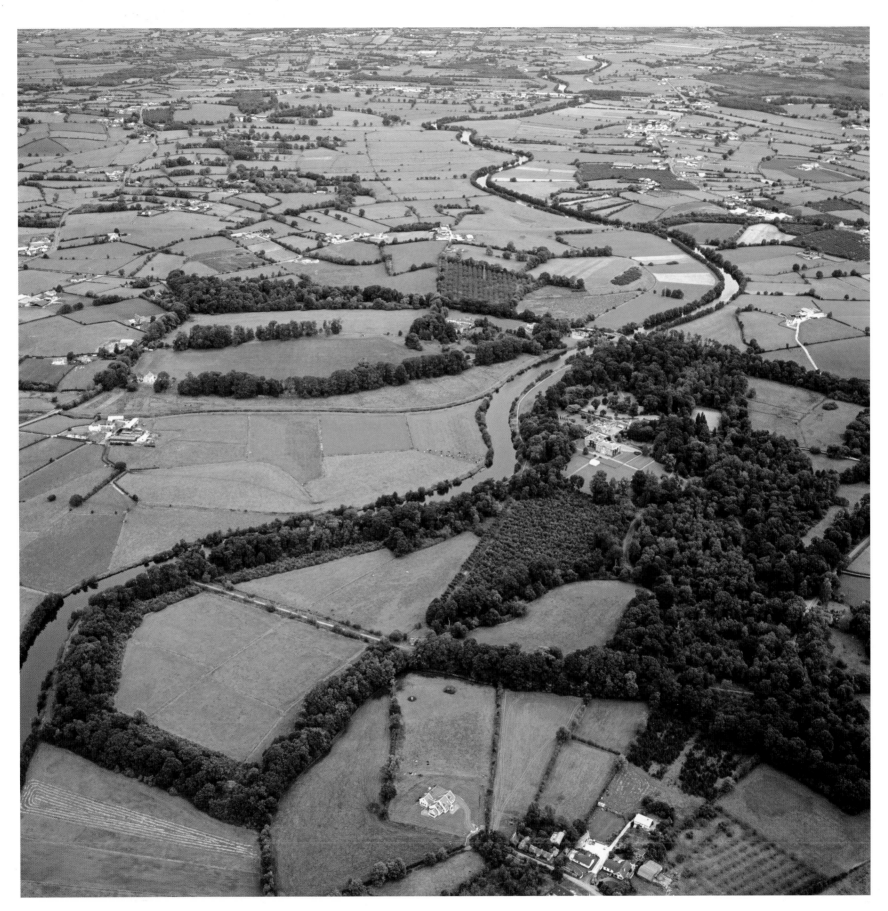

Above: The River Blackwater flowing past the Argory, County Armagh
Opposite: The Servite Priory, Benburb, on the Tyrone–Armagh border

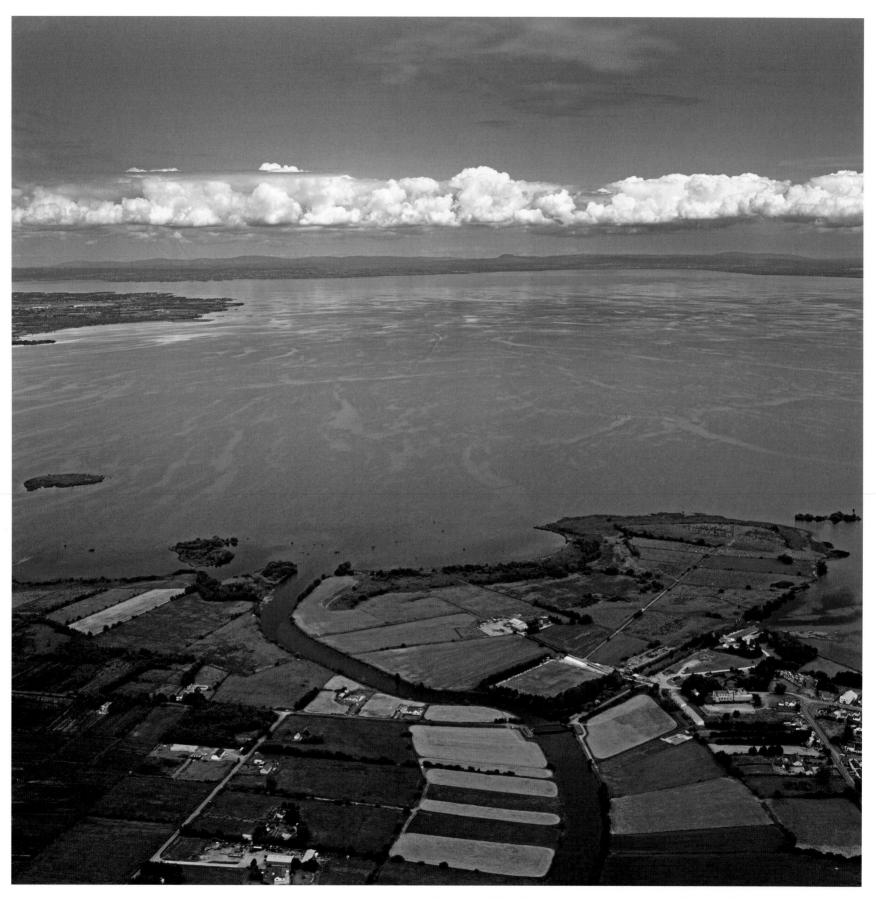

Above: The River Blackwater flowing into Lough Neagh at Maghery, County Armagh
Opposite: The River Bann at Muckery

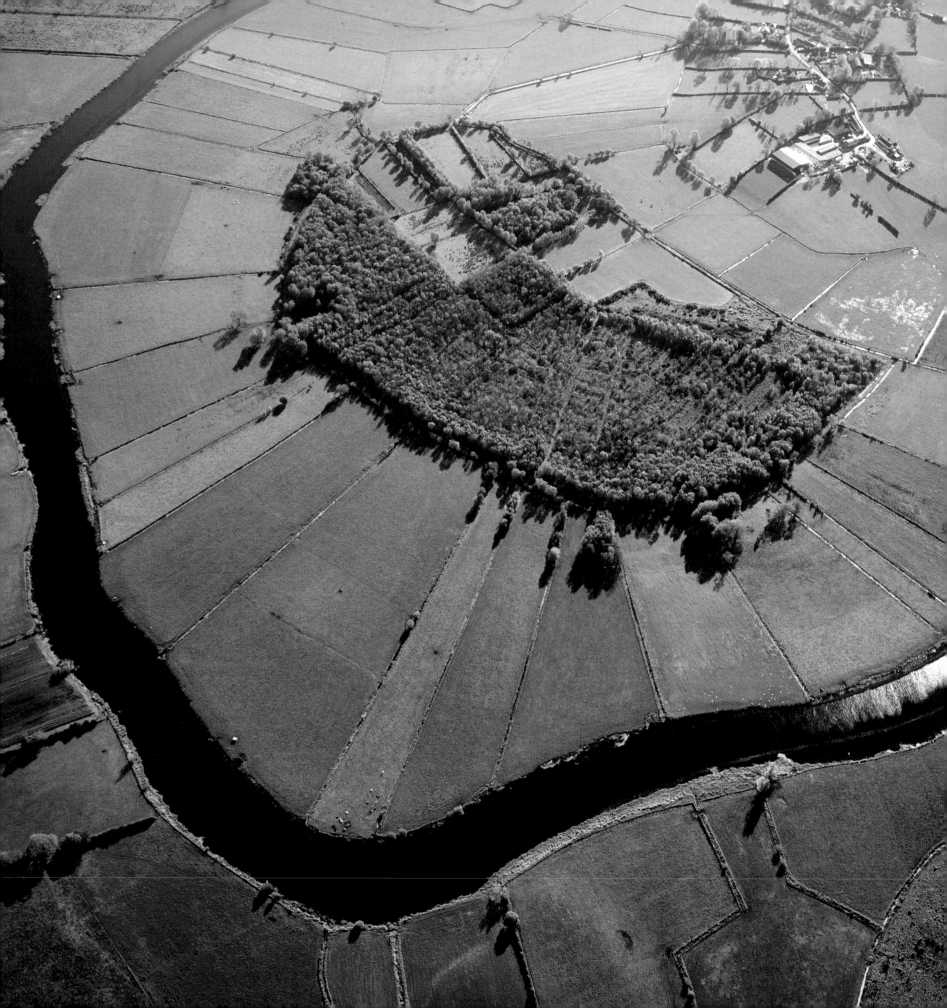

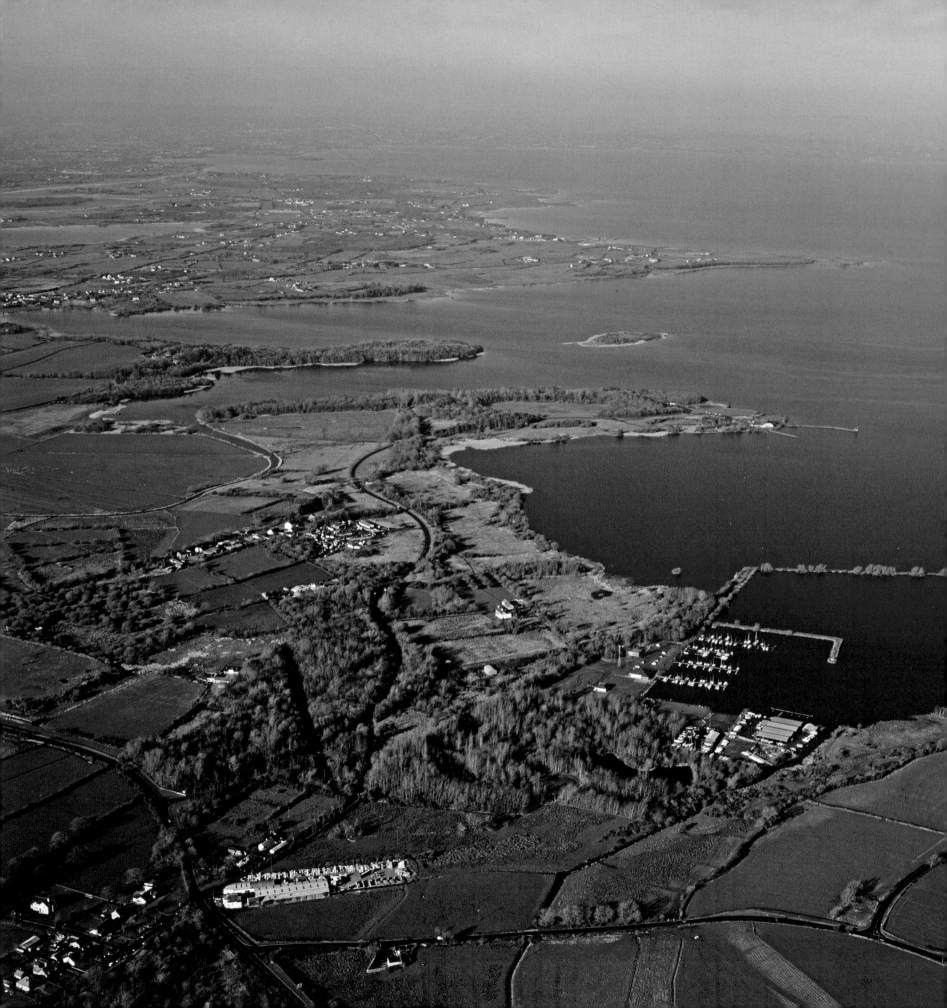

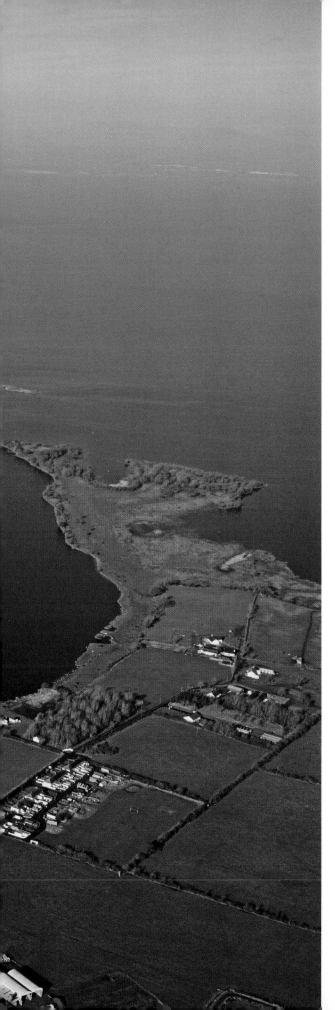

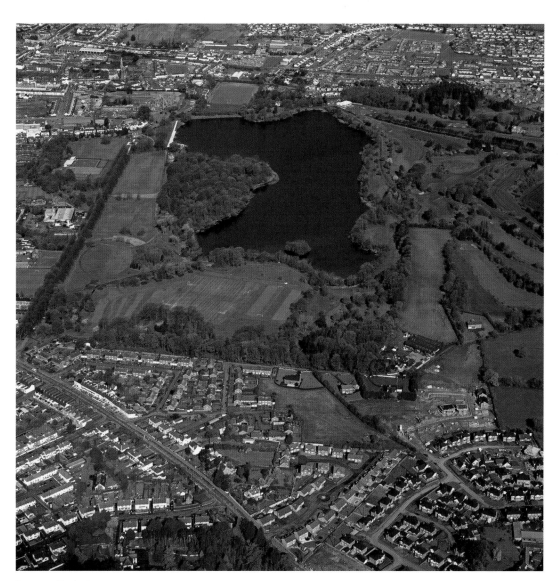

Lurgan Park, Lurgan

Kinnego Marina on the southern shores of Lough Neagh

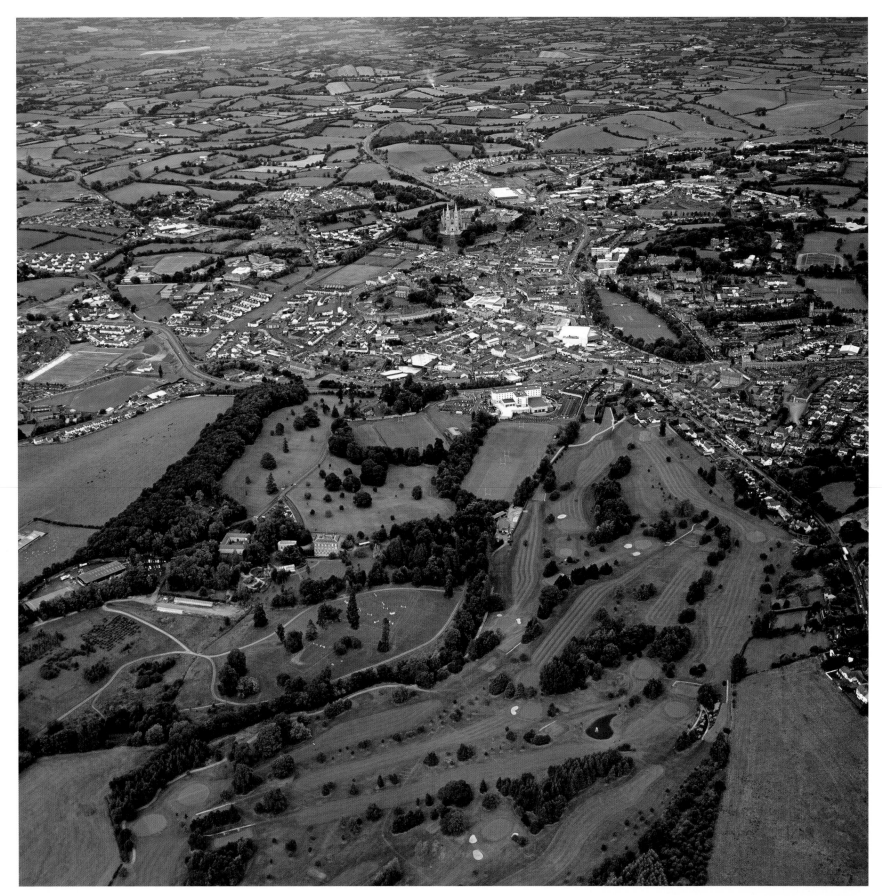

Above: Armagh city
Opposite: Navan Fort

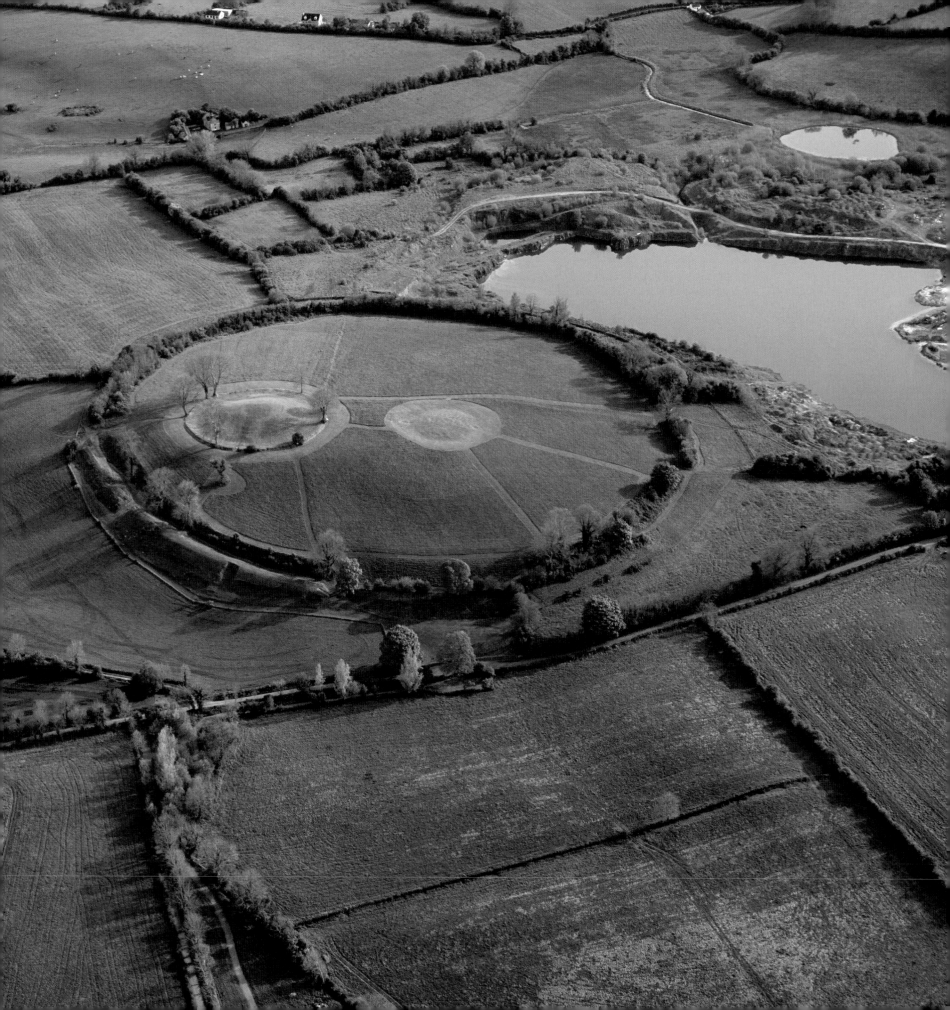

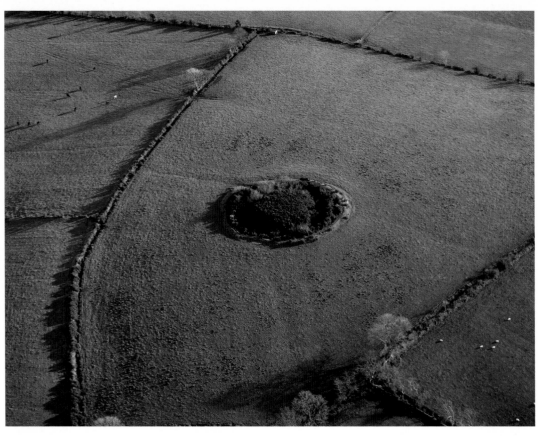

A fairy fort in County Armagh

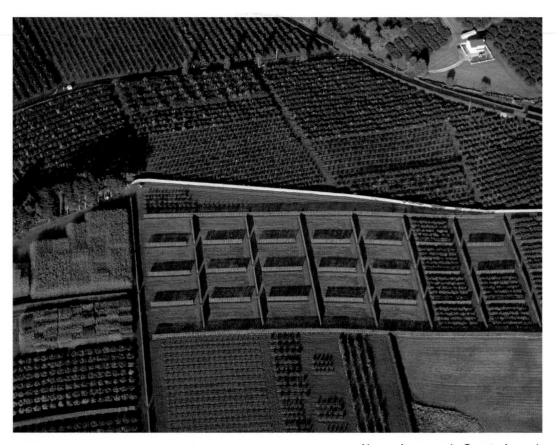

Above: A nursery in County Armagh
Opposite: Tassagh Viaduct

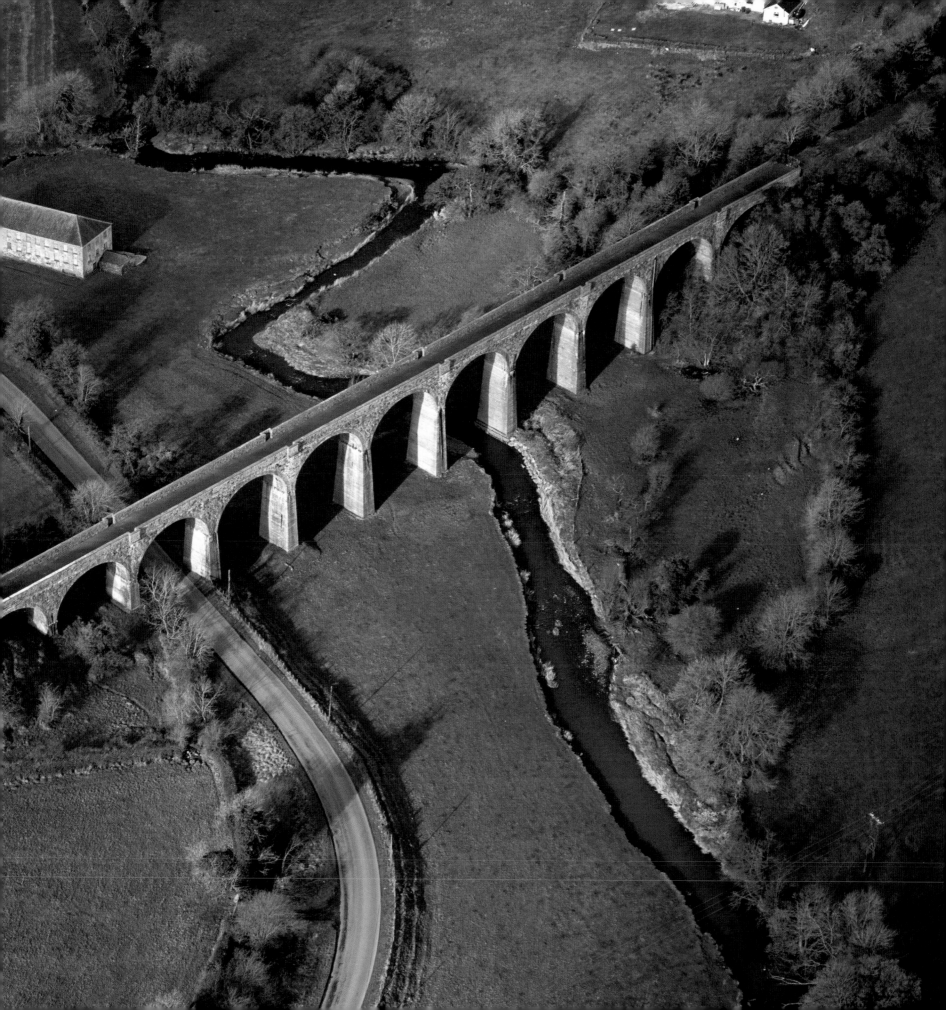

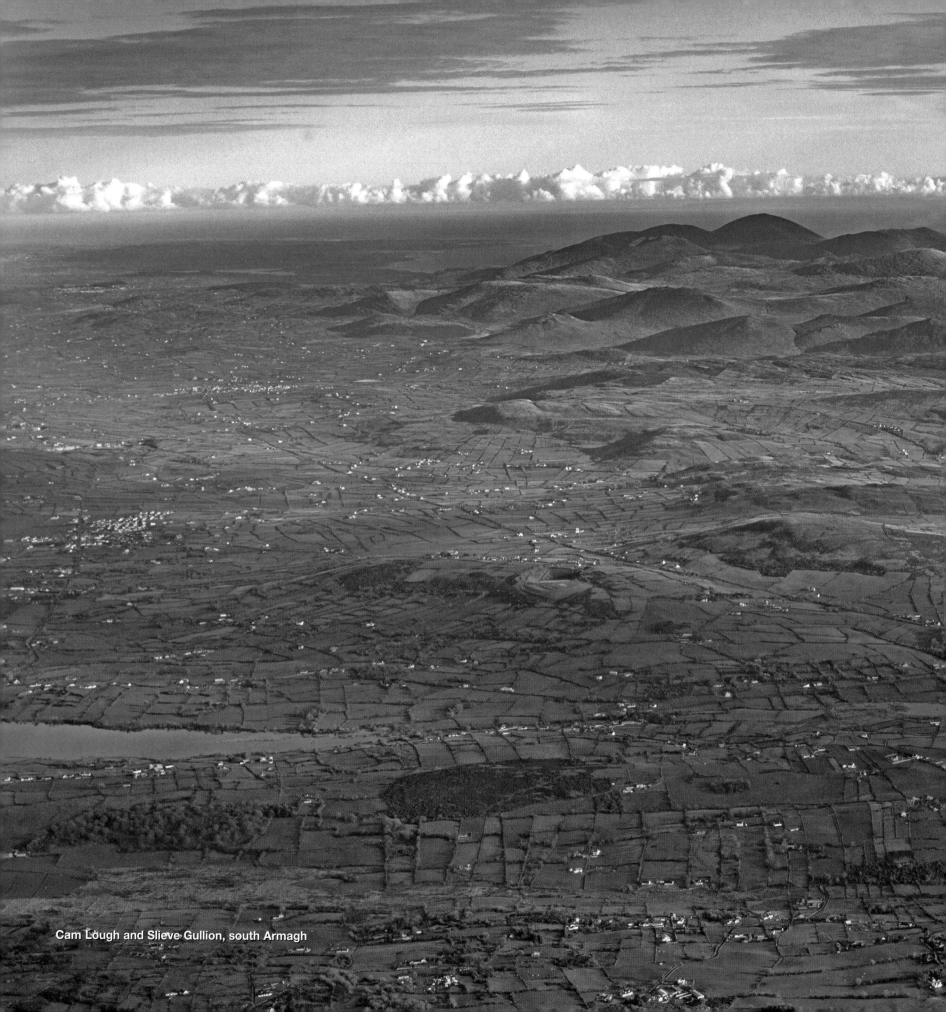

Cam Lough and Slieve Gullion, south Armagh

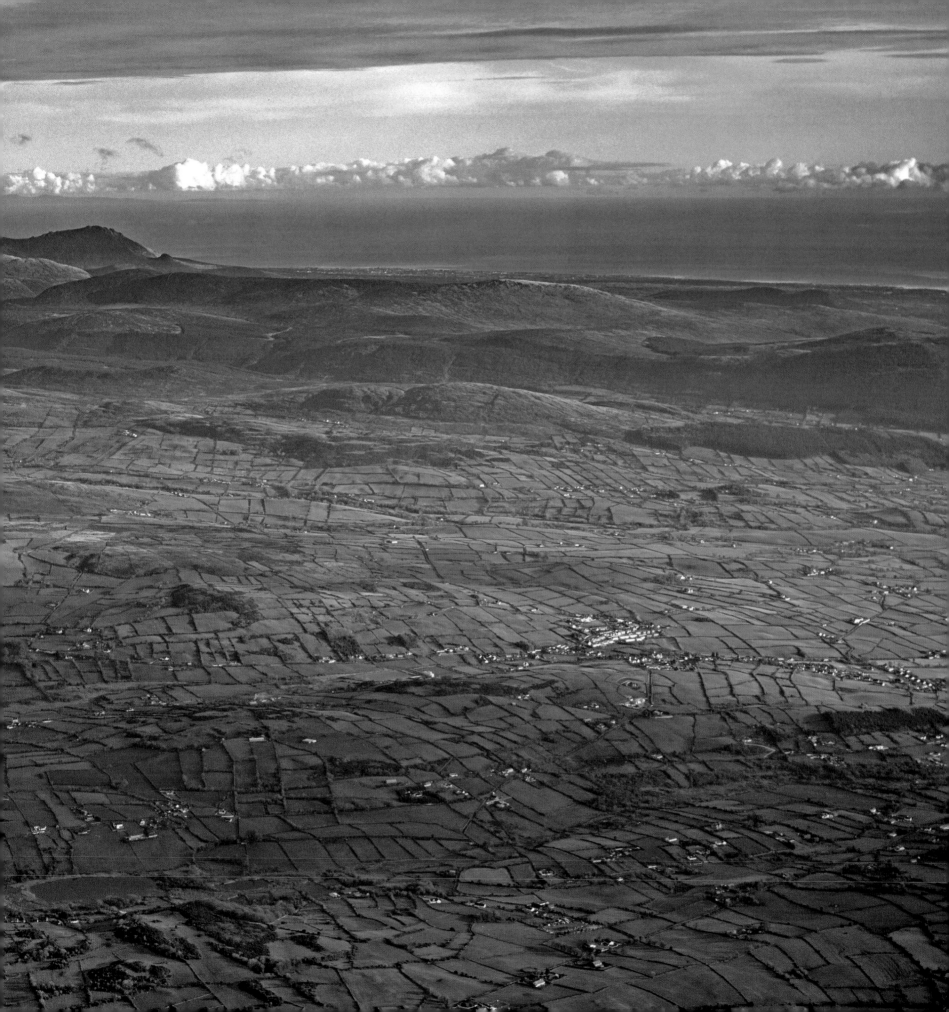

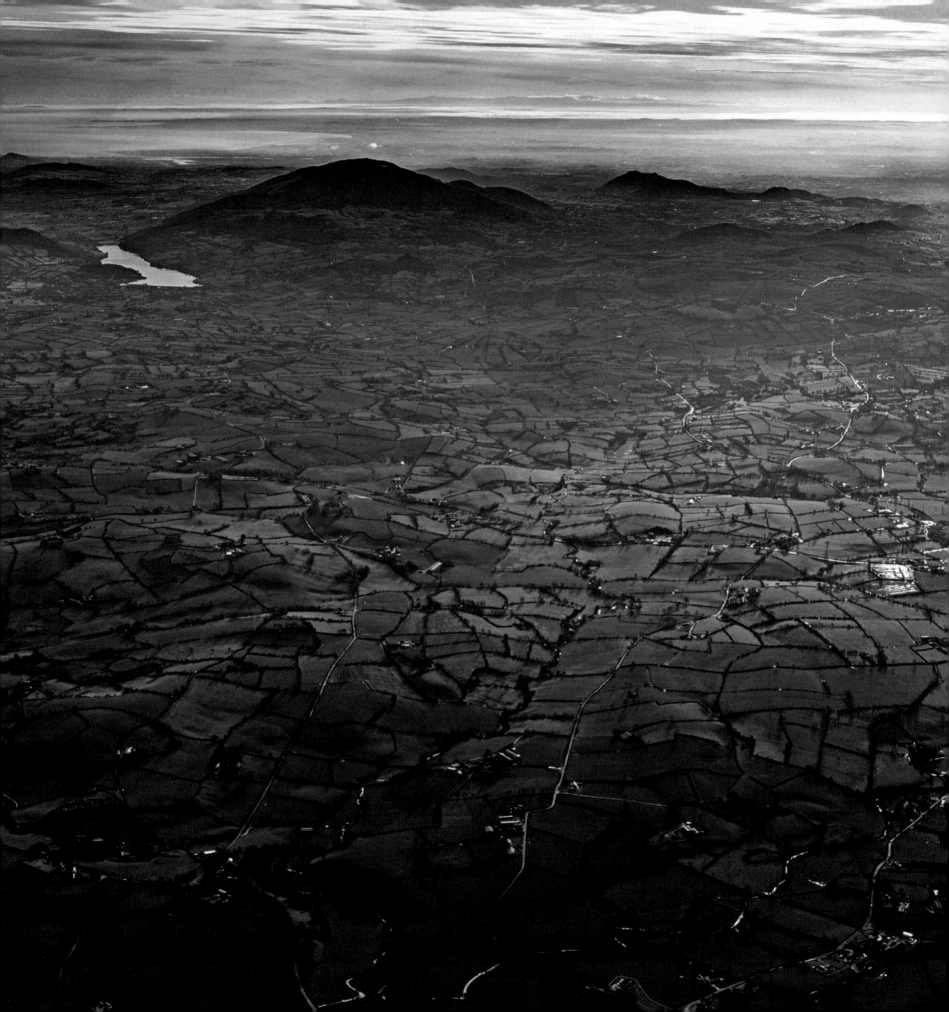

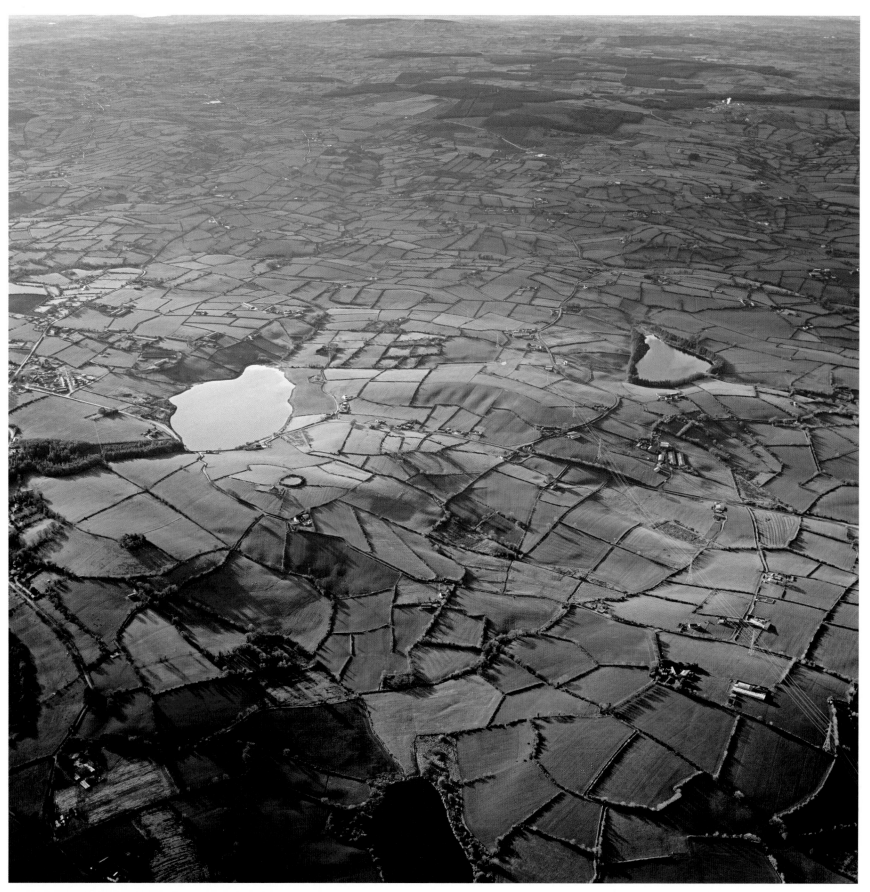

Above: Shaw's Lake and Ballylane Lough, near Glennane, County Armagh
Opposite: The Ring of Gullion

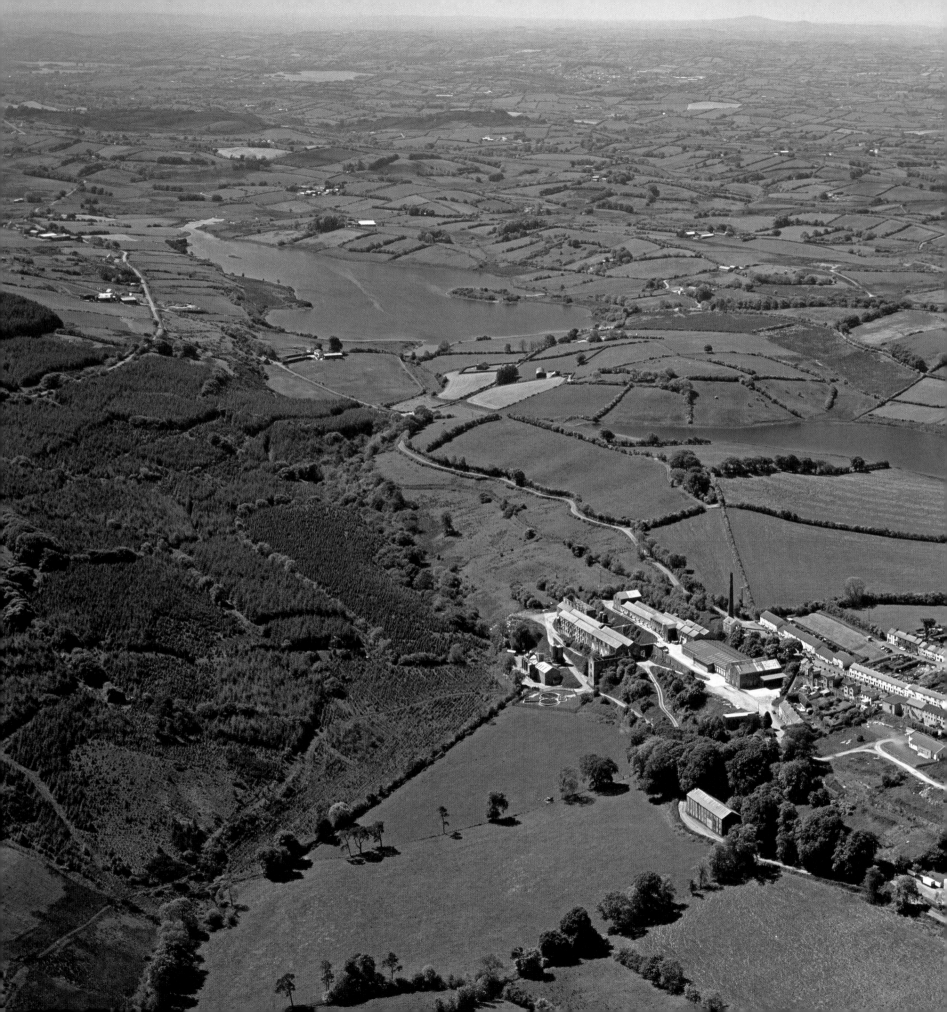

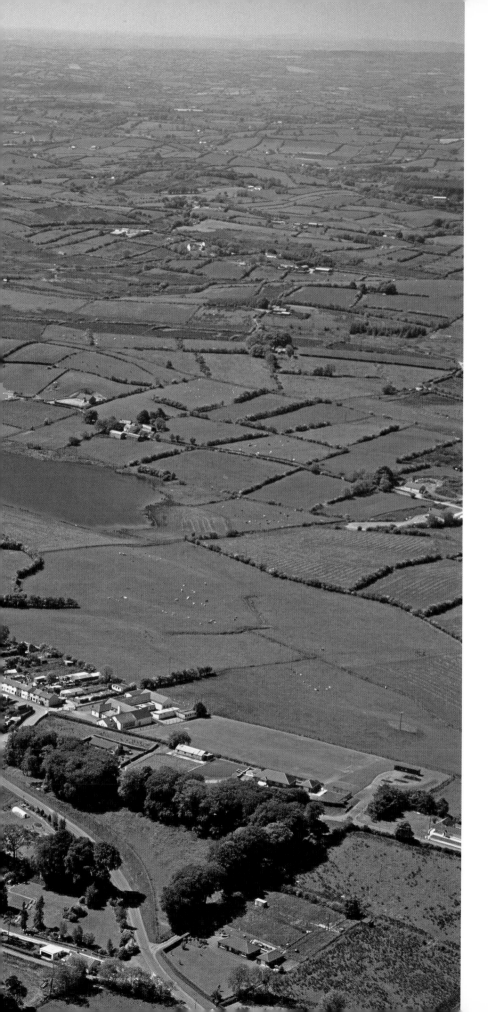

Darkley, near Keady, County Armagh

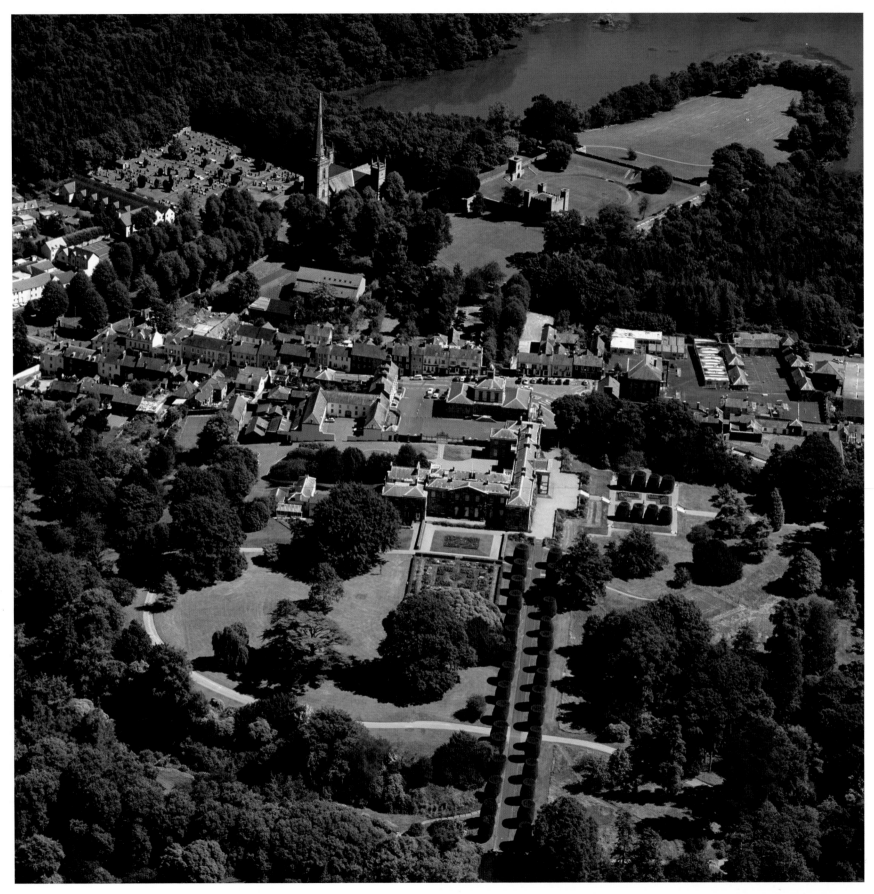

Above: Hillsborough village, County Down, with the Castle and gardens in the foreground
Opposite: Newry Canal and the Albert Basin, looking towards Carlingford Lough

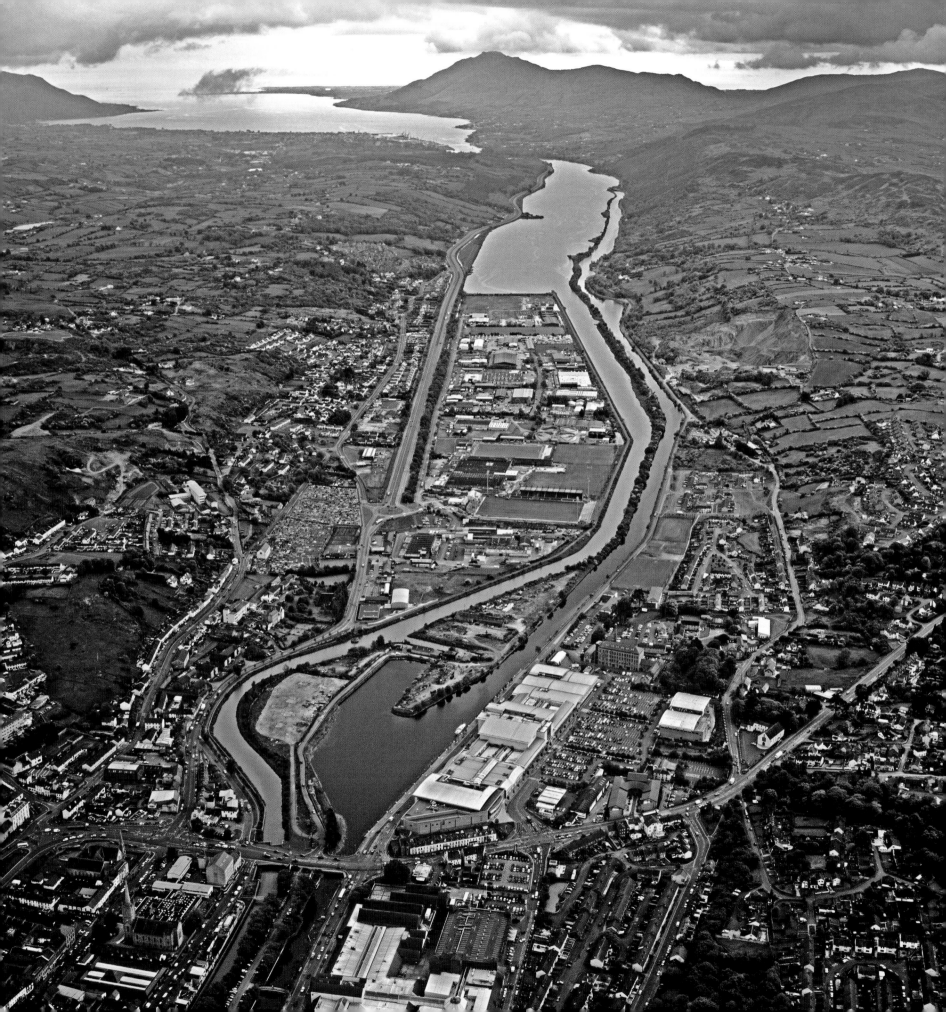

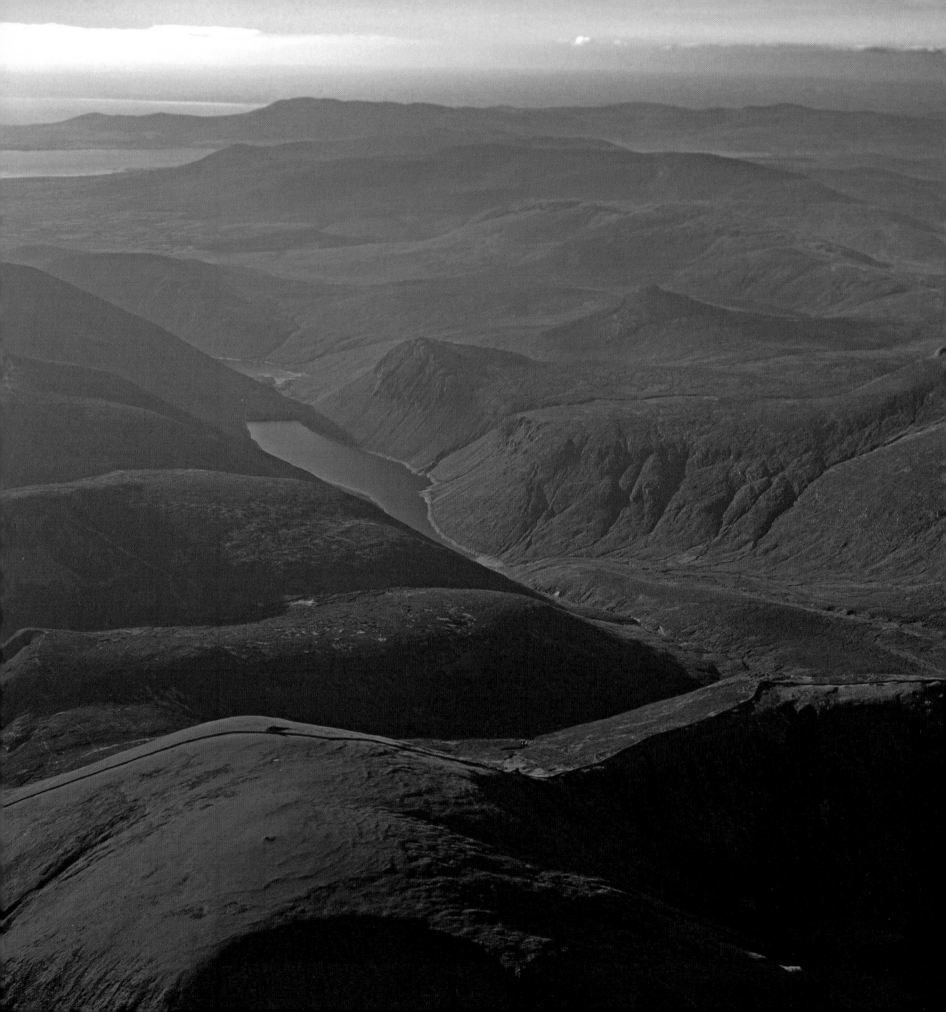

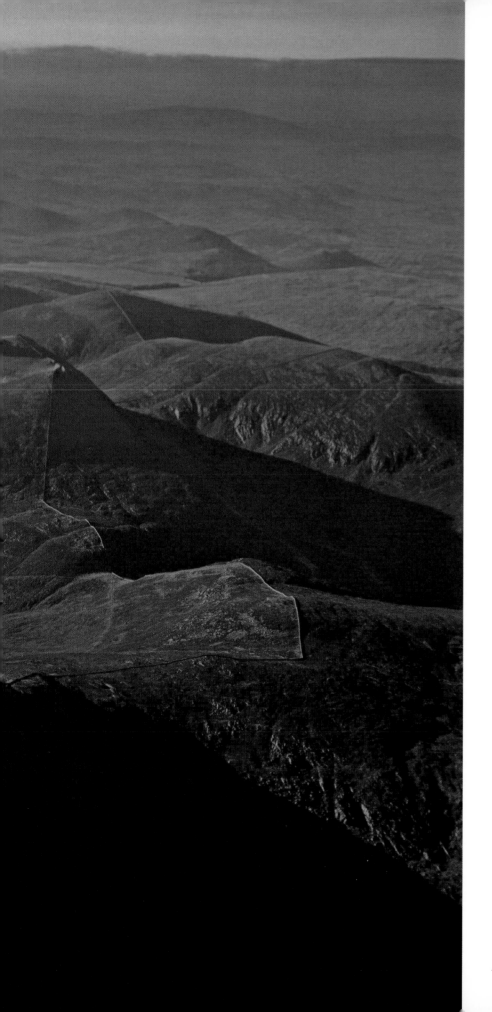

The Mournes and Ben Crom Reservoir, County Down

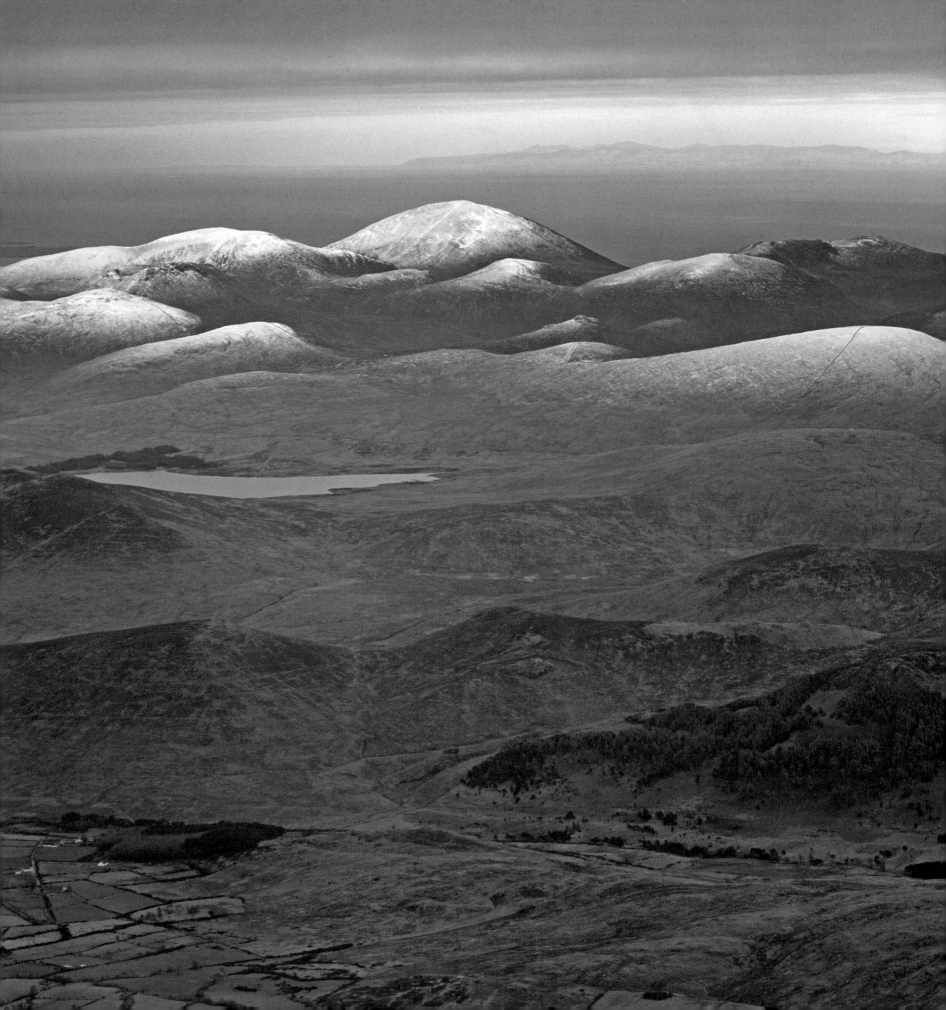

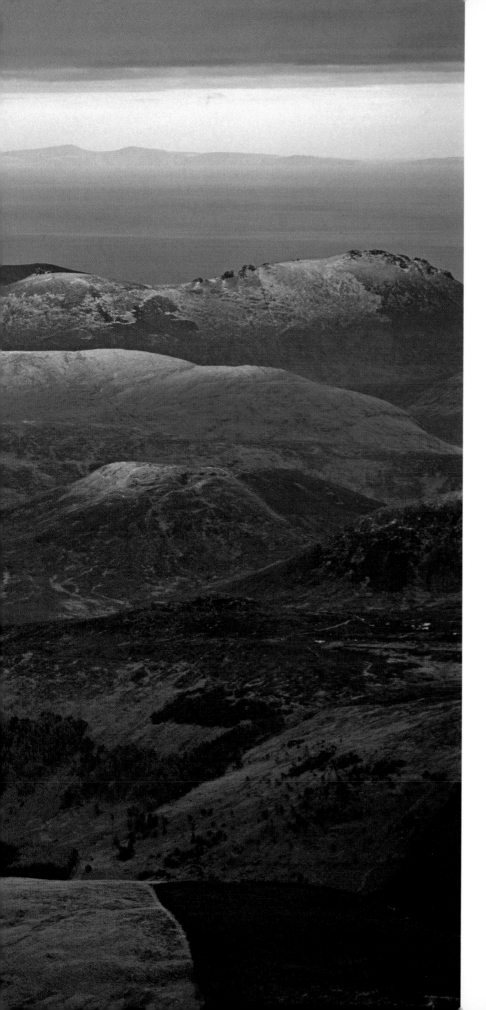

The Mournes in winter

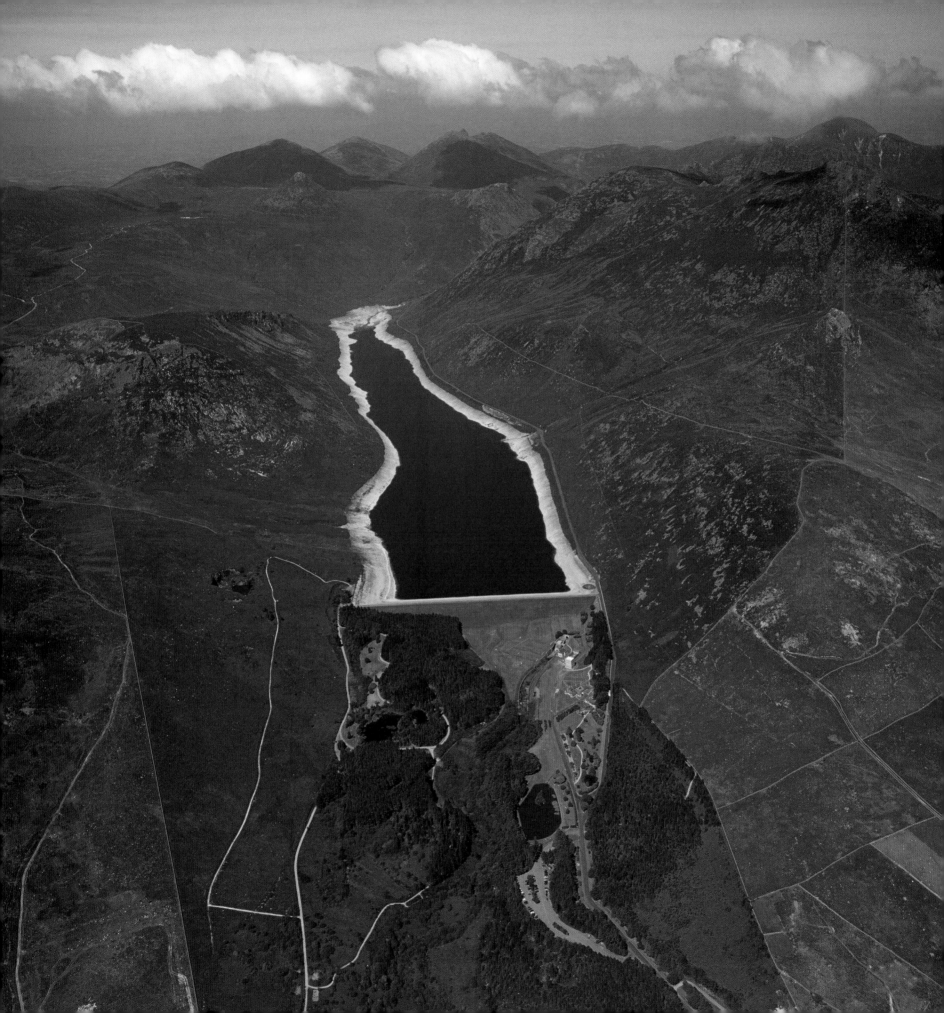

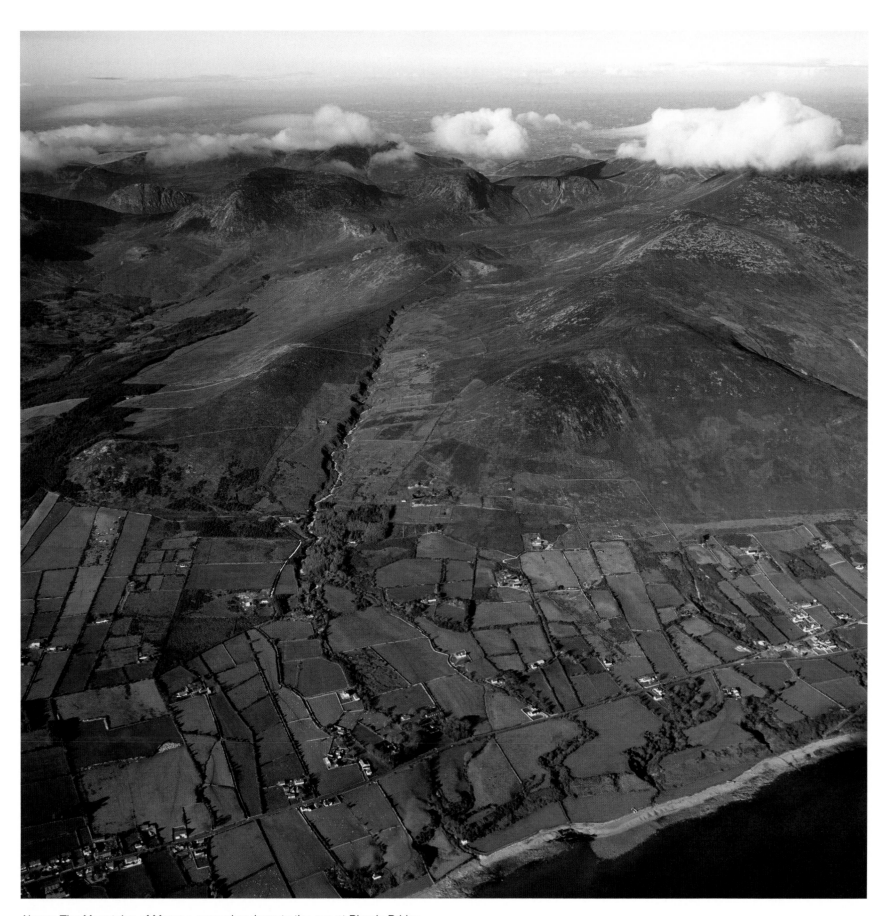

Above: The Mountains of Mourne, sweeping down to the sea at Bloody Bridge
Opposite: Silent Valley

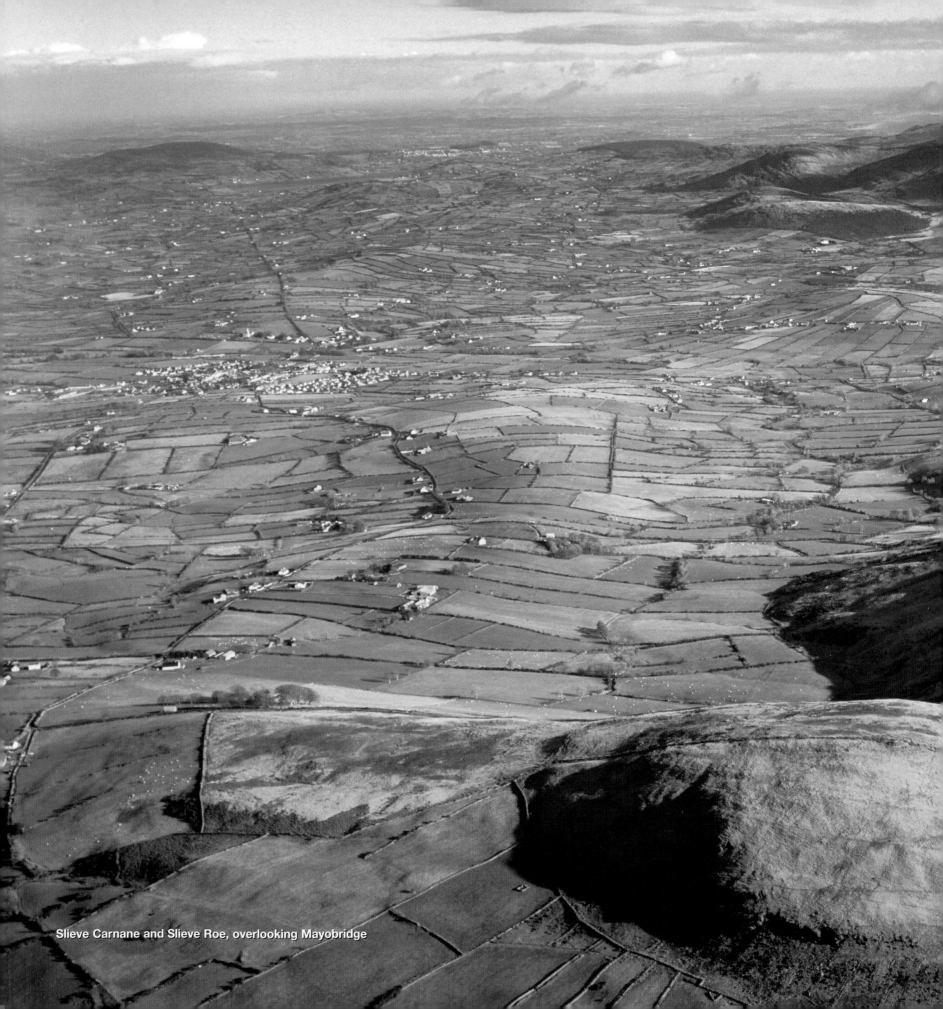

Slieve Carnane and Slieve Roe, overlooking Mayobridge

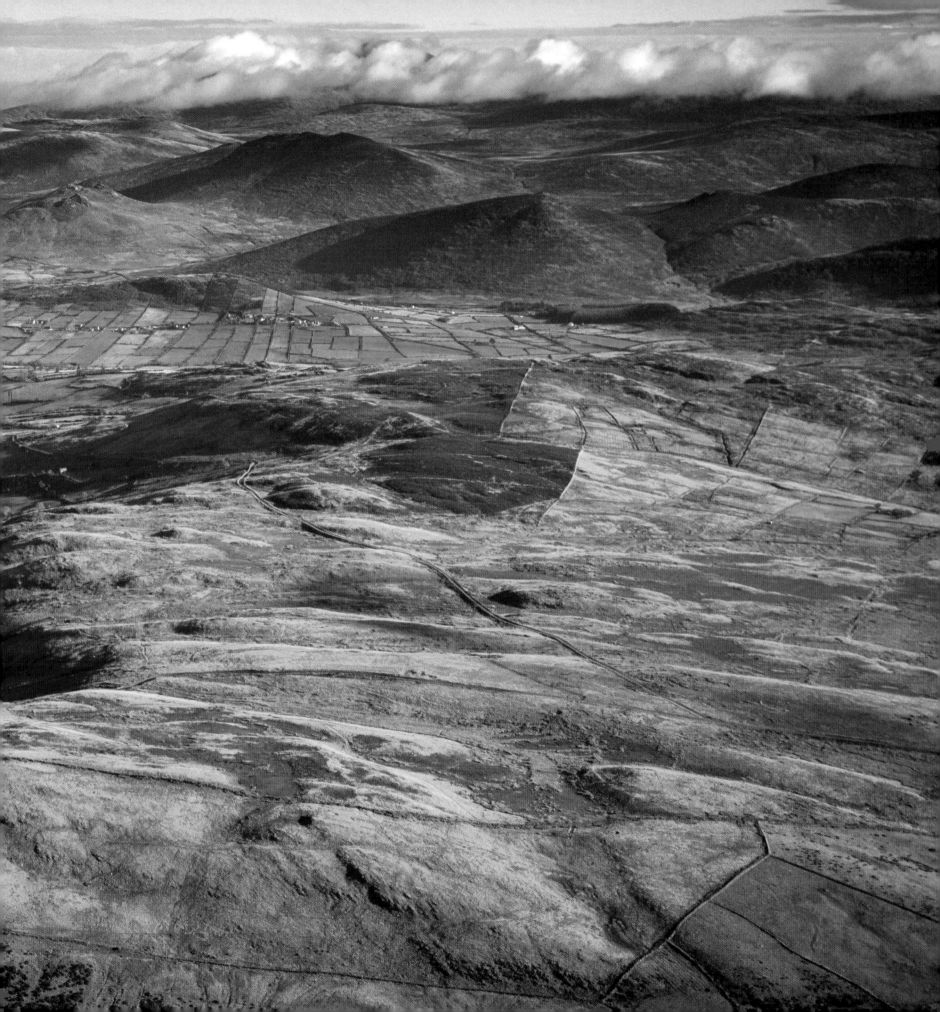

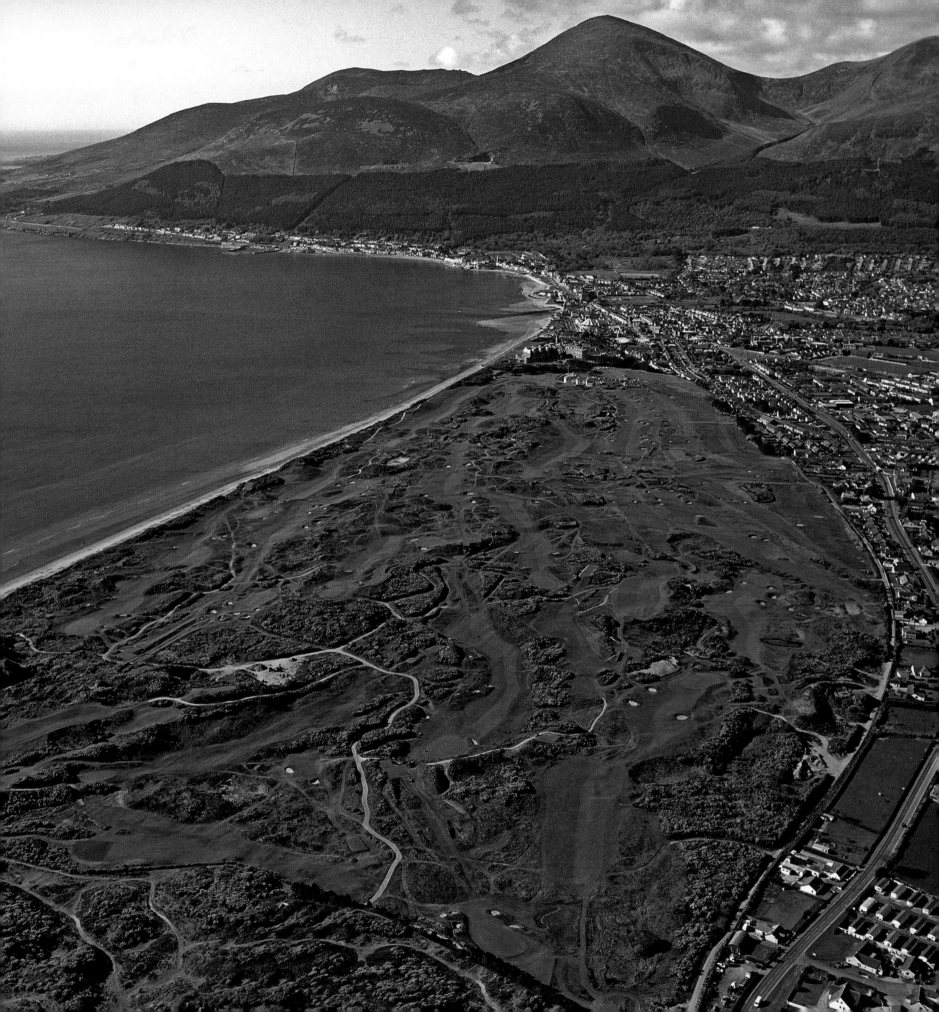

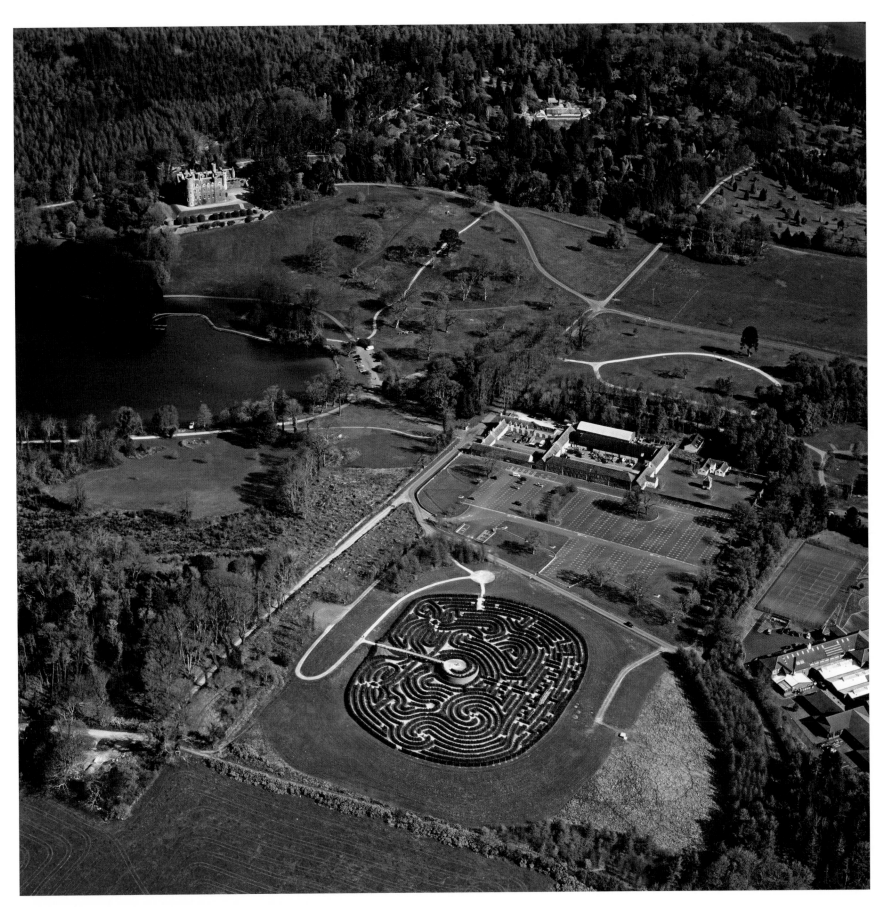

Above: The Peace Maze – the largest and longest maze in the world – at Castlewellan Forest Park
Opposite: Royal County Down Golf Club, Newcastle

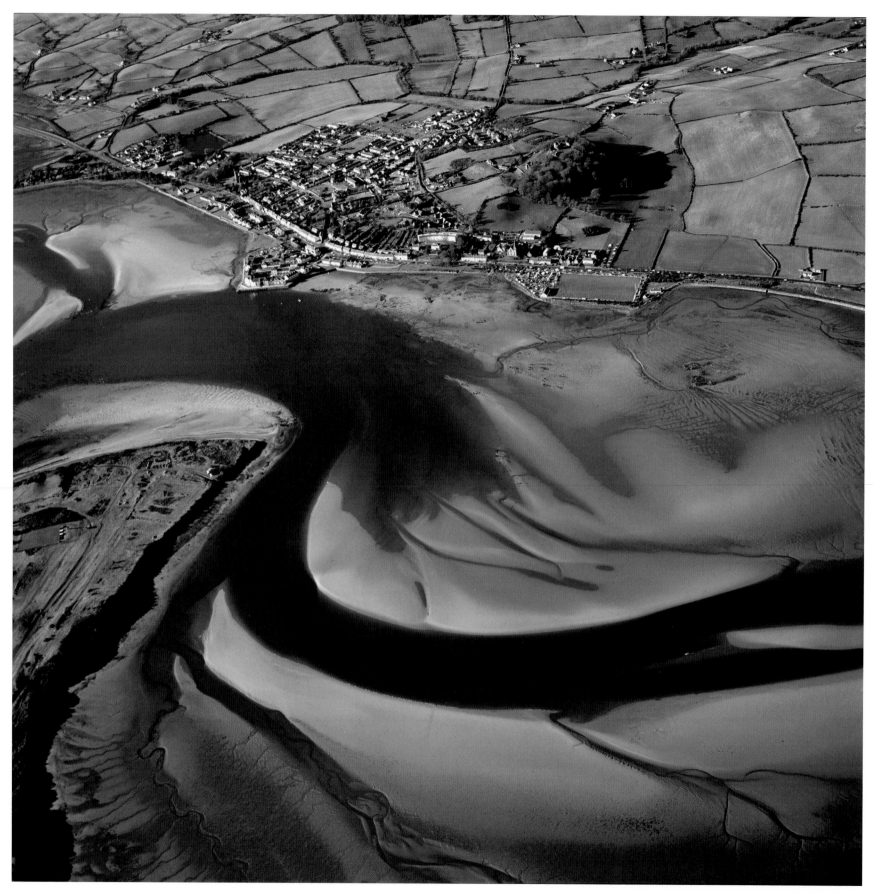

Above: Dundrum, at the mouth of Dundrum Bay
Opposite: Killough bay and village, with Coney Island in the foreground

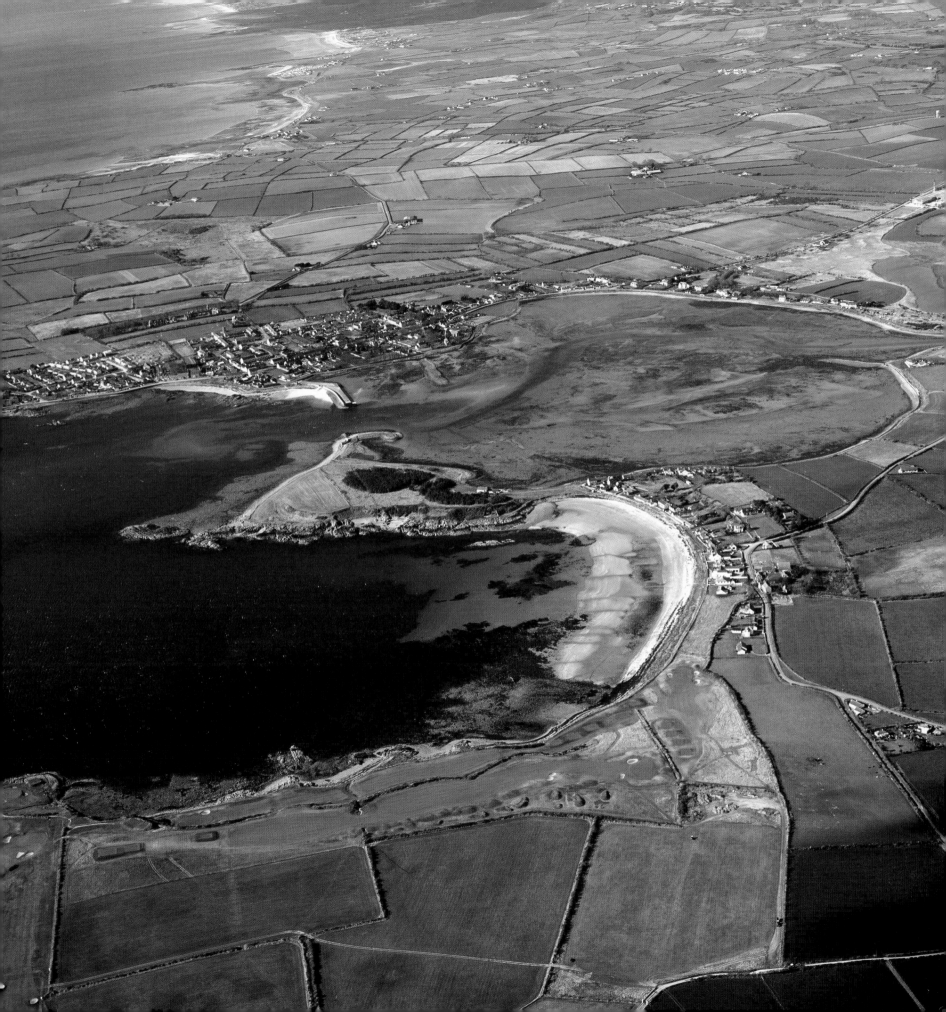

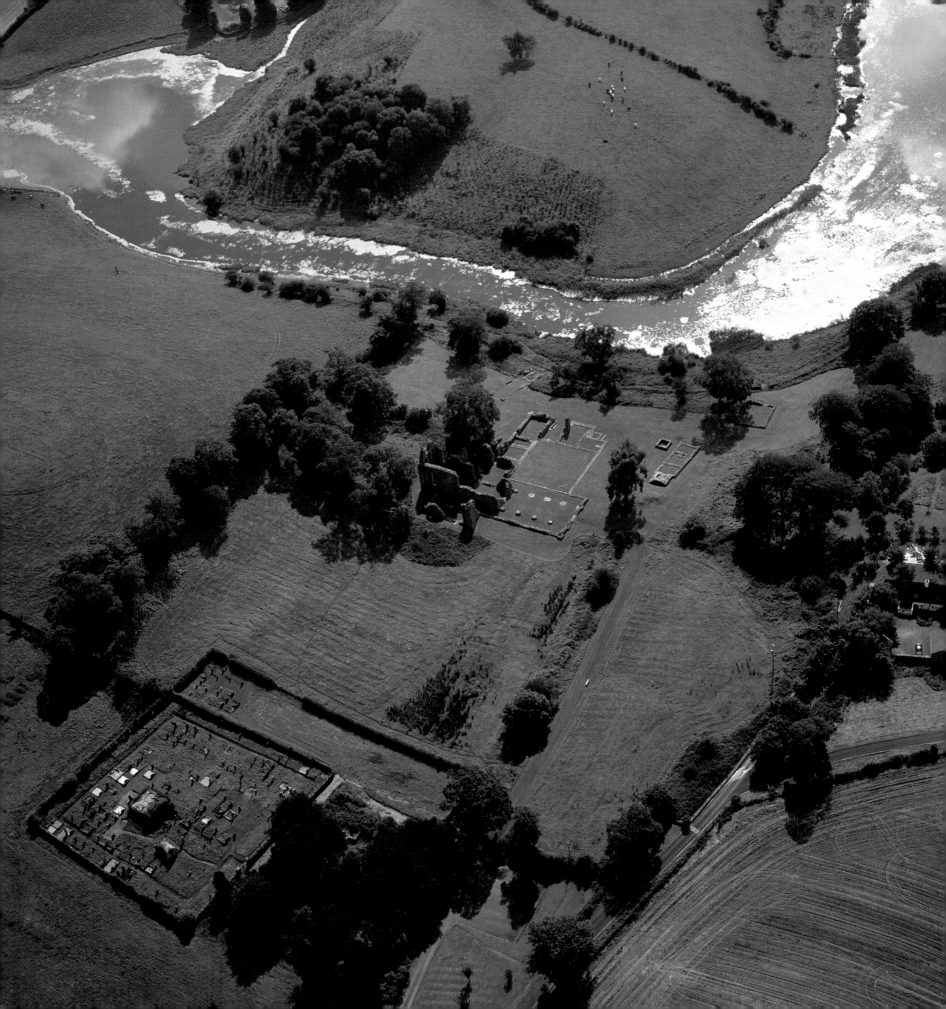

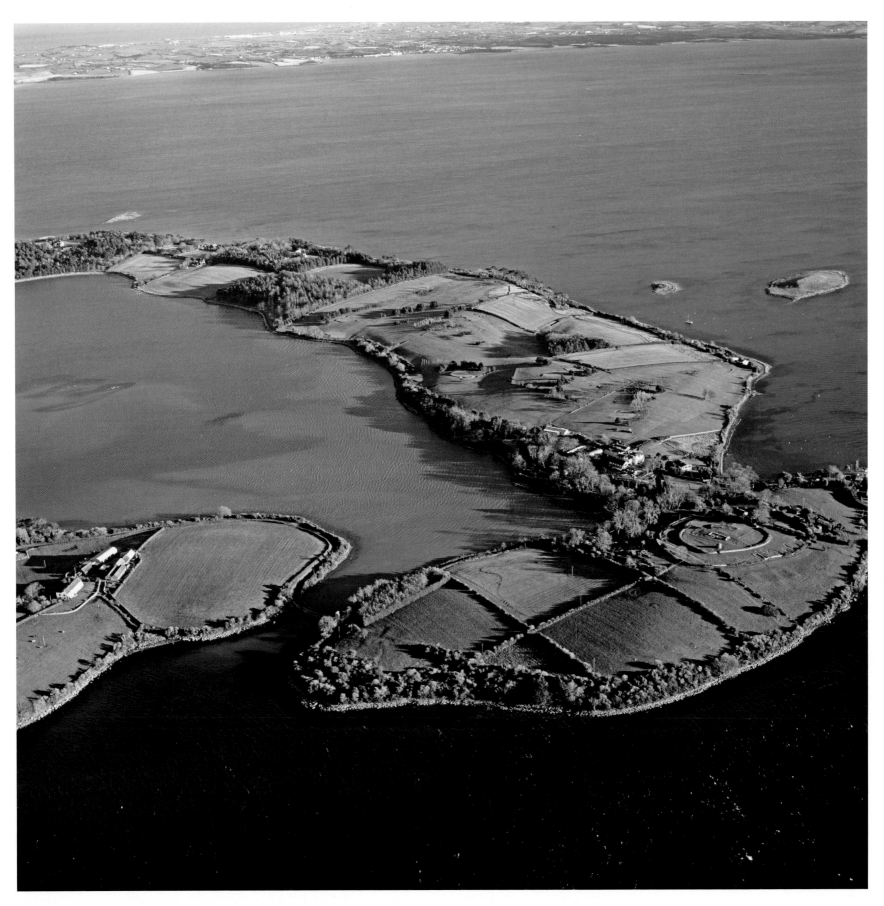

Above: Nendrum monastic site on Mahee Island, Strangford Lough, which is joined to Reagh Island by a causeway
Opposite: Inch Abbey and the River Quoile near Downpatrick

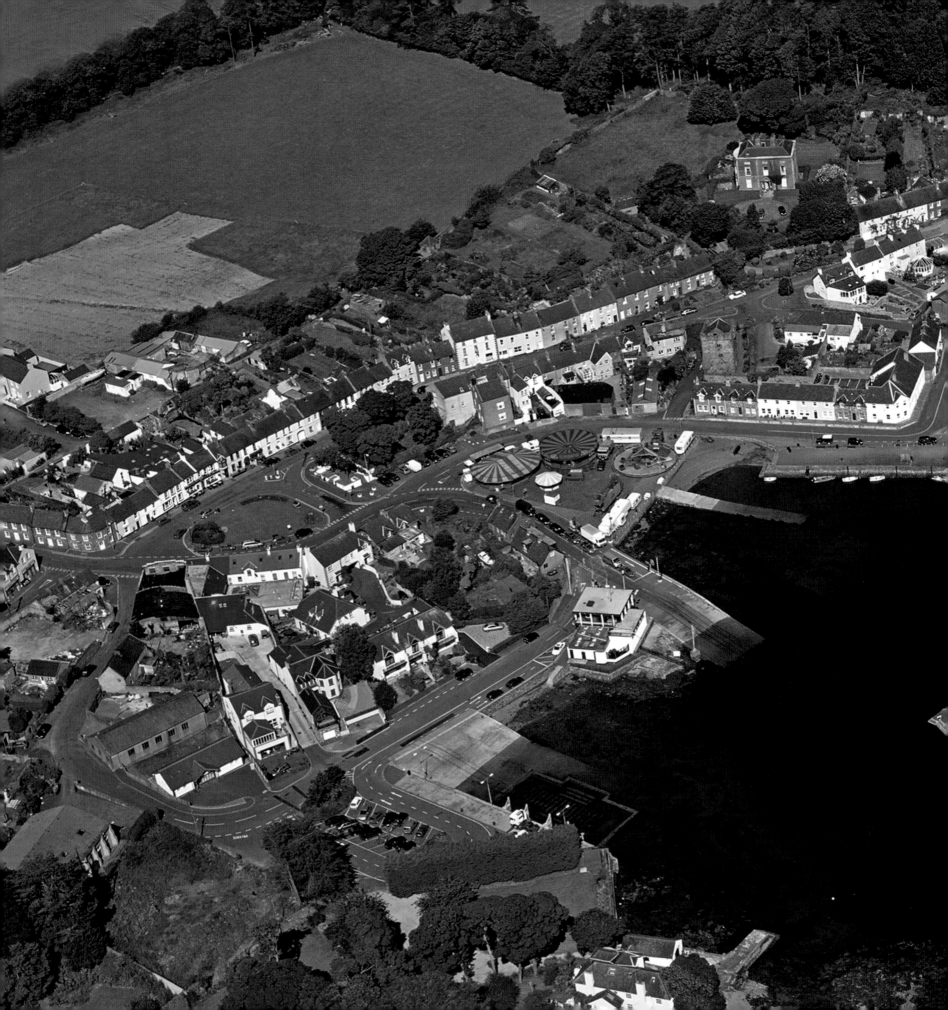

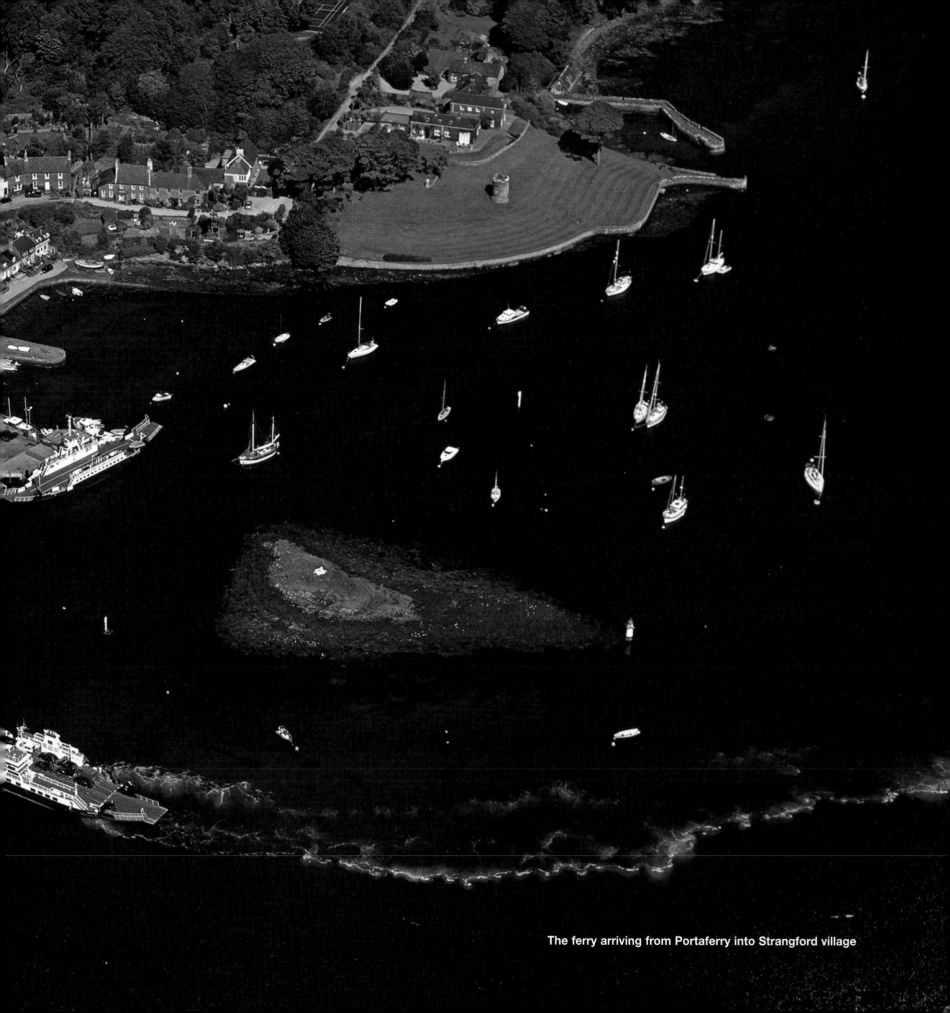

The ferry arriving from Portaferry into Strangford village

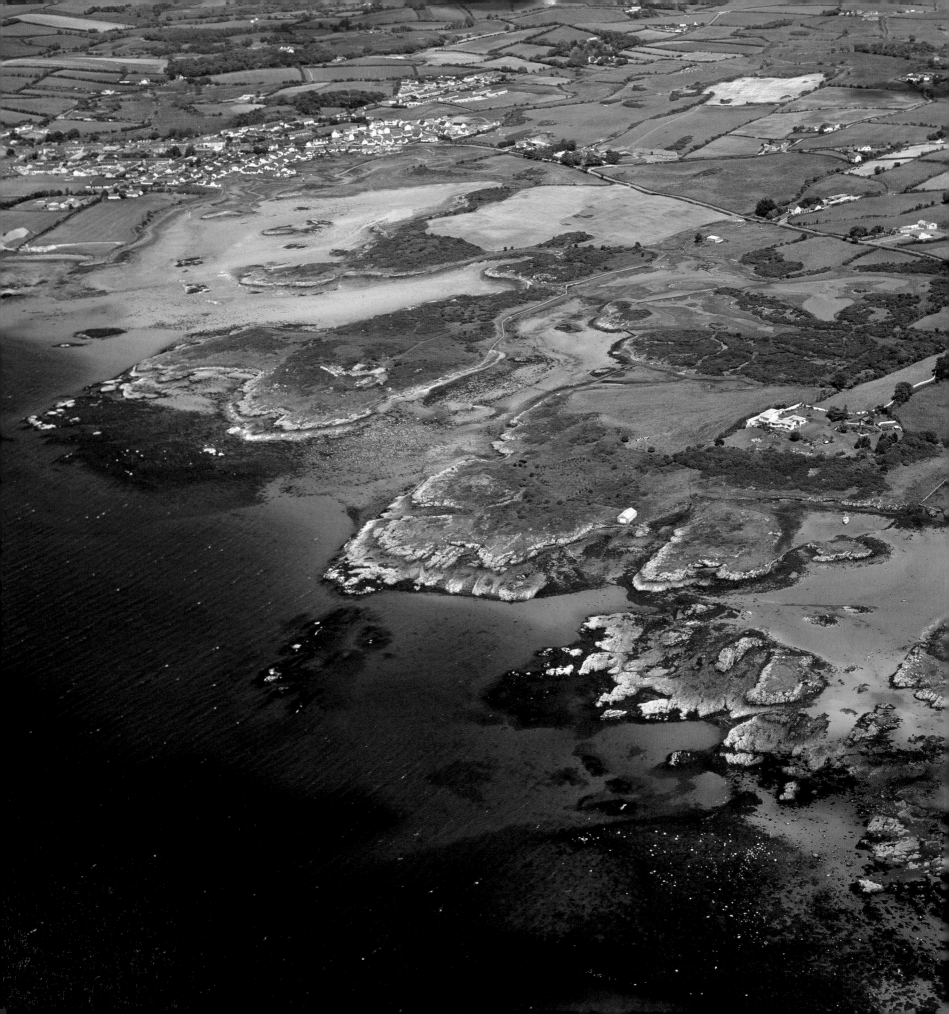

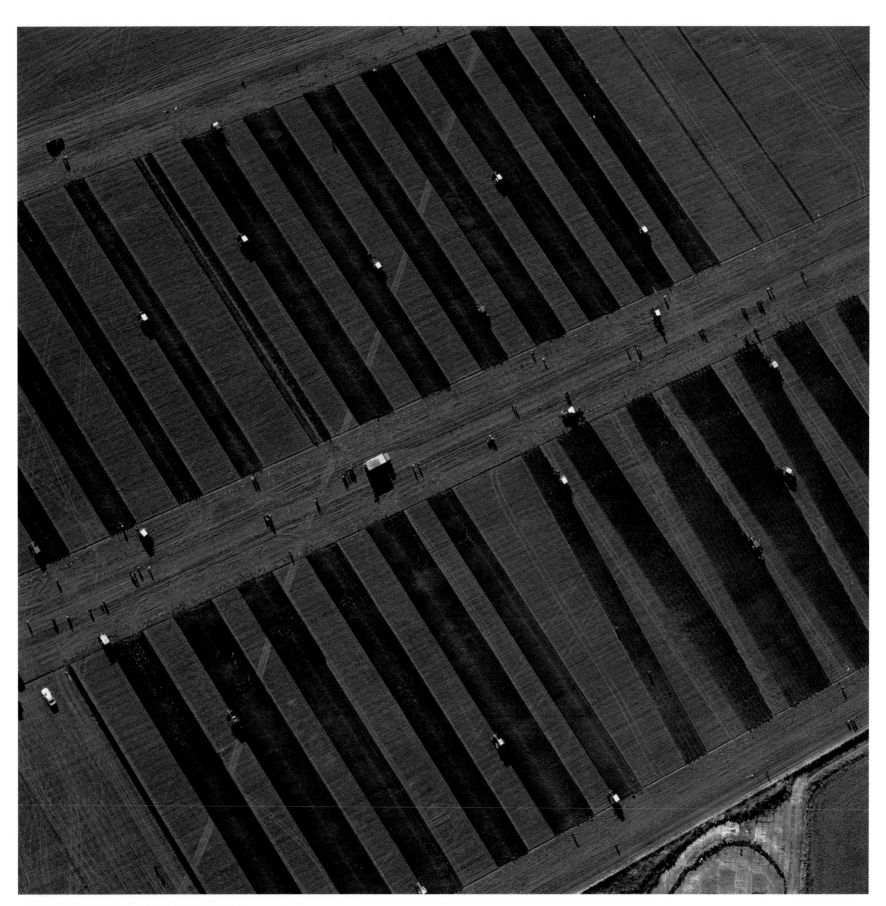

Above: A ploughing match near Kircubbin
Opposite: Kircubbin on the shores of Strangford Lough

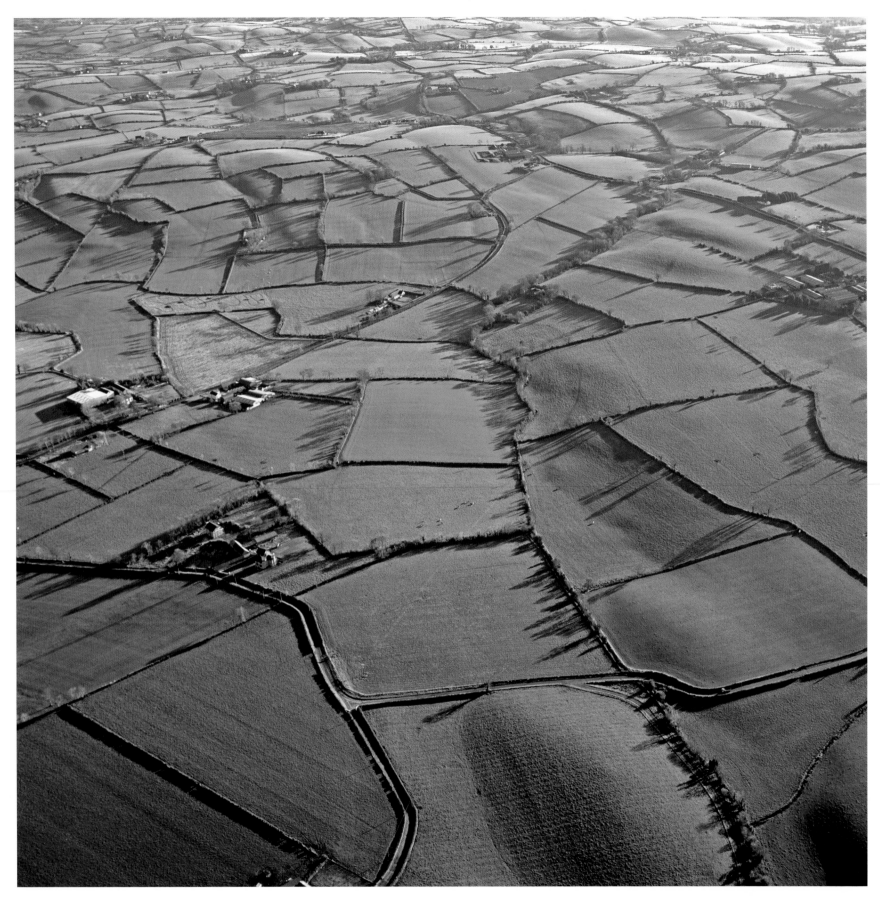

Above: Farmland near Baileysmill in County Down
Opposite: Mount Stewart House and gardens on the eastern shore of Strangford Lough

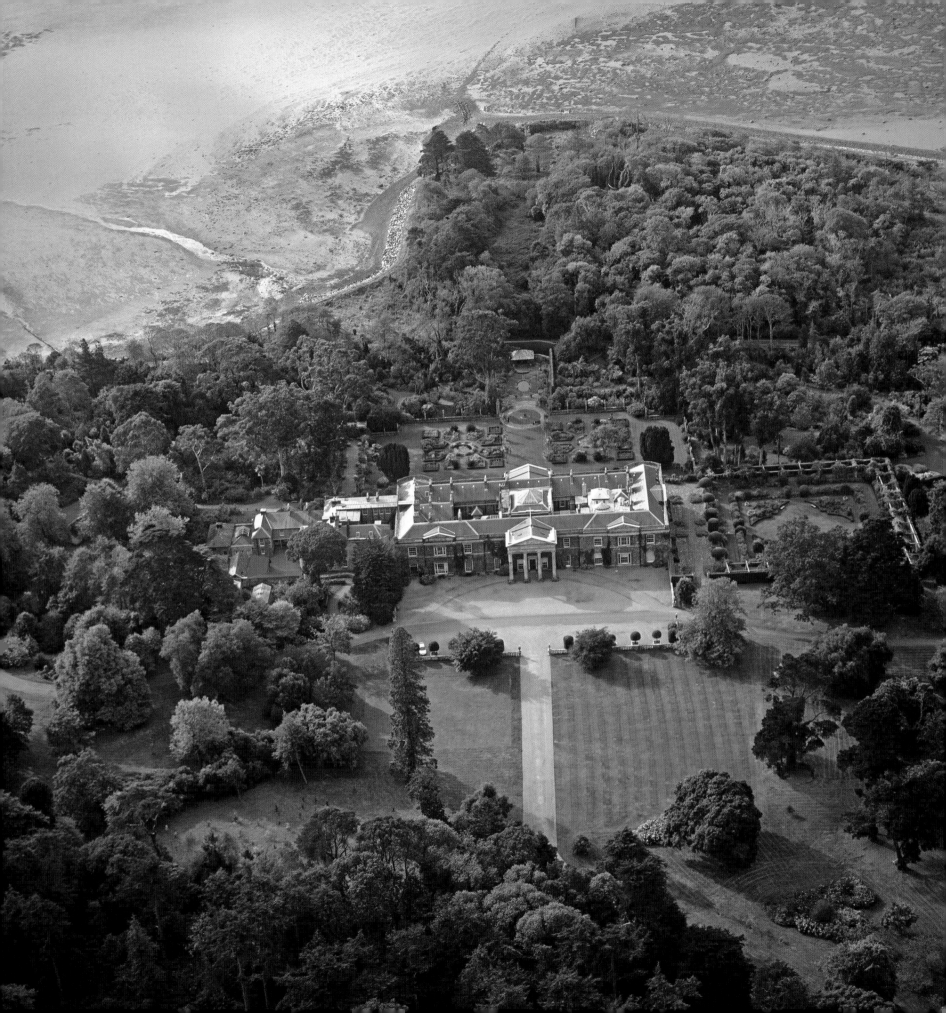

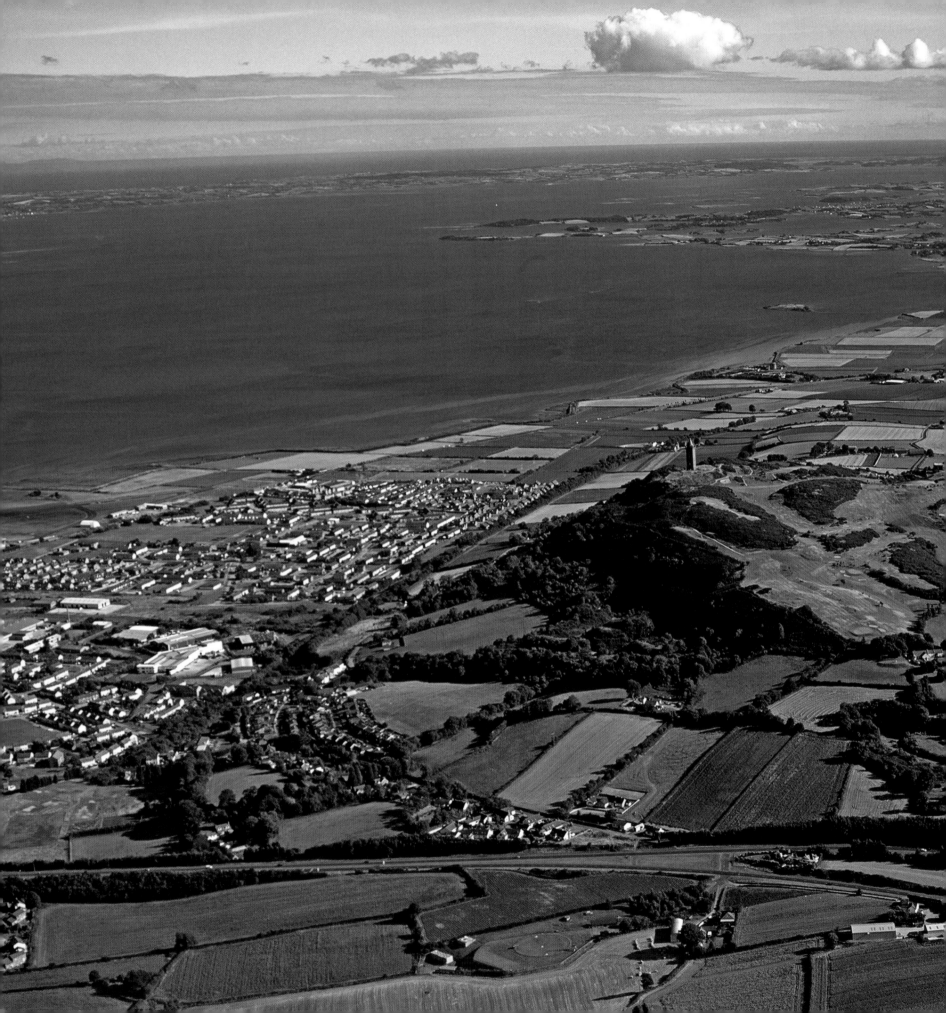

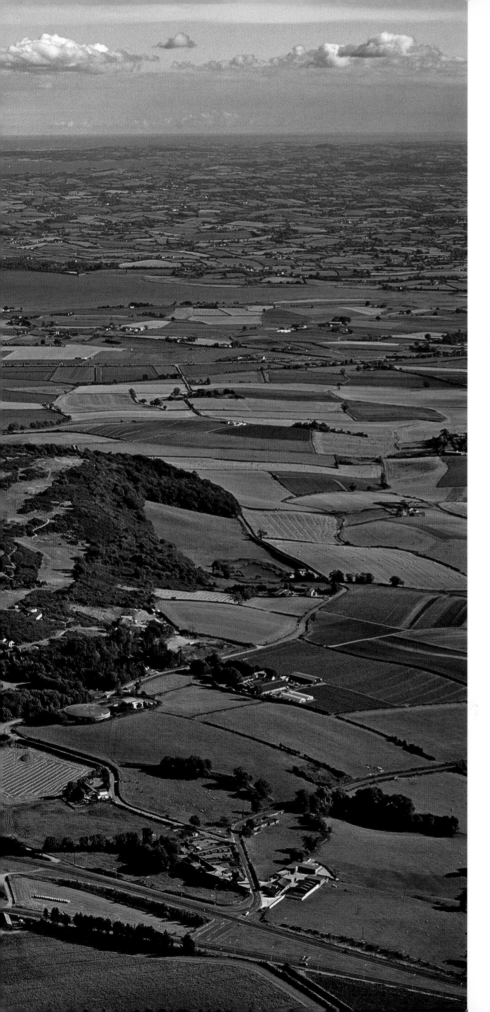

Scrabo Tower and Newtownards, with Strangford Lough in the background	67

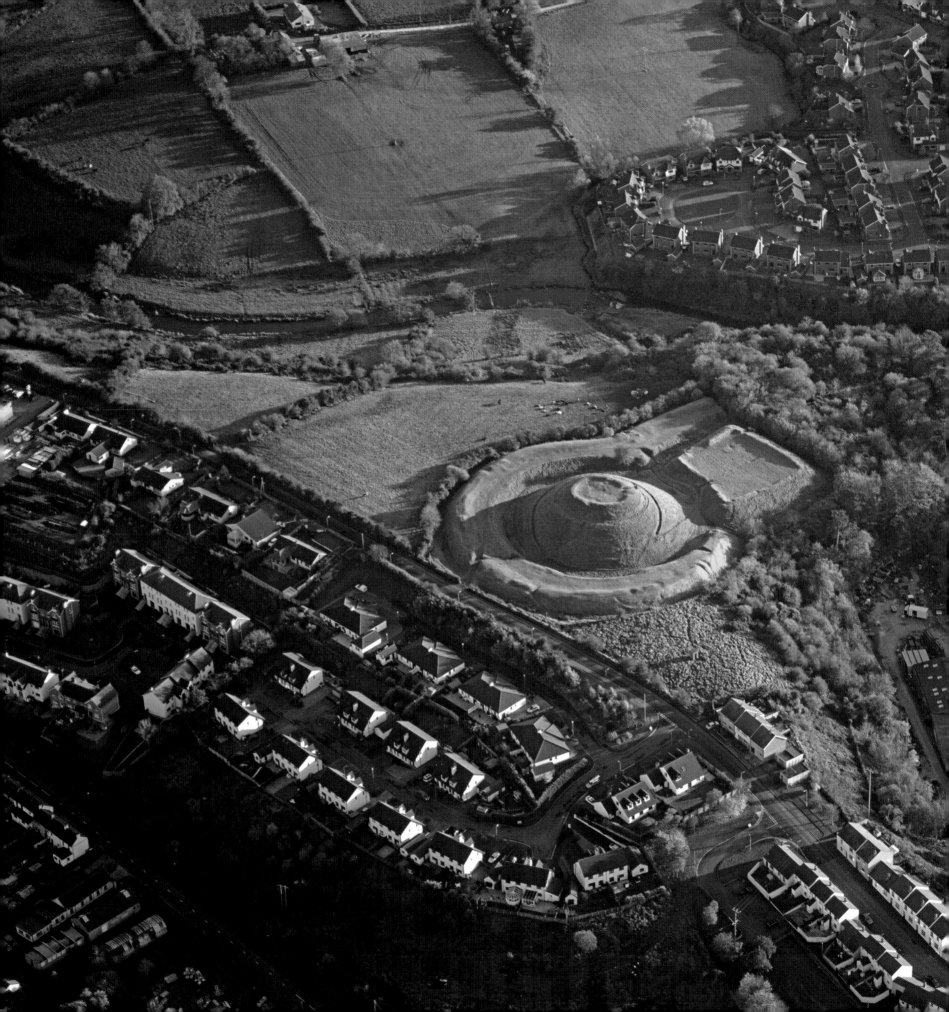

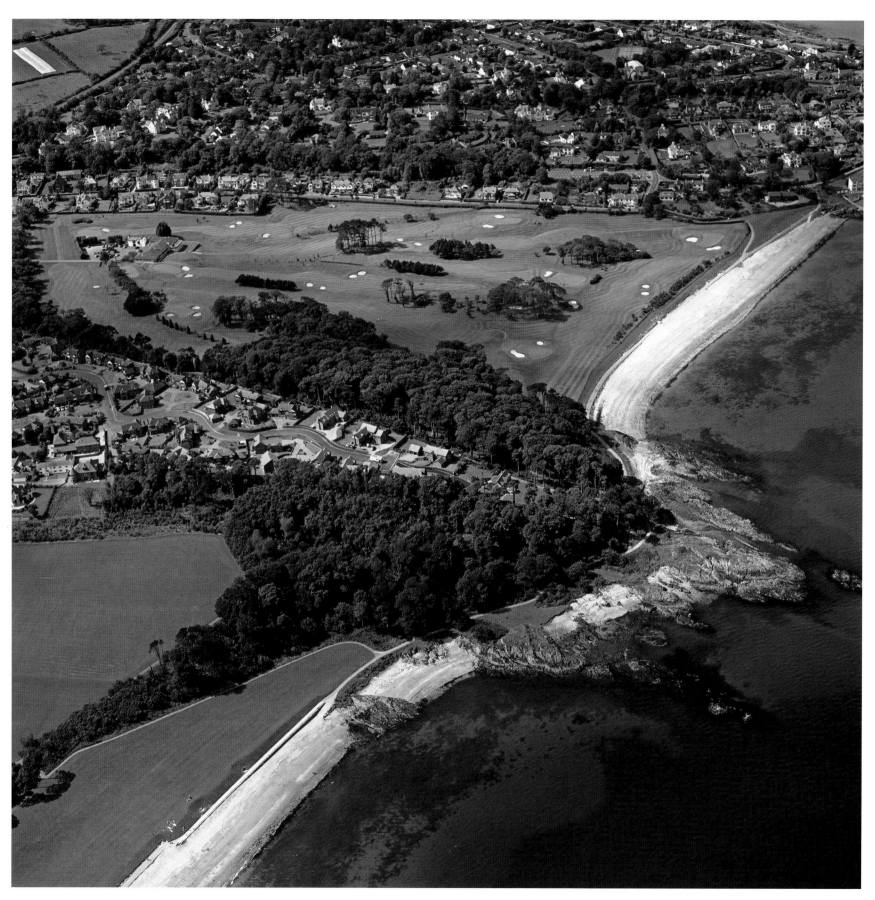

Above: Helen's Bay Golf Club on the County Down shore of Belfast Lough
Opposite: Dromore Motte and Bailey

69

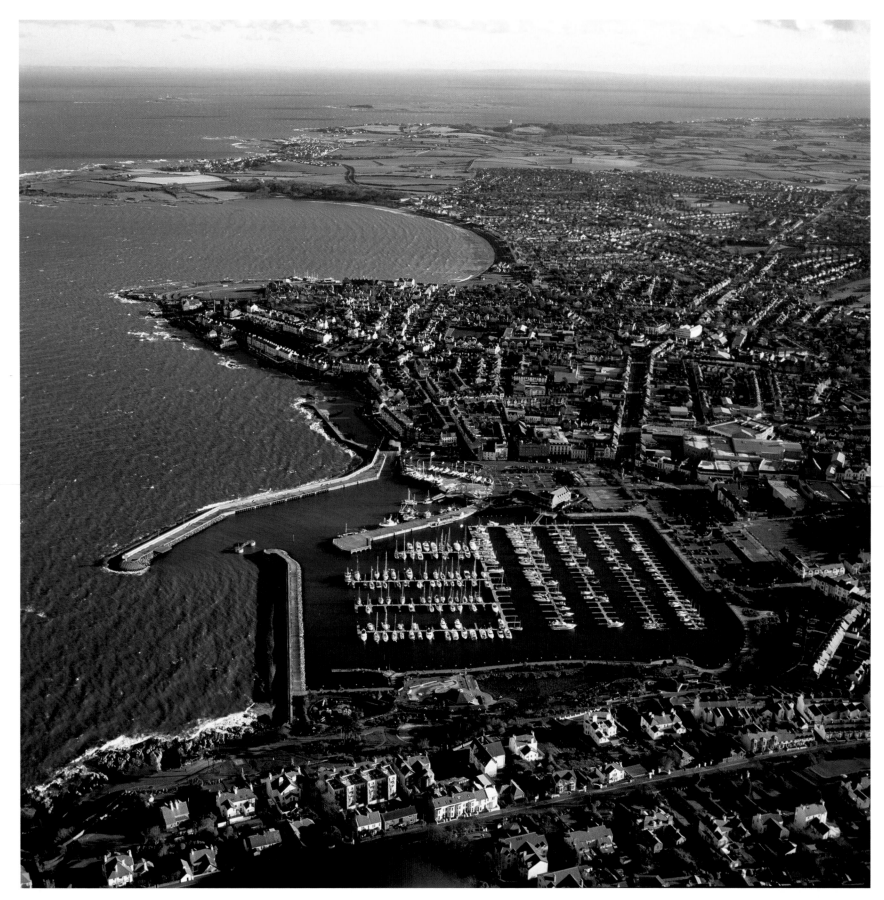

Above: Bangor, with the marina in the foreground
Opposite: Donaghadee, with its lighthouse on the South Pier

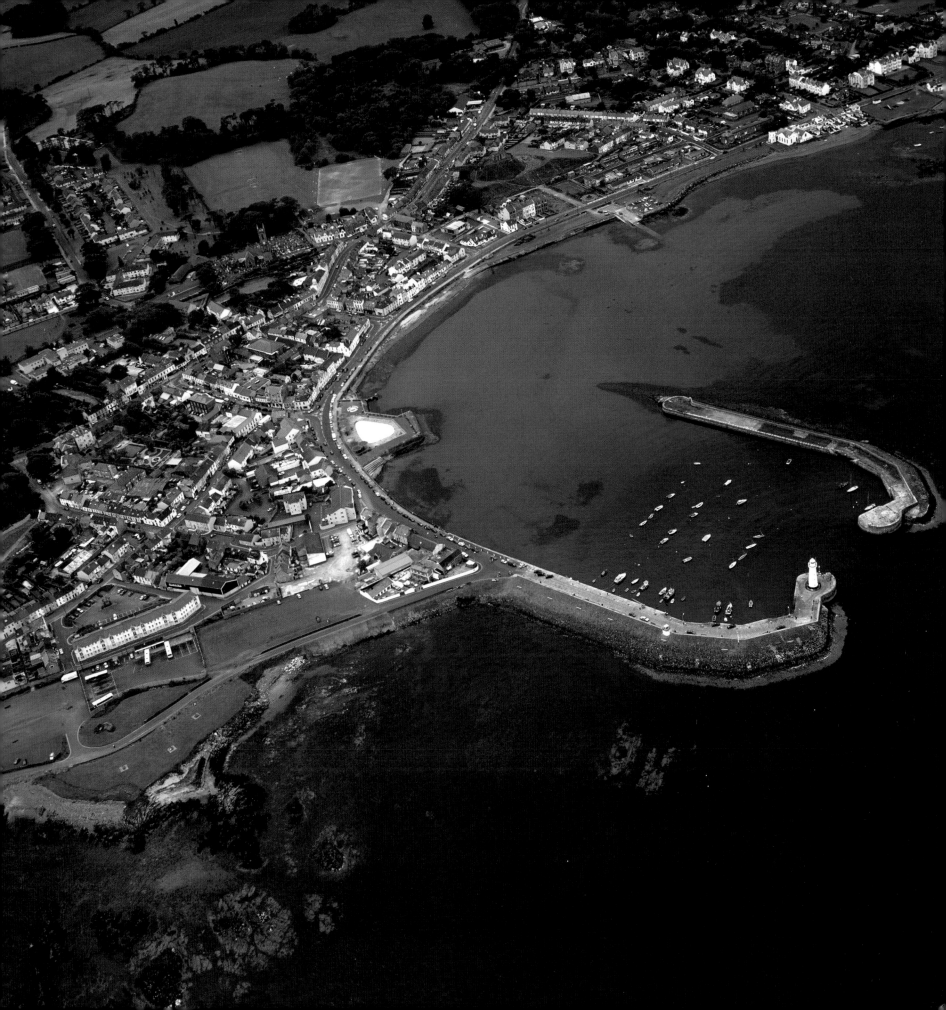

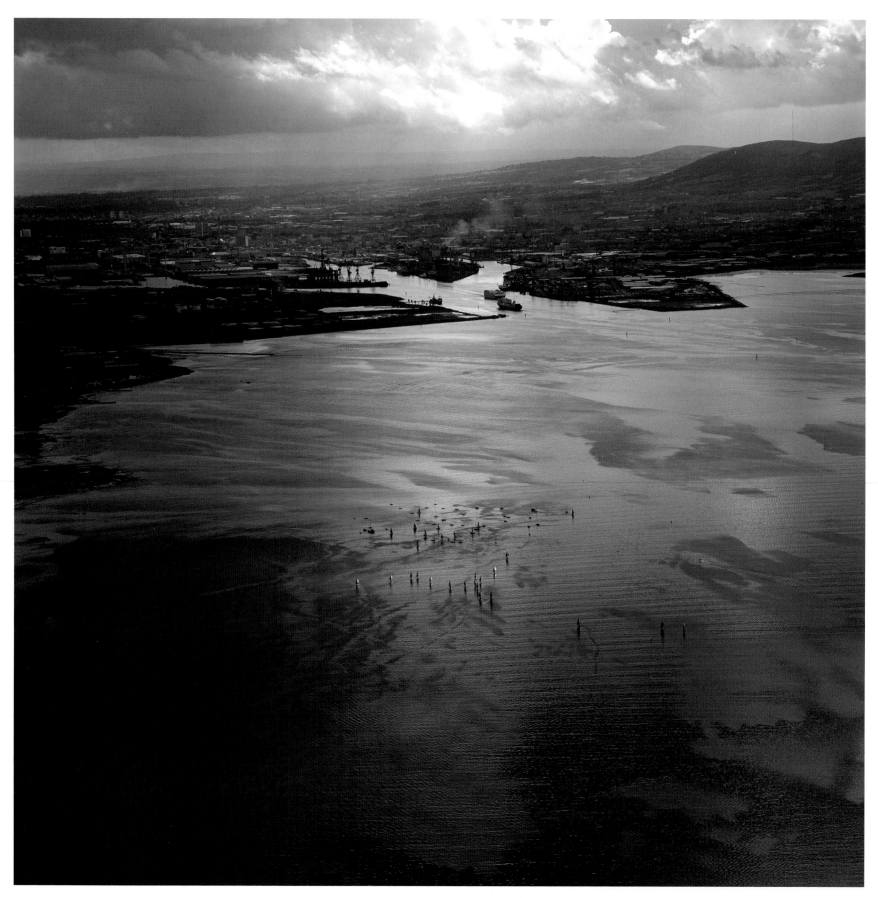

Above: A fleet of Squibs sailing in Belfast Lough, off Cultra
Opposite: Sir Thomas and Lady Dixon Park, south Belfast

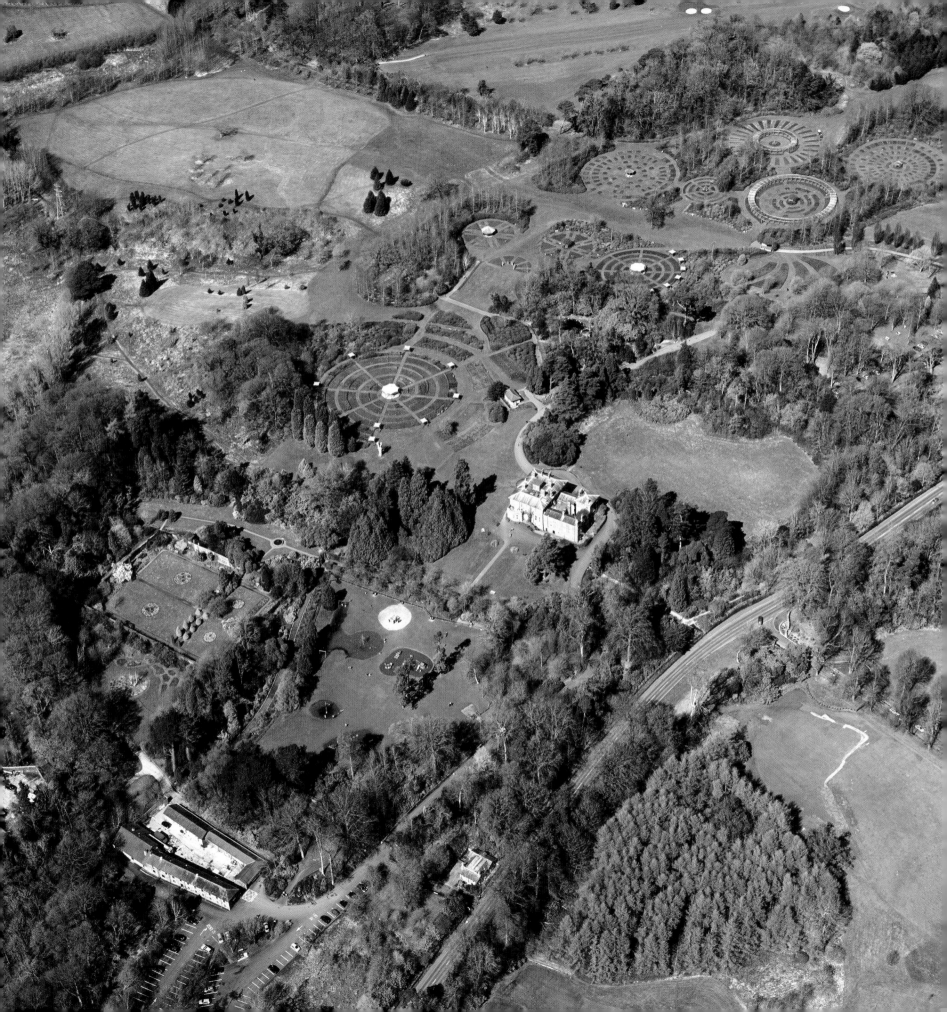

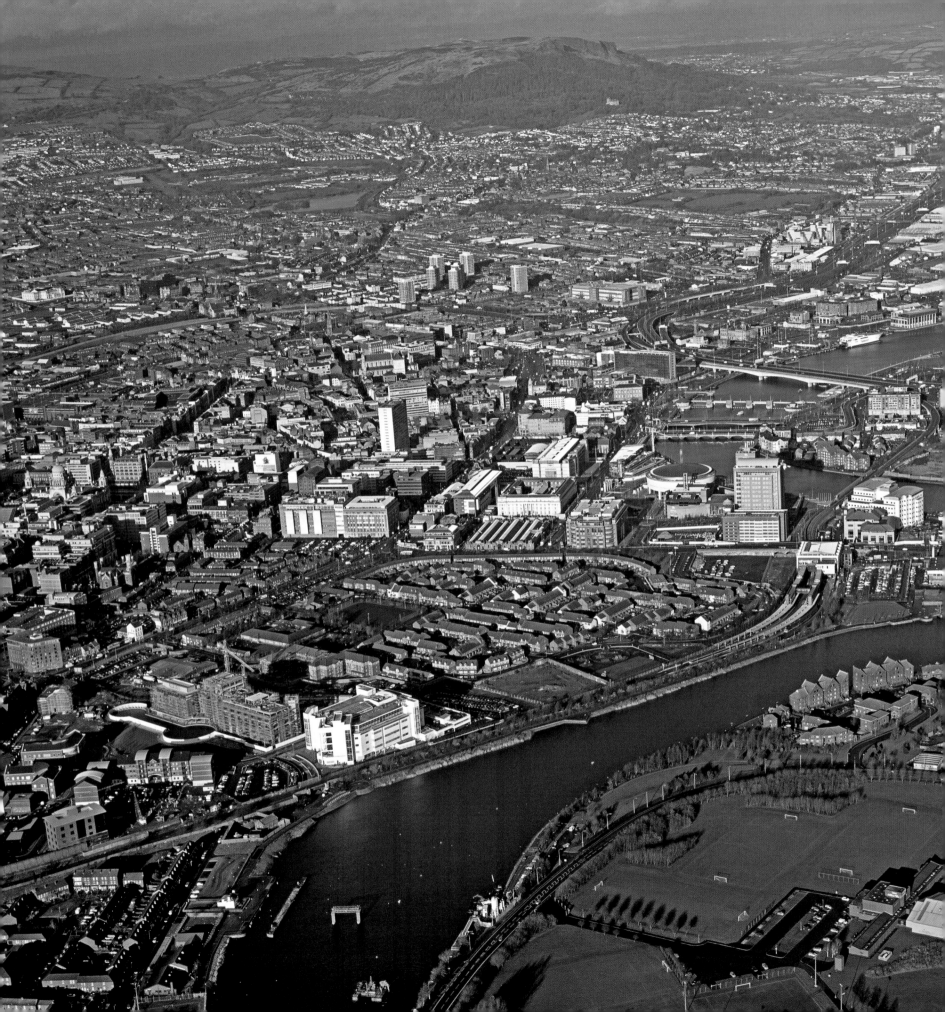

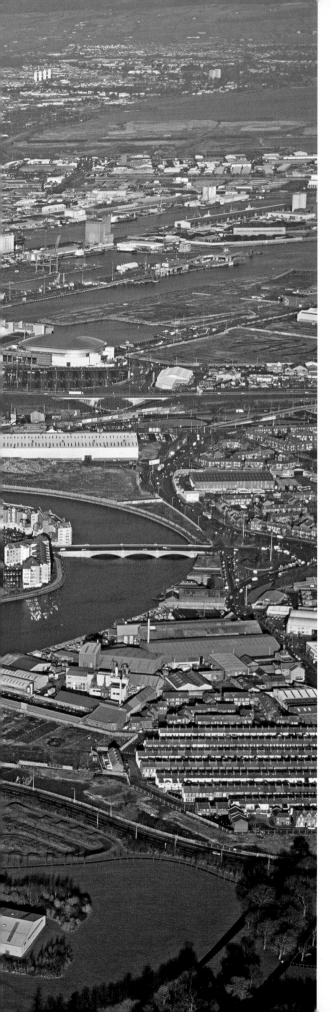

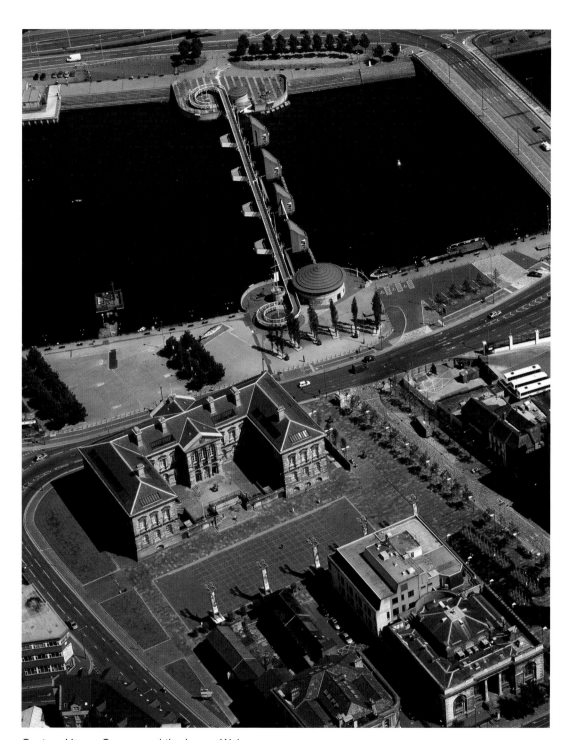

Custom House Square and the Lagan Weir

South Belfast, looking towards Cave Hill in the north of the city

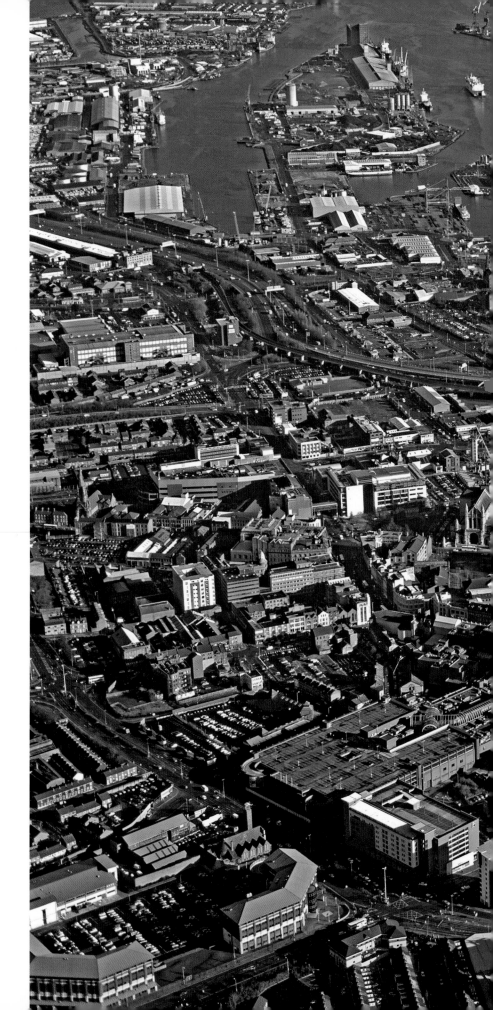

Belfast city centre and the Harbour Estate

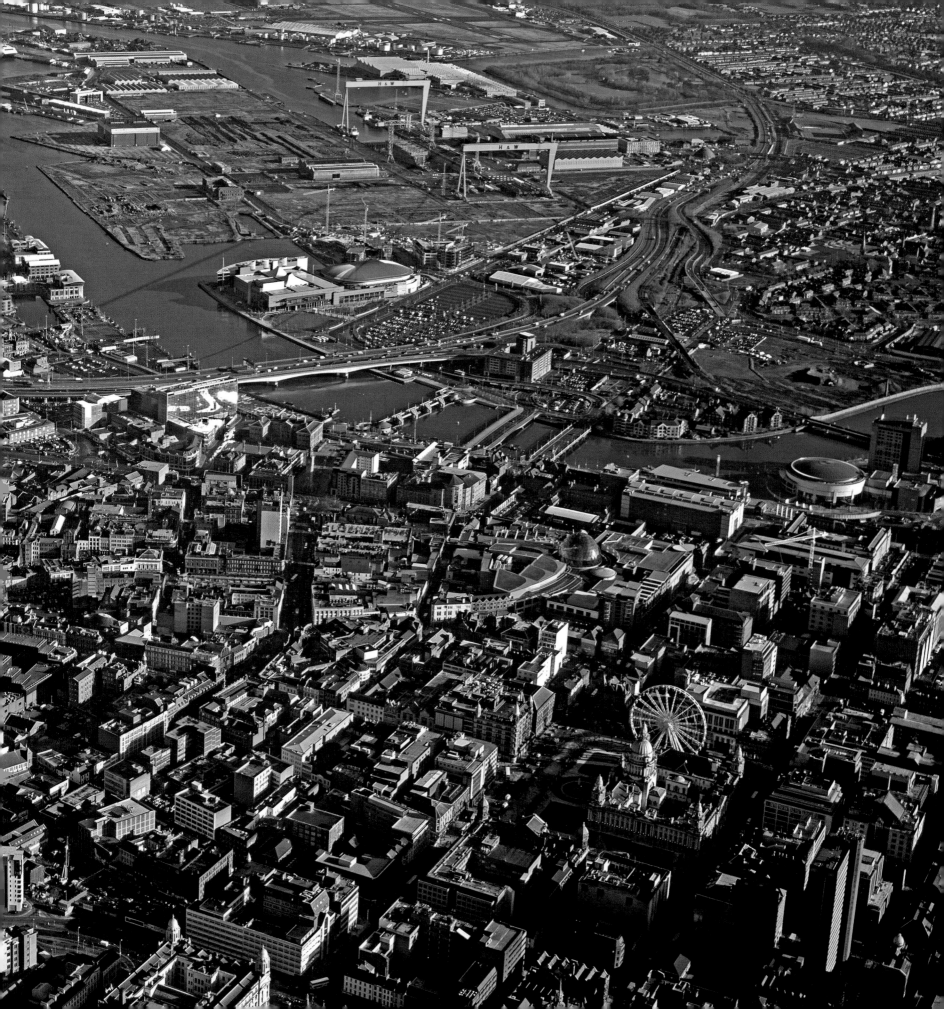

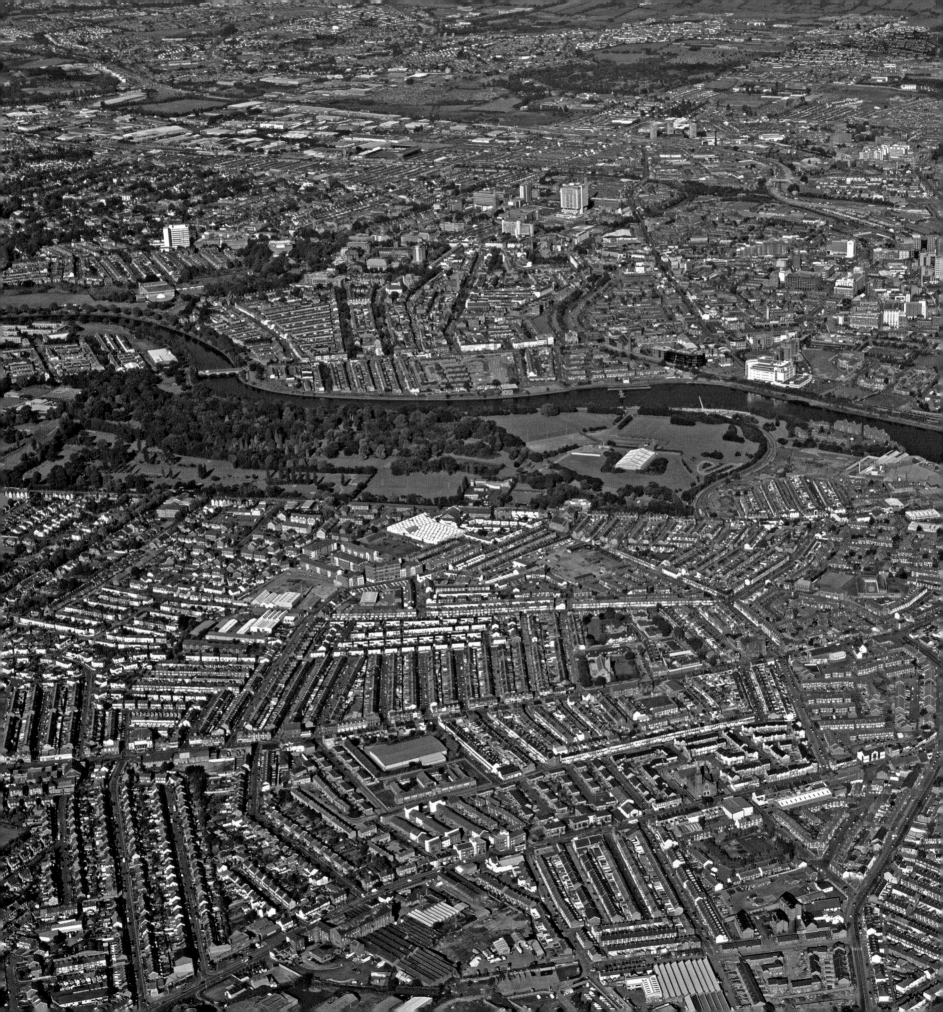

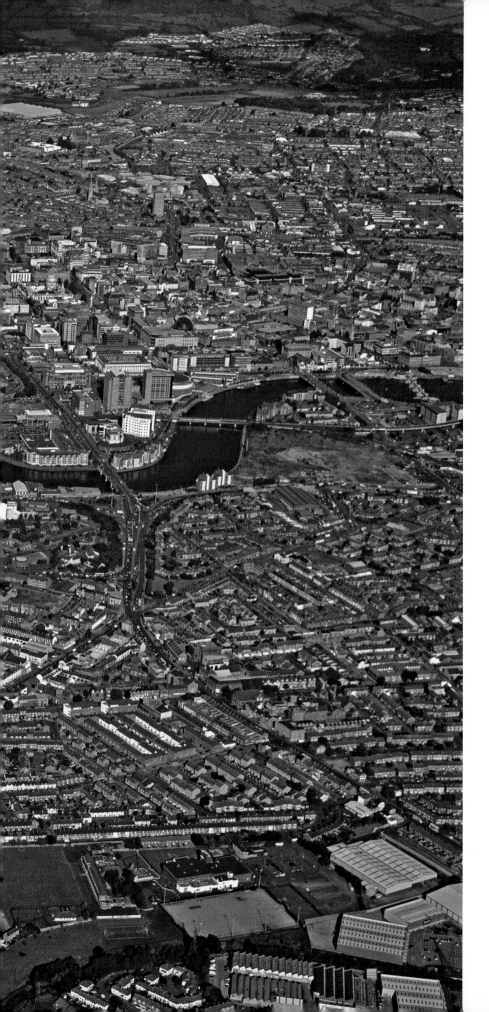

The River Lagan flowing through Belfast

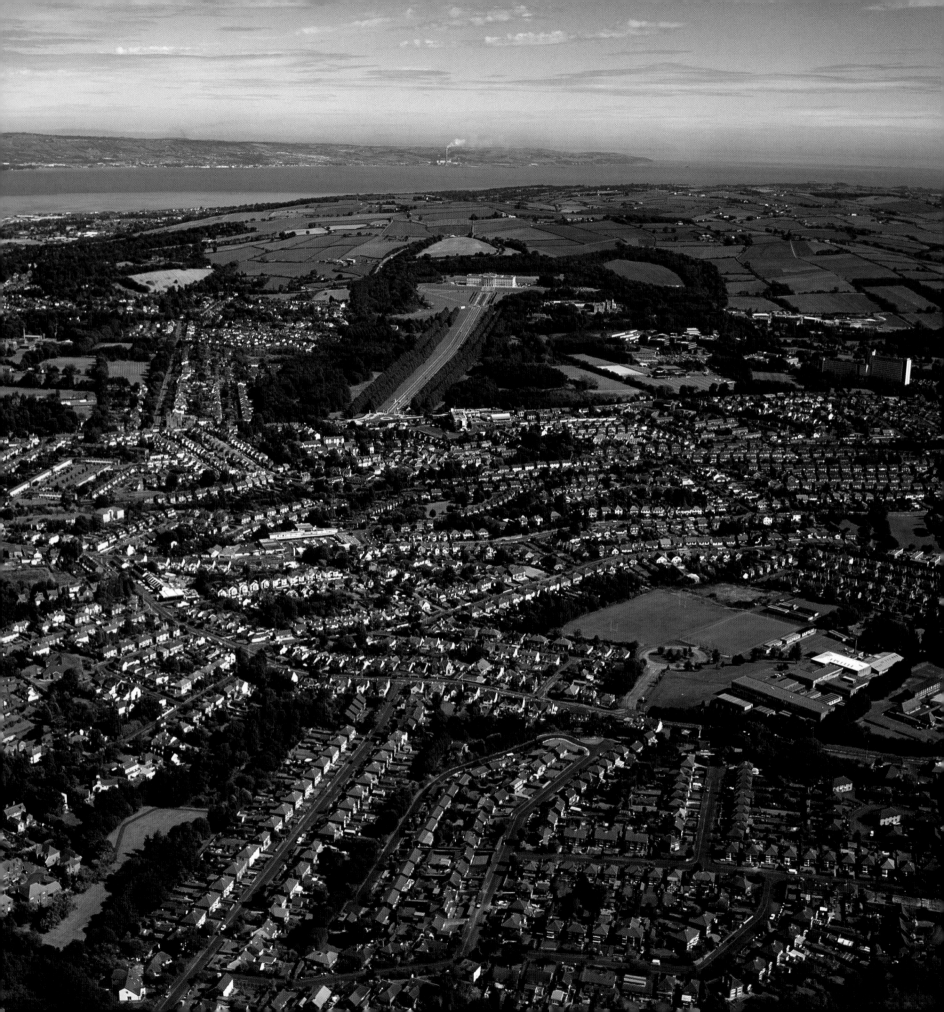

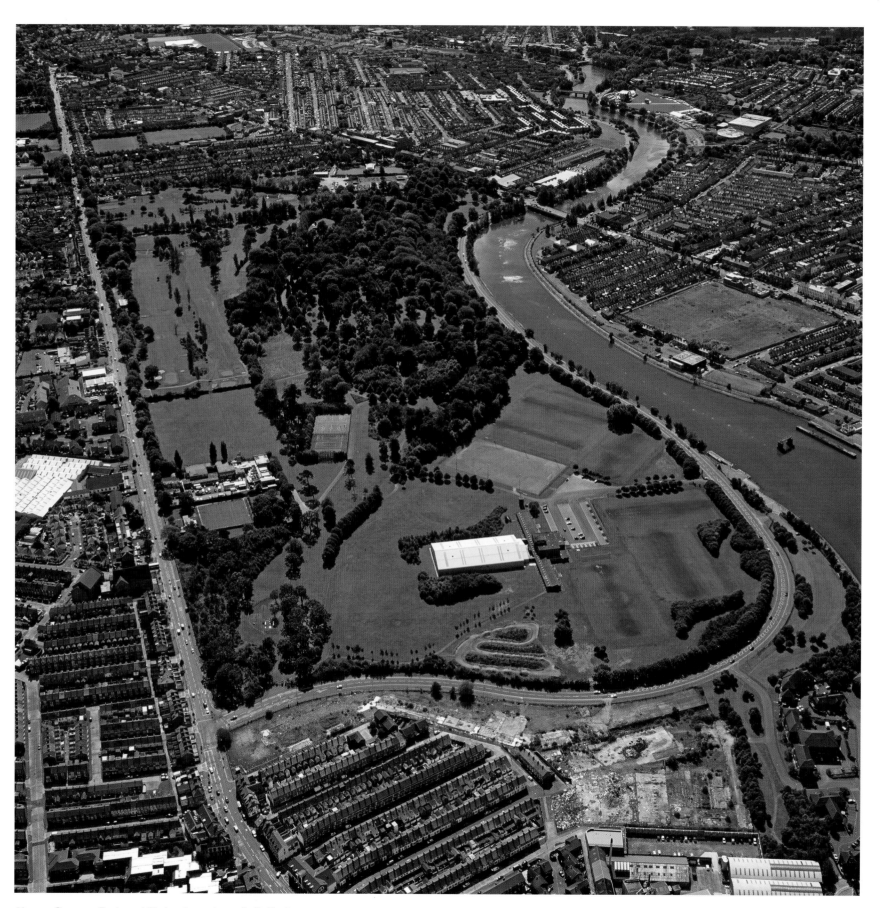

Above: Ormeau Park and Embankment, south Belfast
Opposite: East Belfast, looking towards Stormont and Belfast Lough

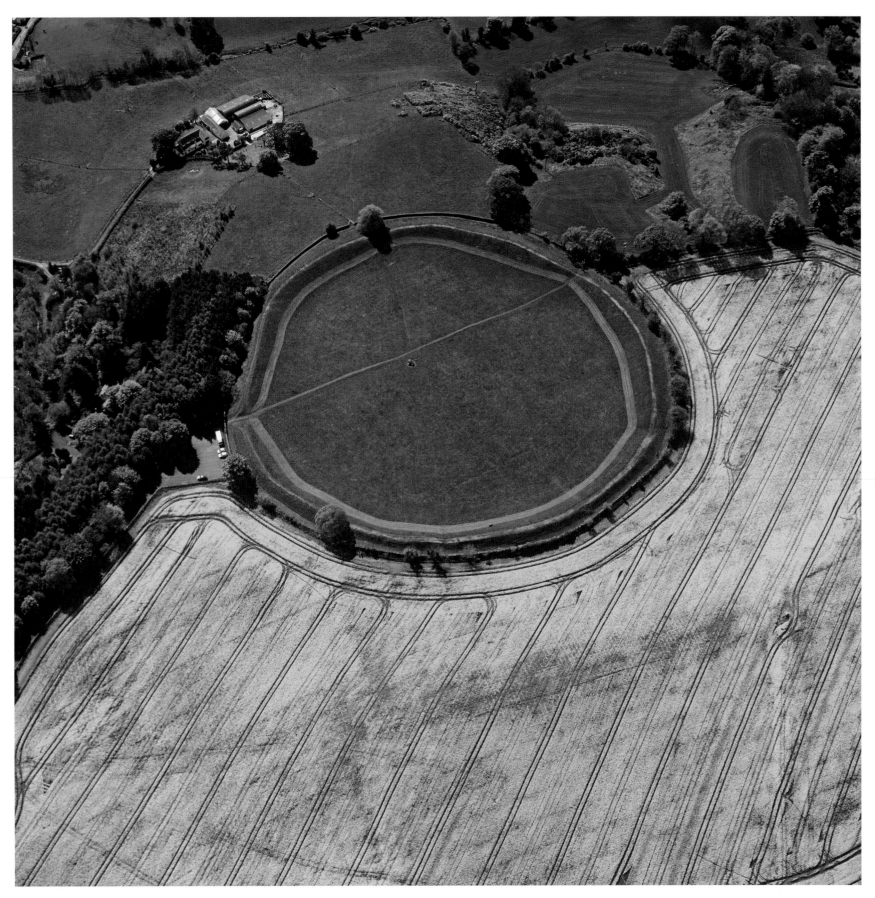

Above: The Giant's Ring near Belfast, with oilseed rape growing in neighbouring fields
Opposite: Belfast City Cemetery on the Falls Road

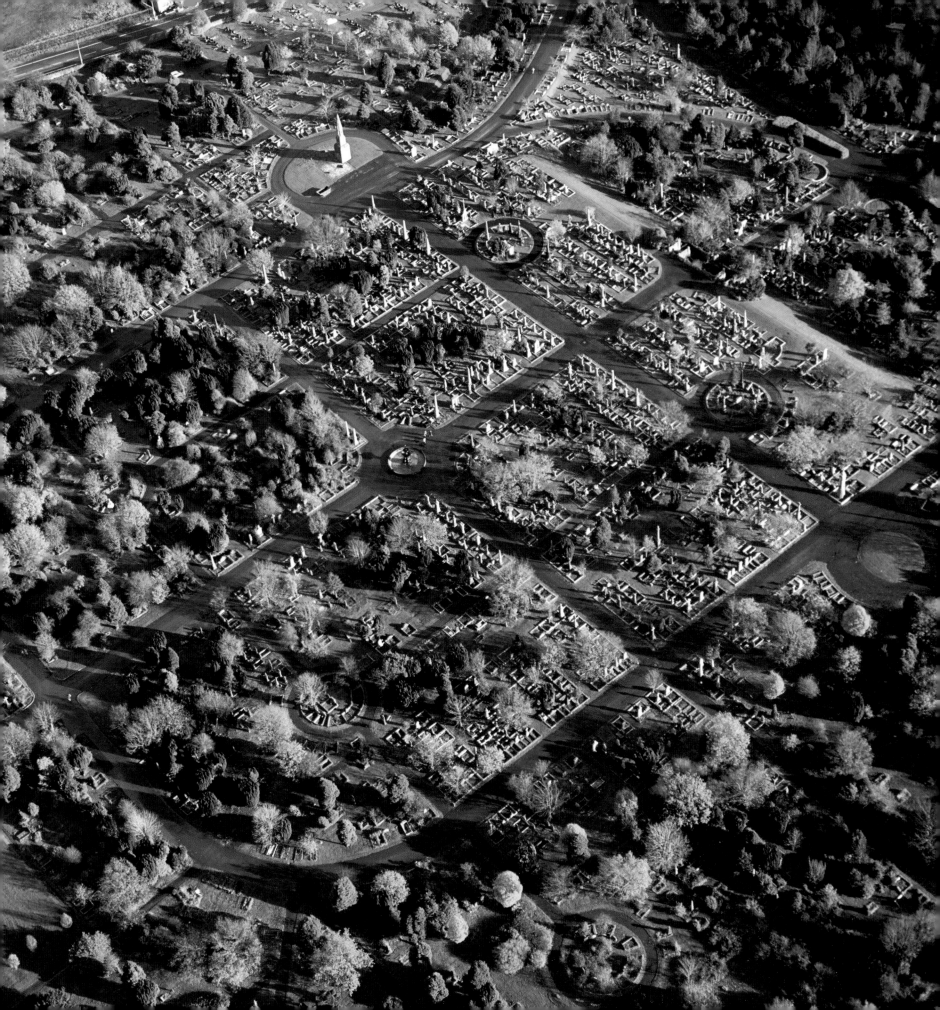

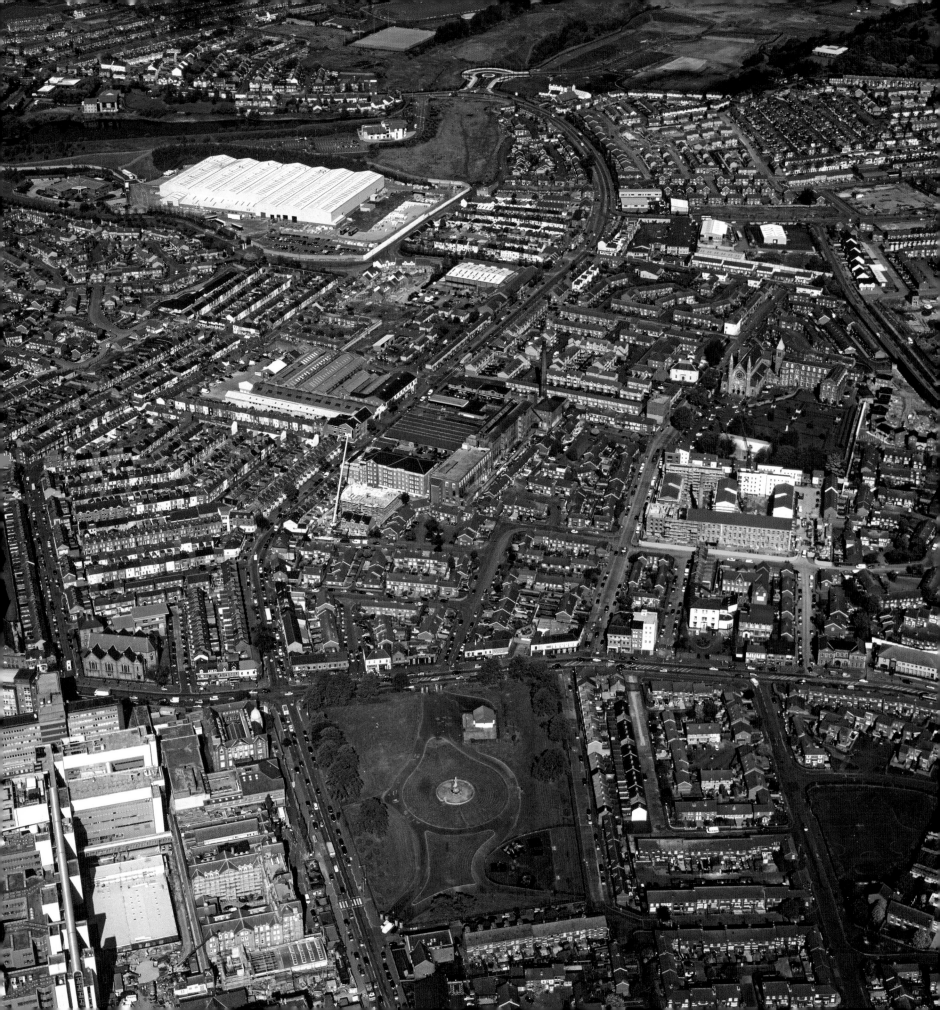

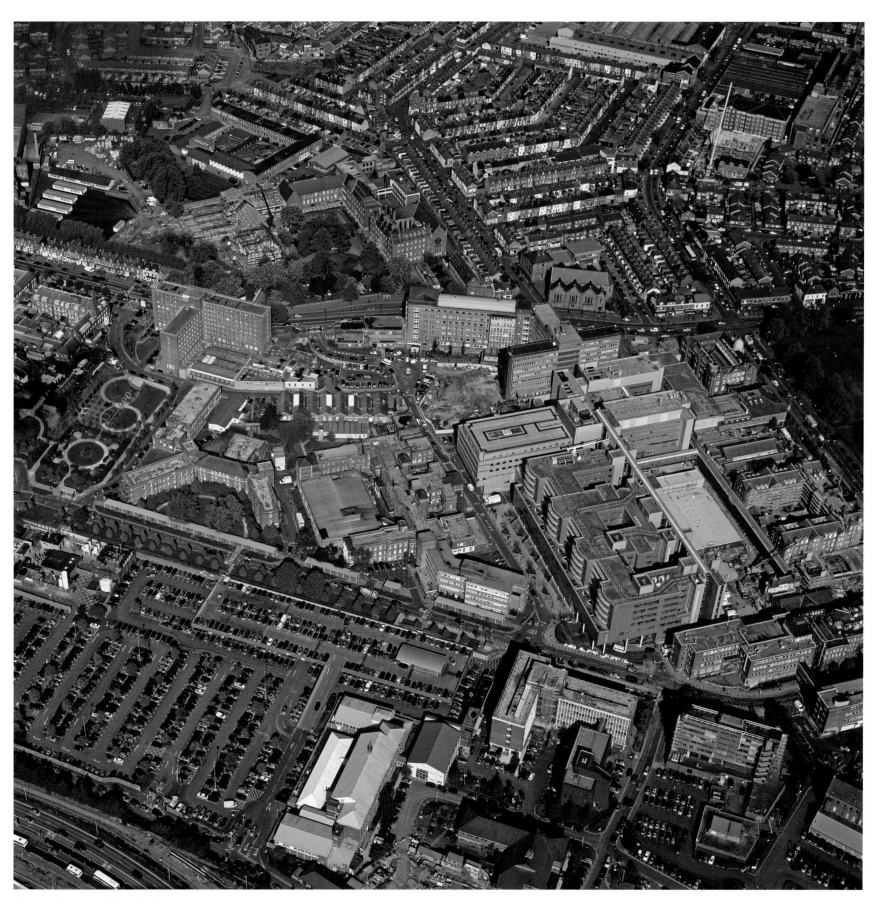

Above: The Royal Victoria Hospital
Opposite: West Belfast, with the Royal Victoria Hospital and Dunville Park in the foreground

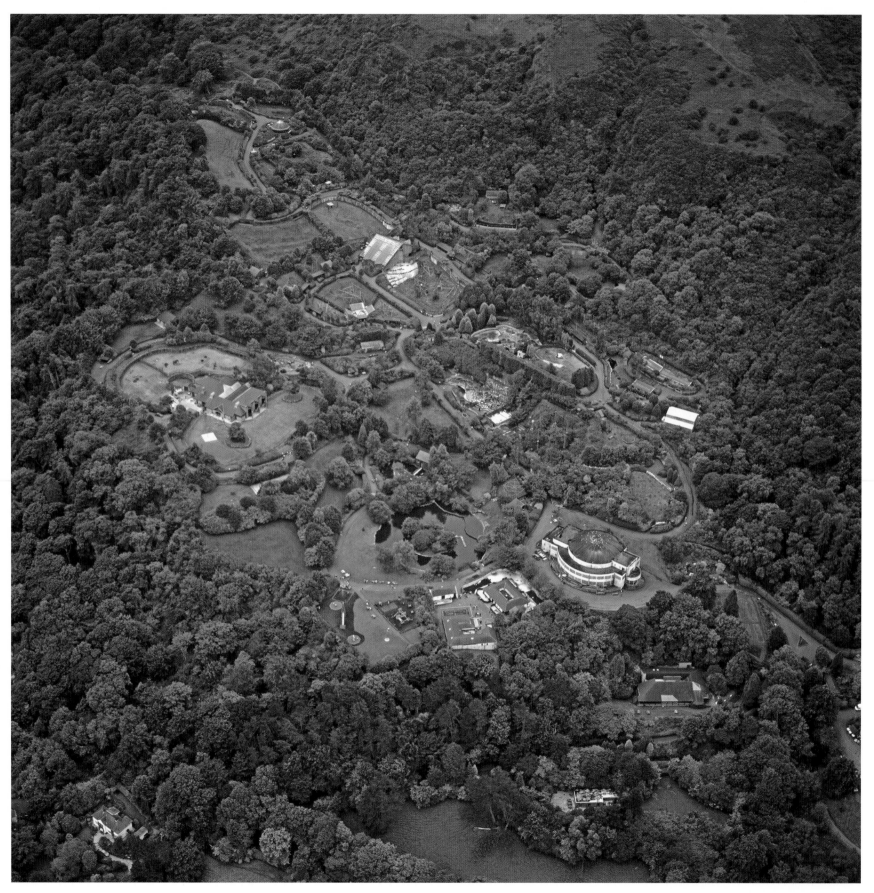

Above: Belfast Zoo in the north of the city
Opposite: Belfast Castle, Cave Hill

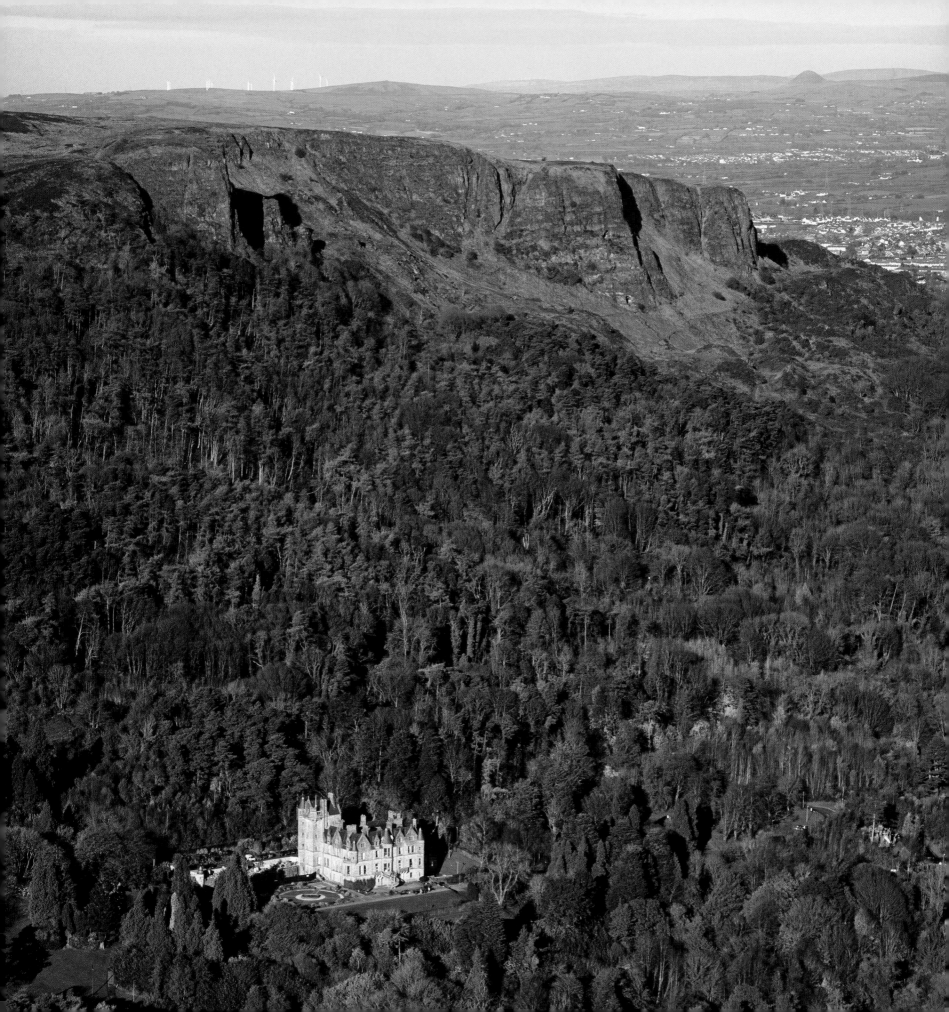

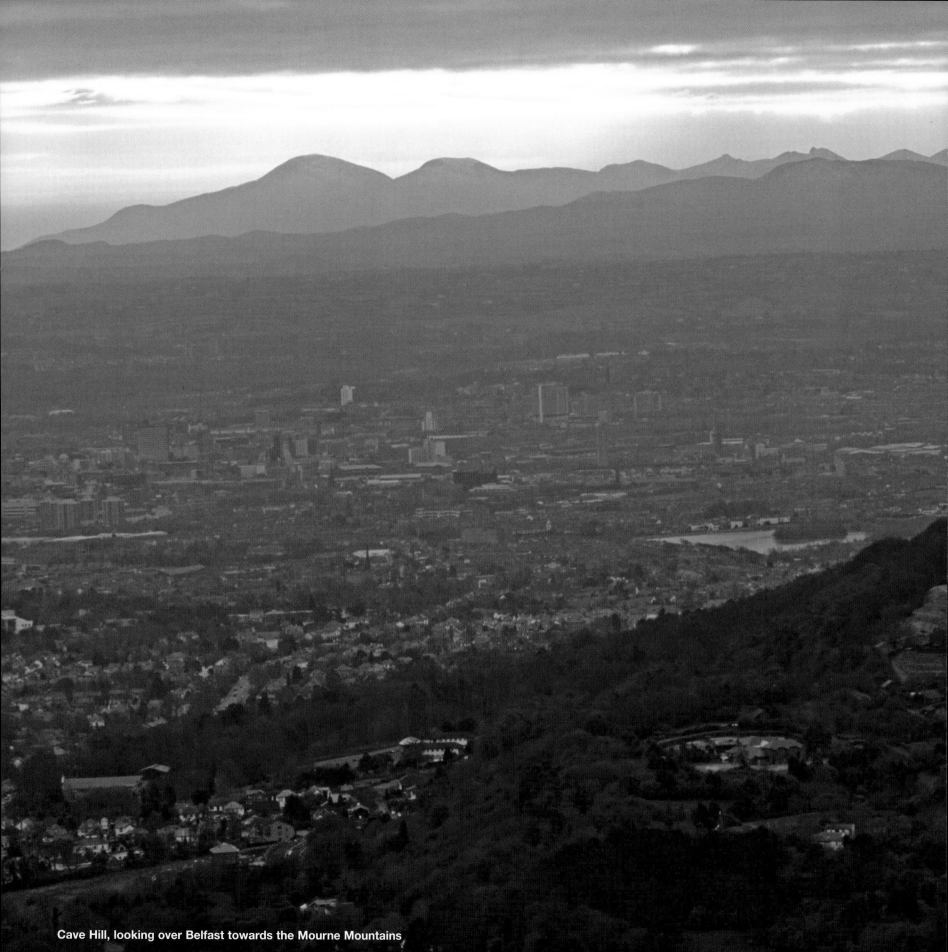

Cave Hill, looking over Belfast towards the Mourne Mountains

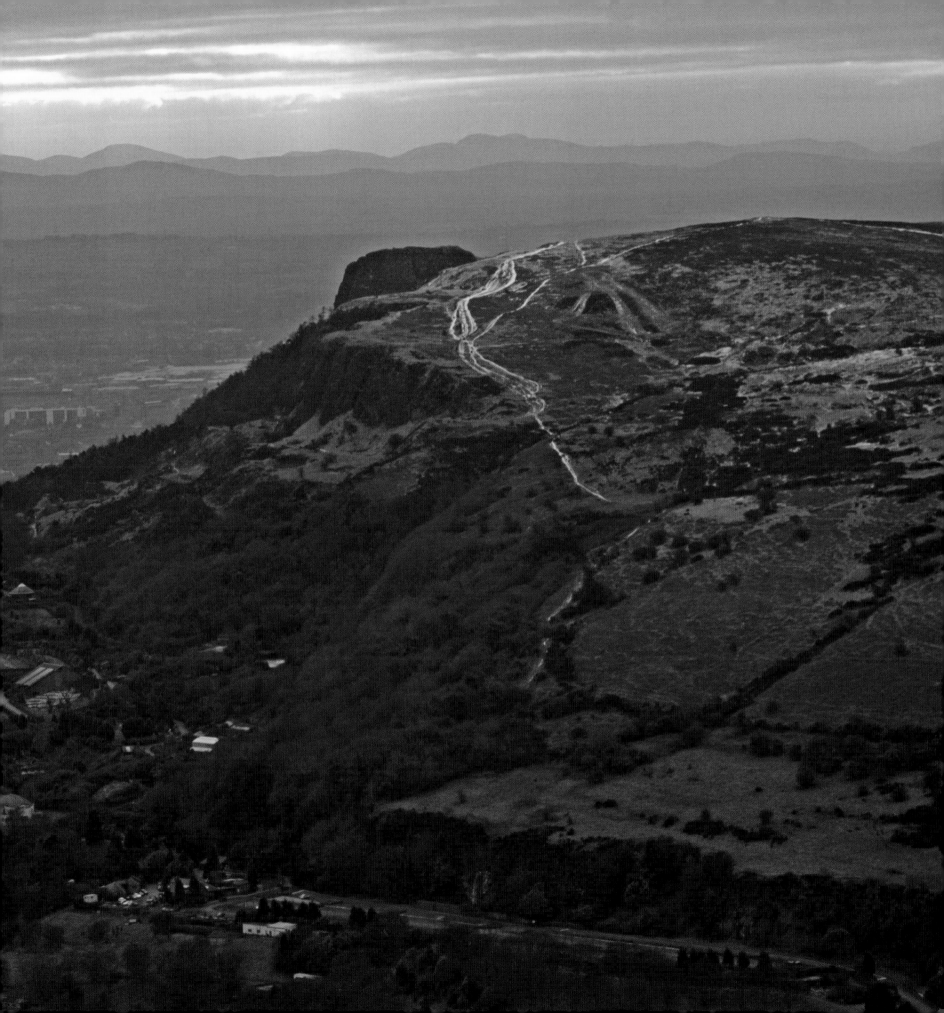

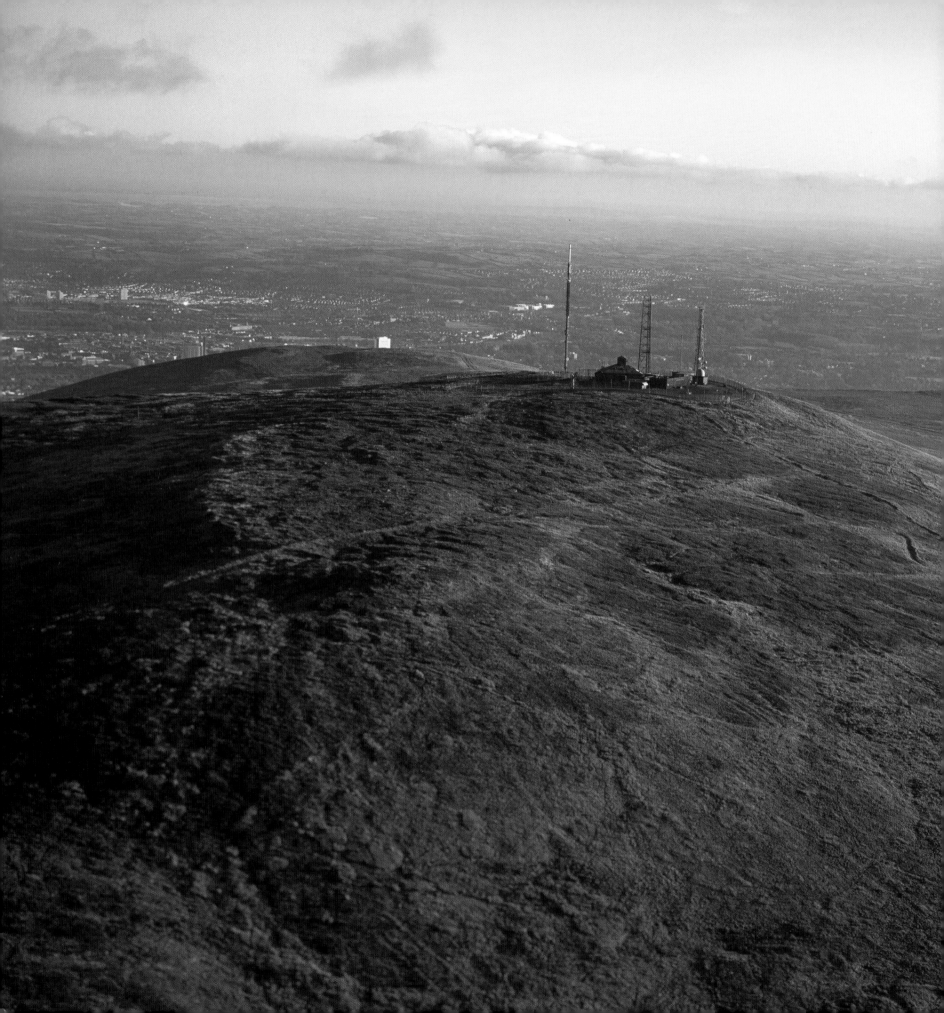

Divis Mountain, County Antrim, overlooking Belfast

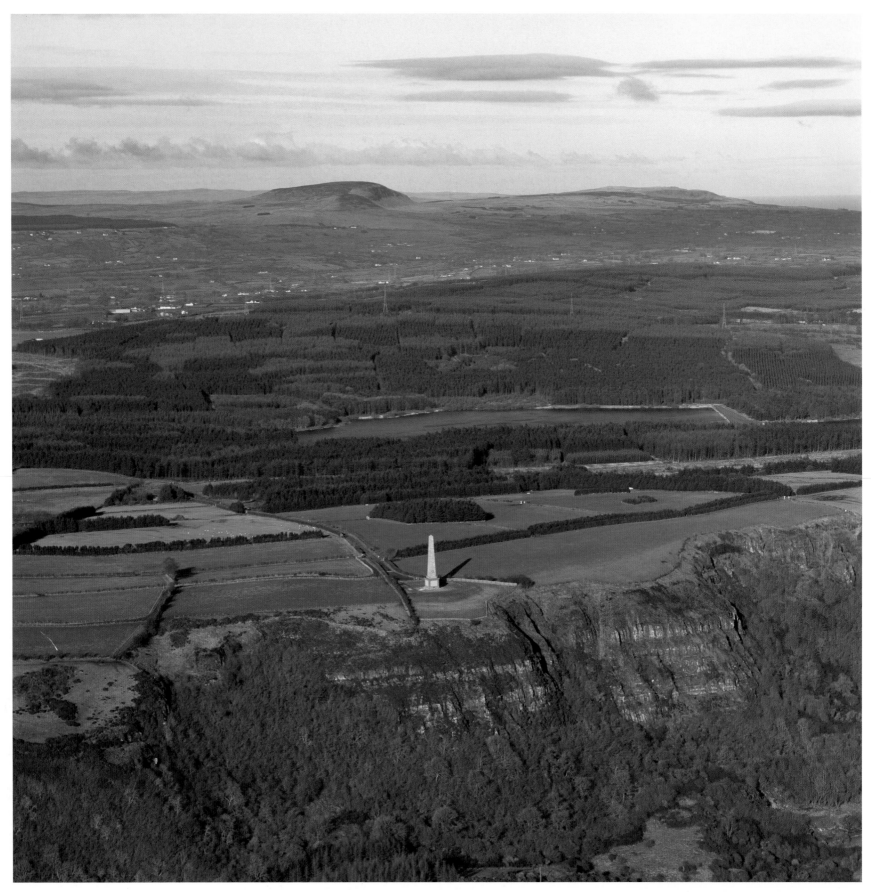

Above: The Knockagh Monument on Knockagh Hill near Greenisland, looking towards Agnew's Hill

Opposite: Whitehead on the east Antrim coast

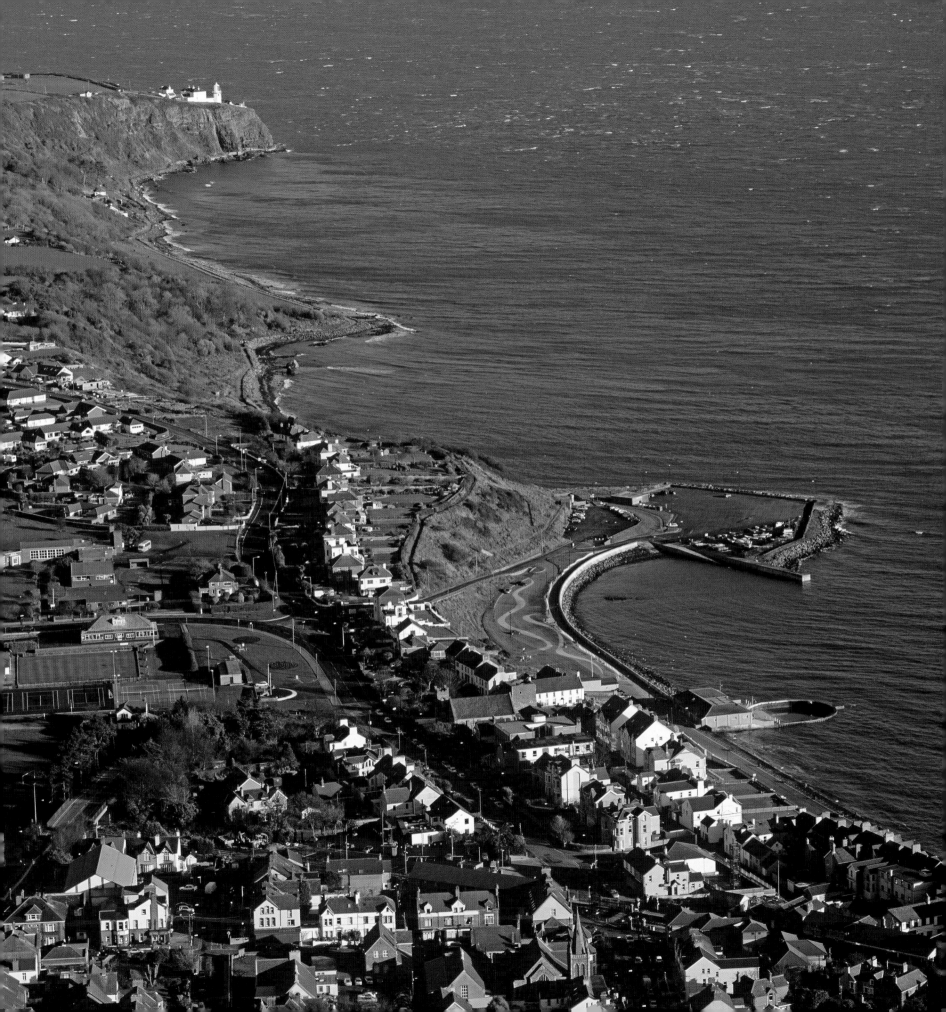

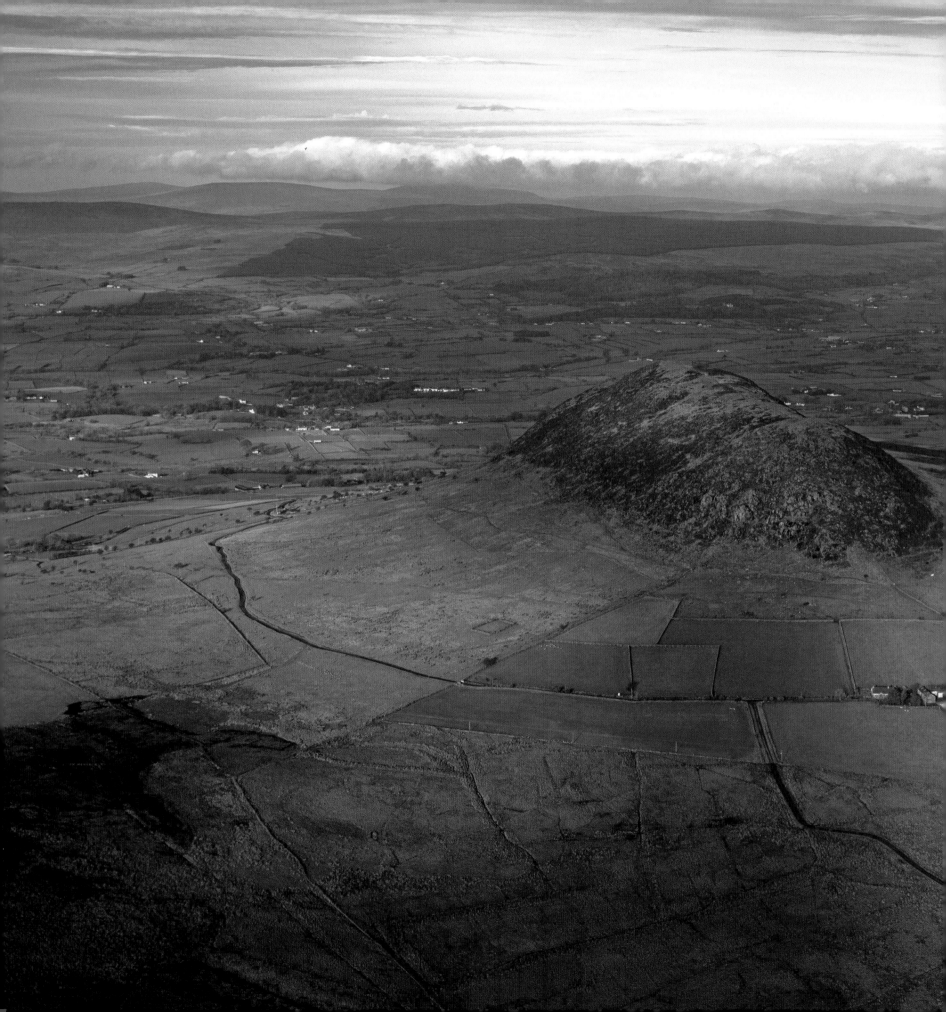

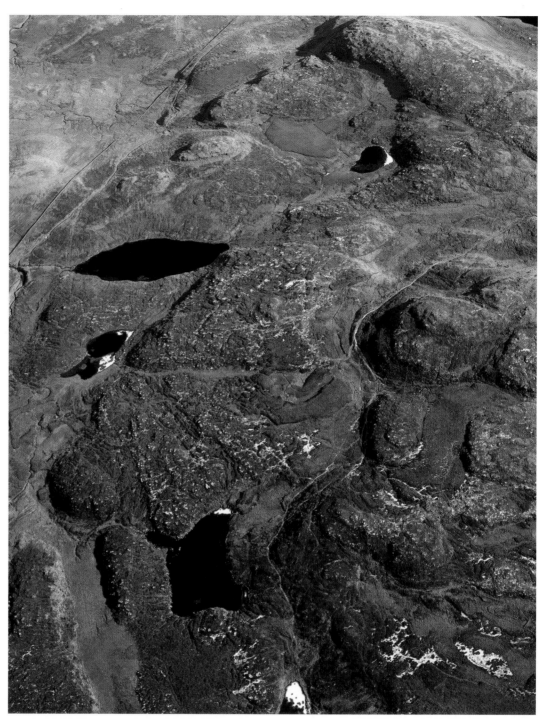

Denny's Lough and Loughfine on the Antrim Plateau,
between Carnlough and Waterfoot

Slemish, near Ballymena, County Antrim

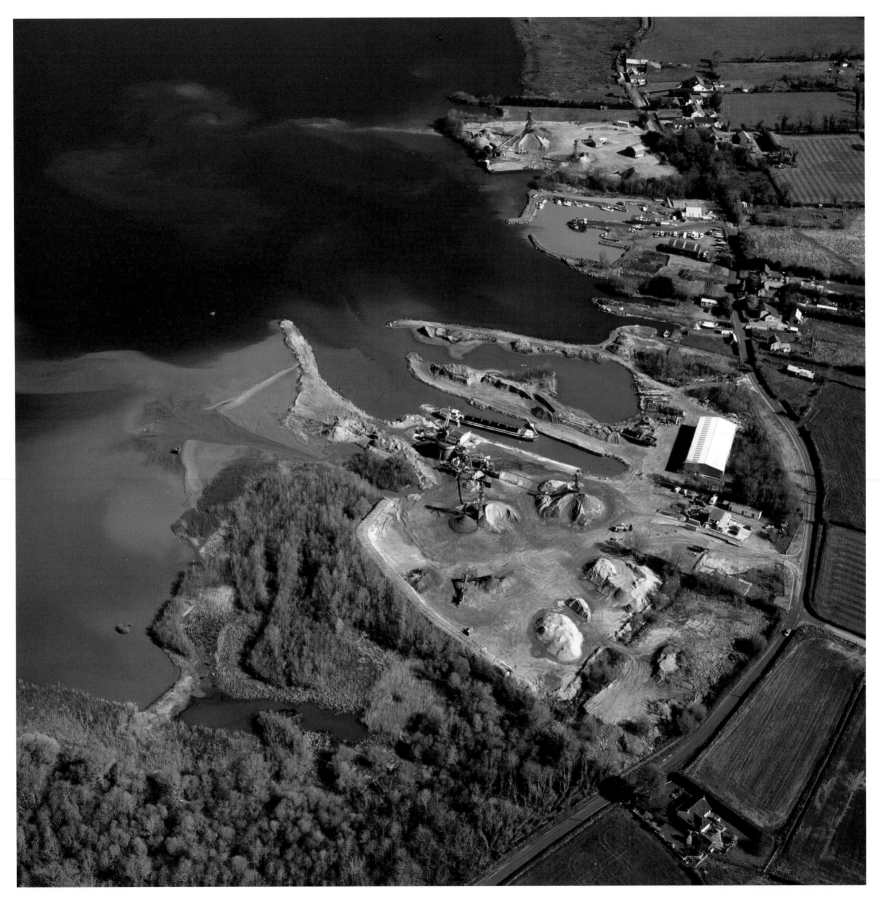

Above: Sandy Bay on the eastern shore of Lough Neagh
Opposite: Sallagh Braes, near Larne

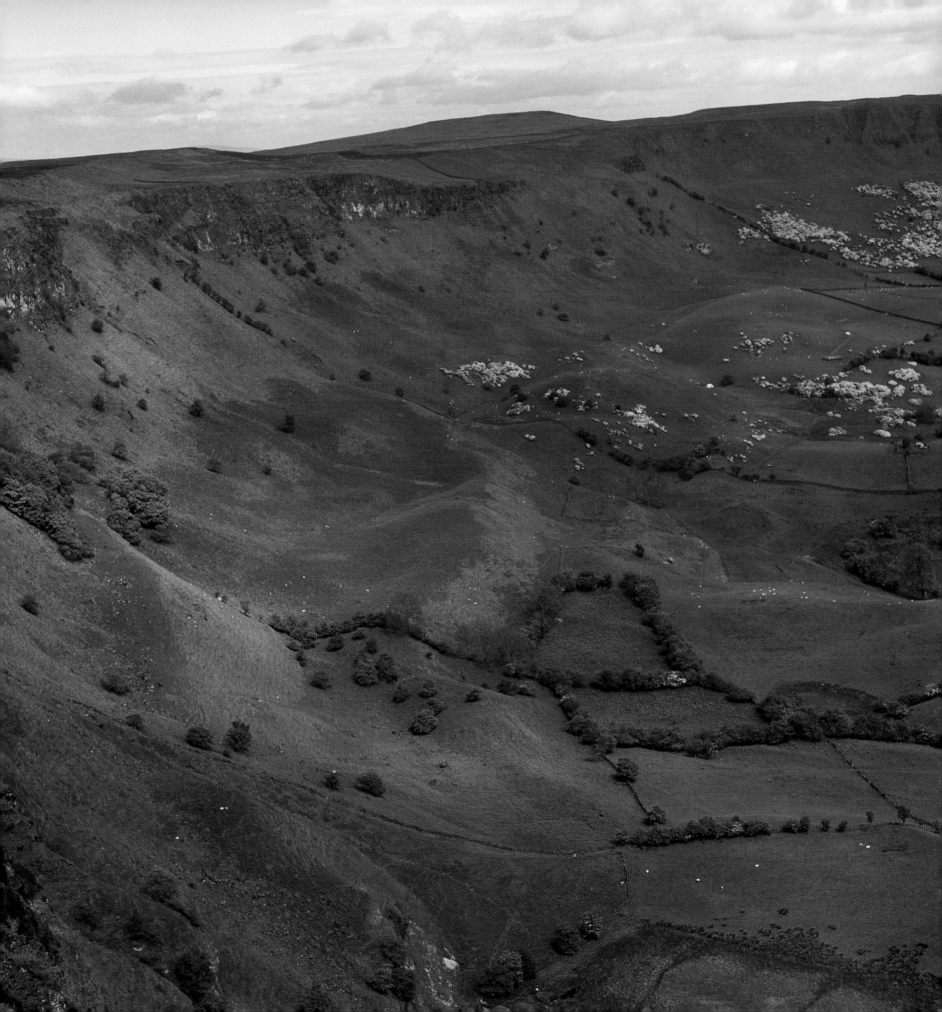

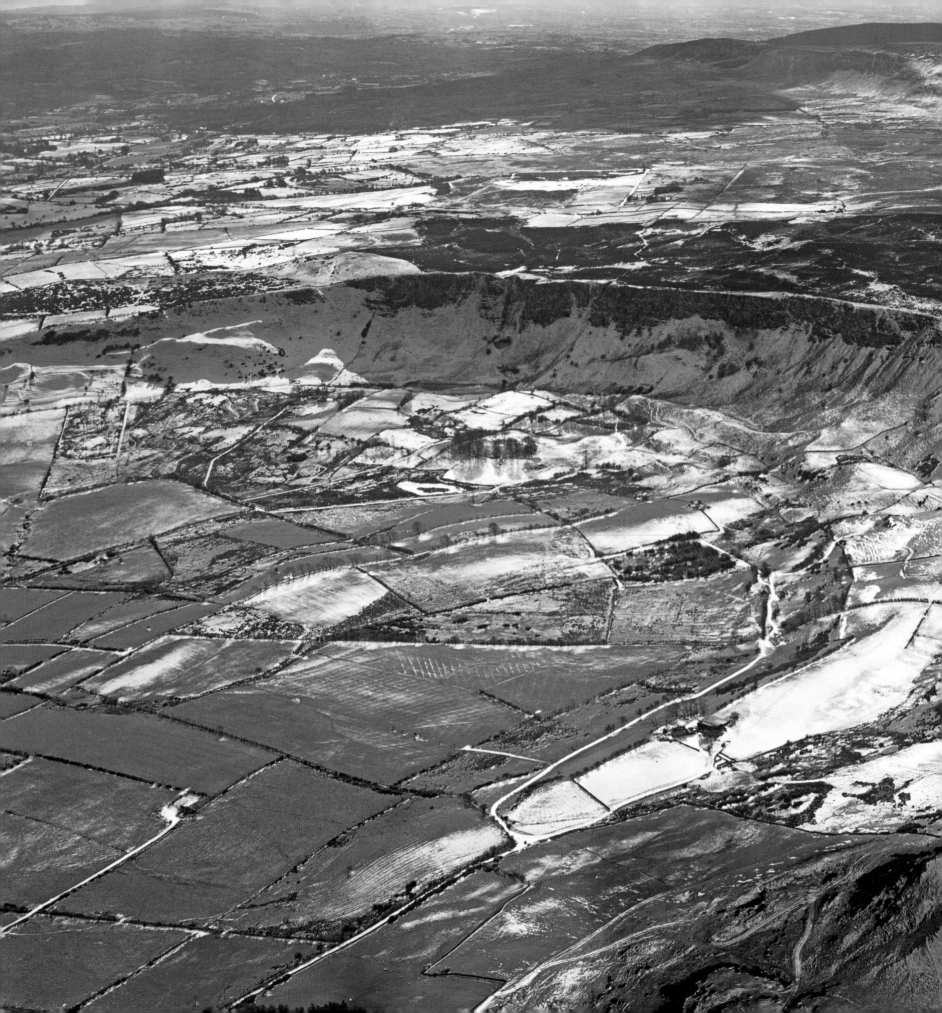

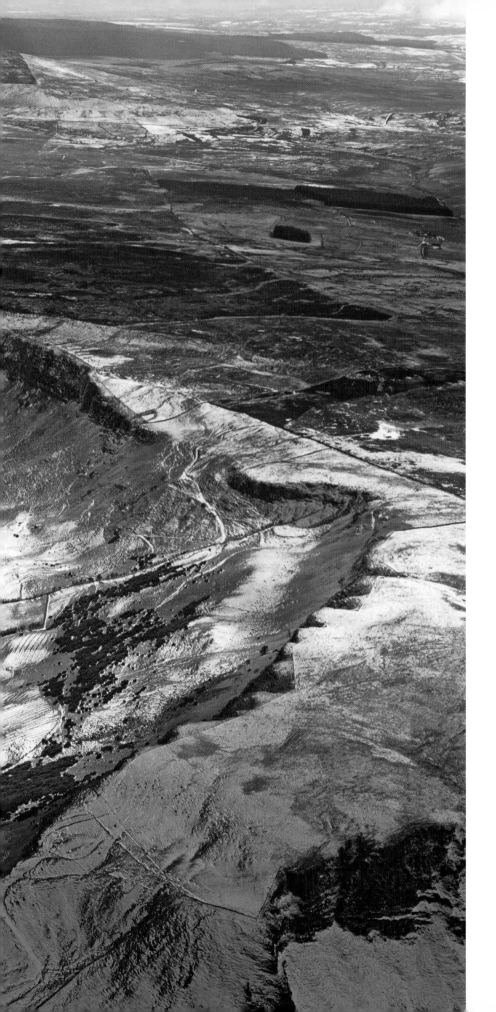

Sallagh Braes in winter

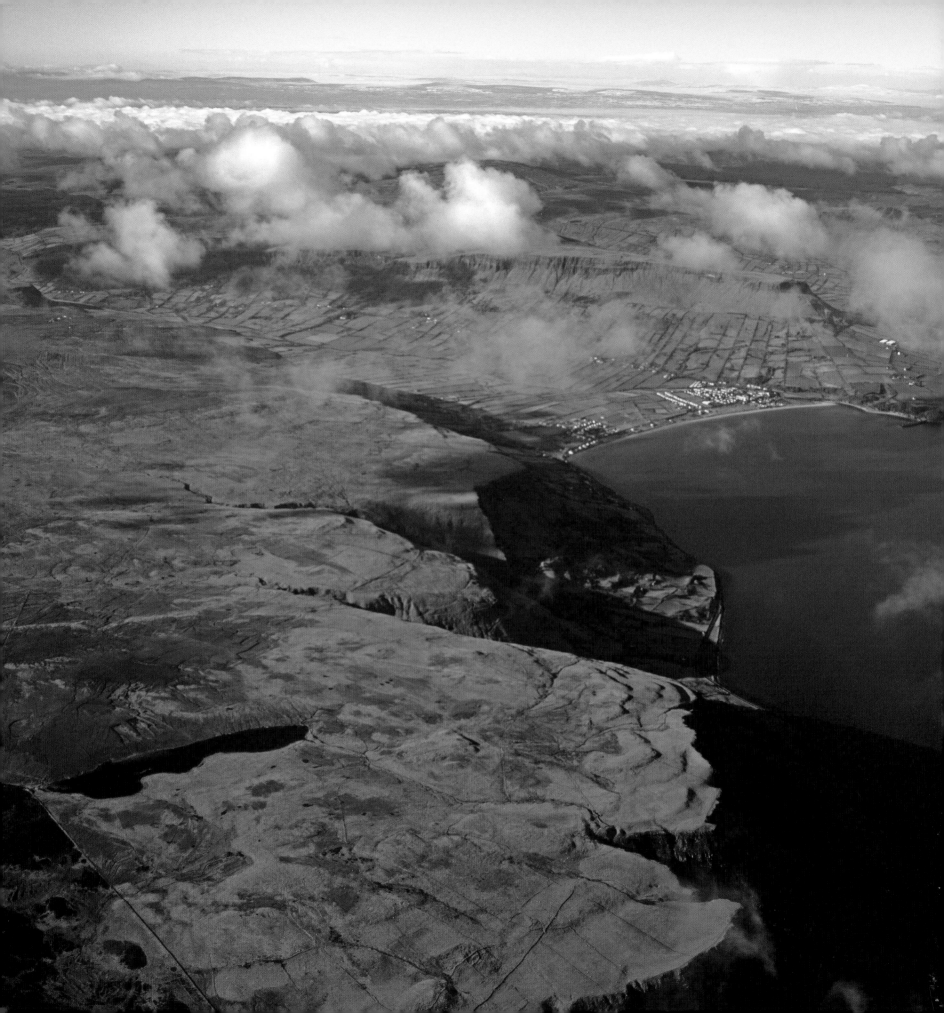

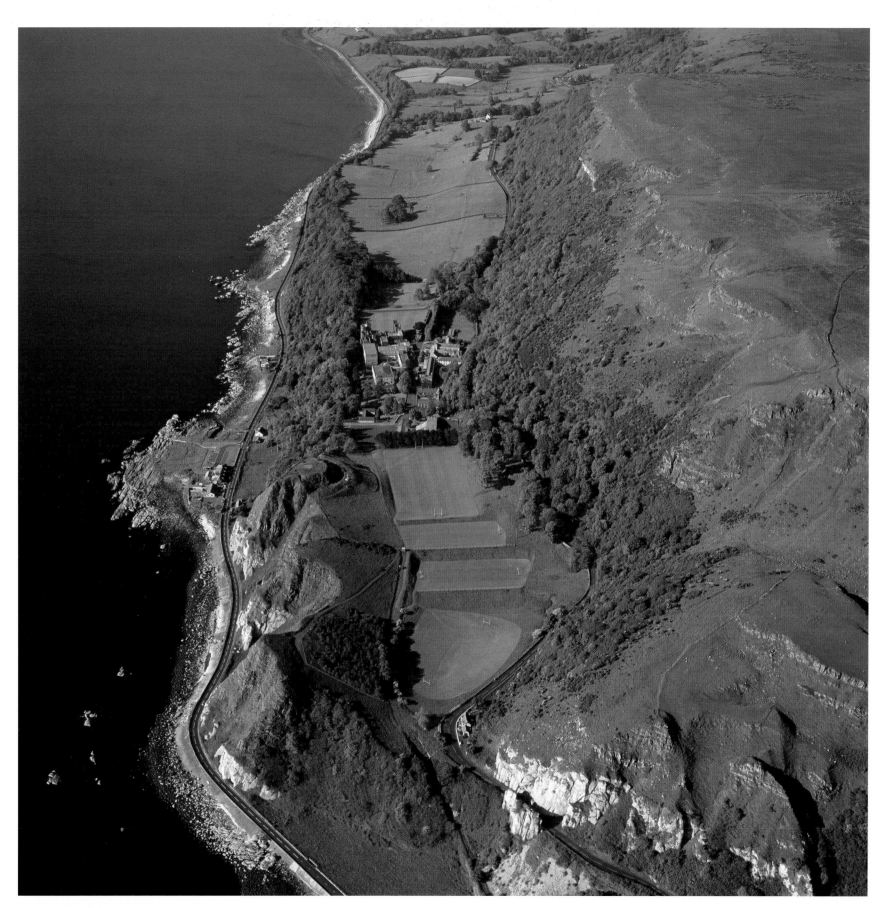

Above: St MacNissi's College at Garron Point in the Glens of Antrim
Opposite: Glenariff with Lough Galboly in the foreground

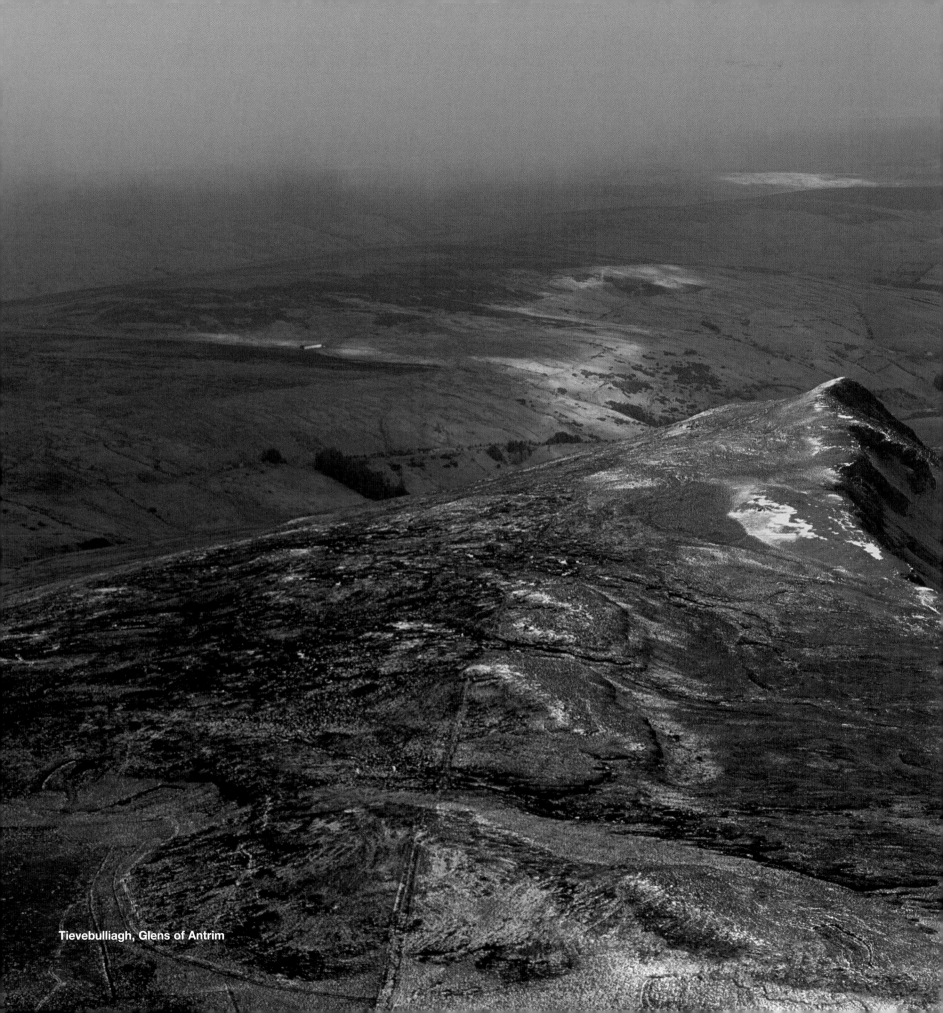

Tievebulliagh, Glens of Antrim

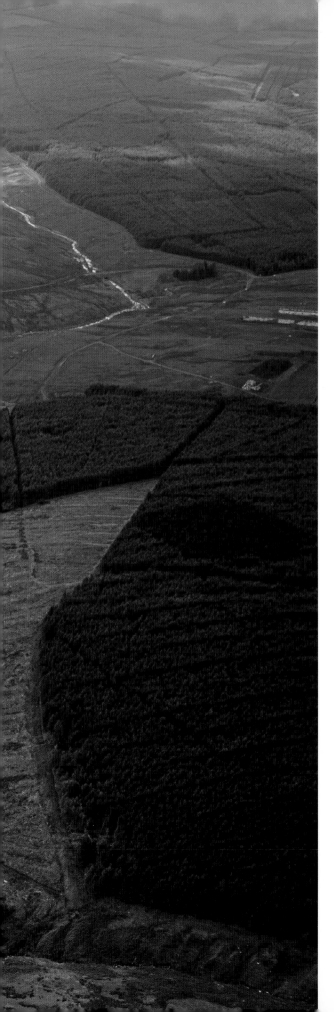

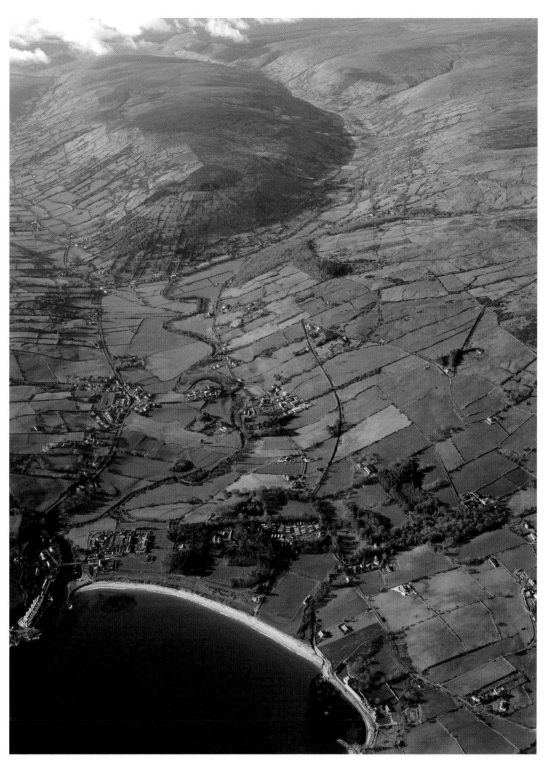

Lower Glendun and Cushendun Bay

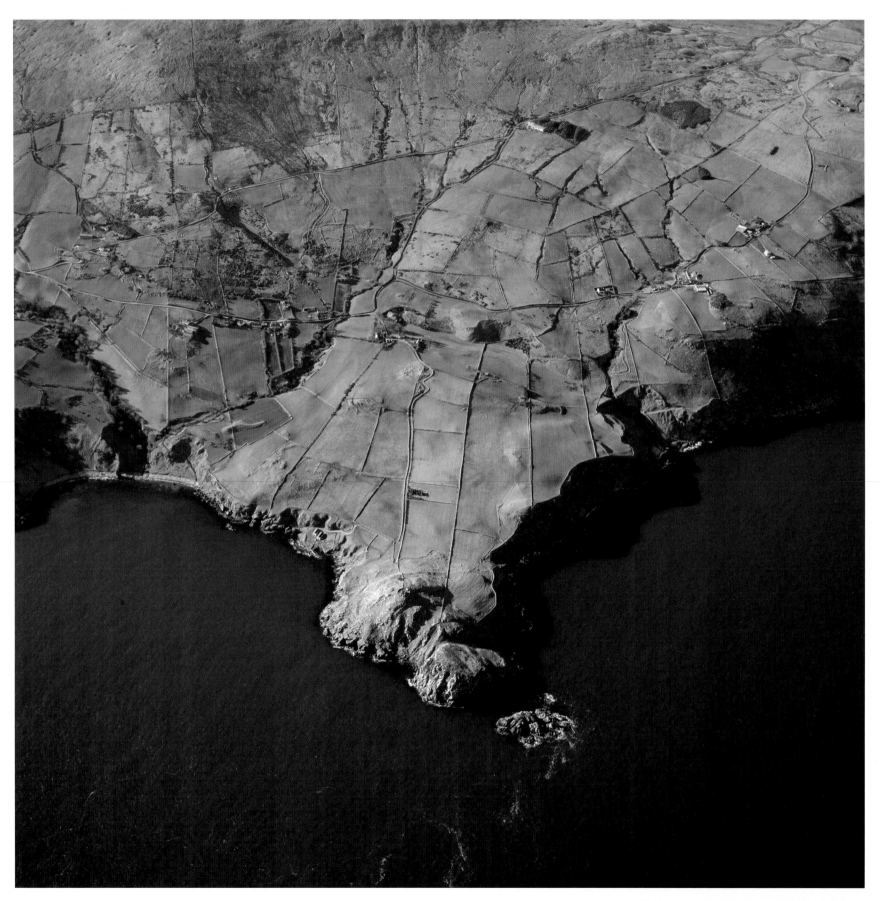

Above: Torr Head on the north Antrim coast
Opposite: Fair Head with Loughs na Cranagh and Fadden, and Knocklayd in the distance

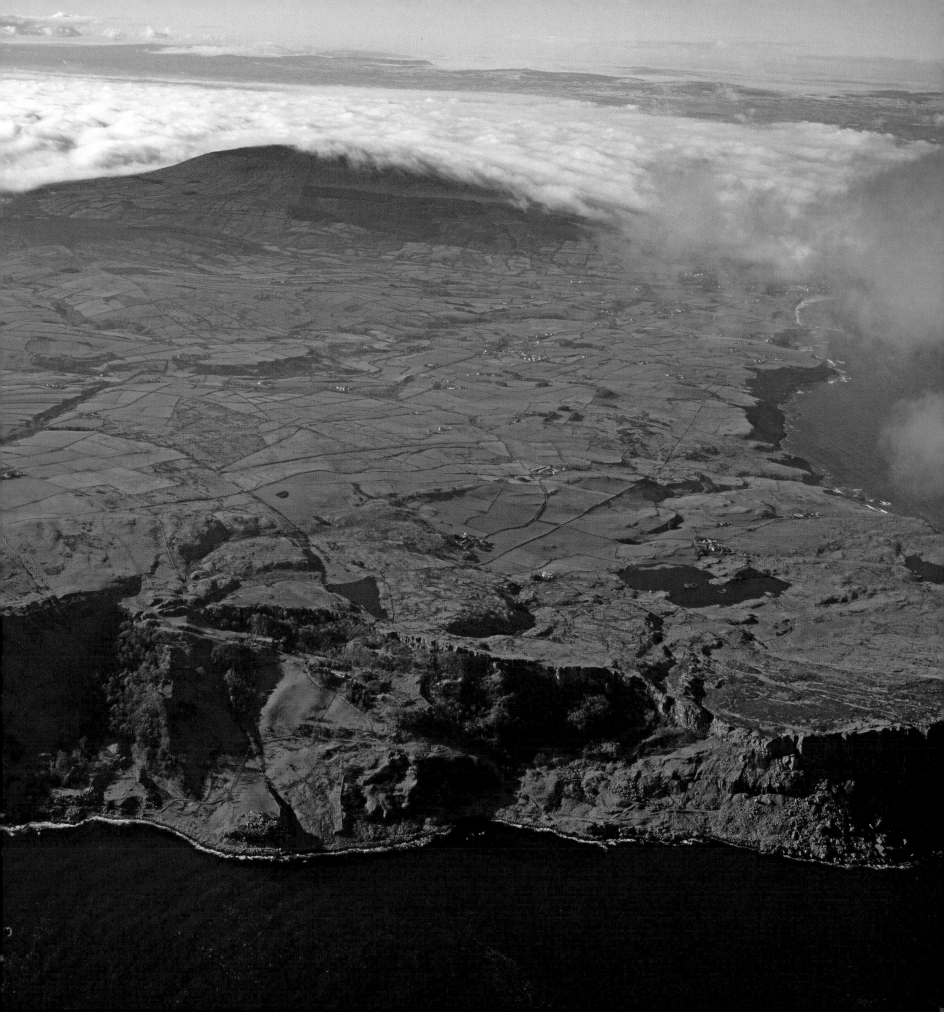

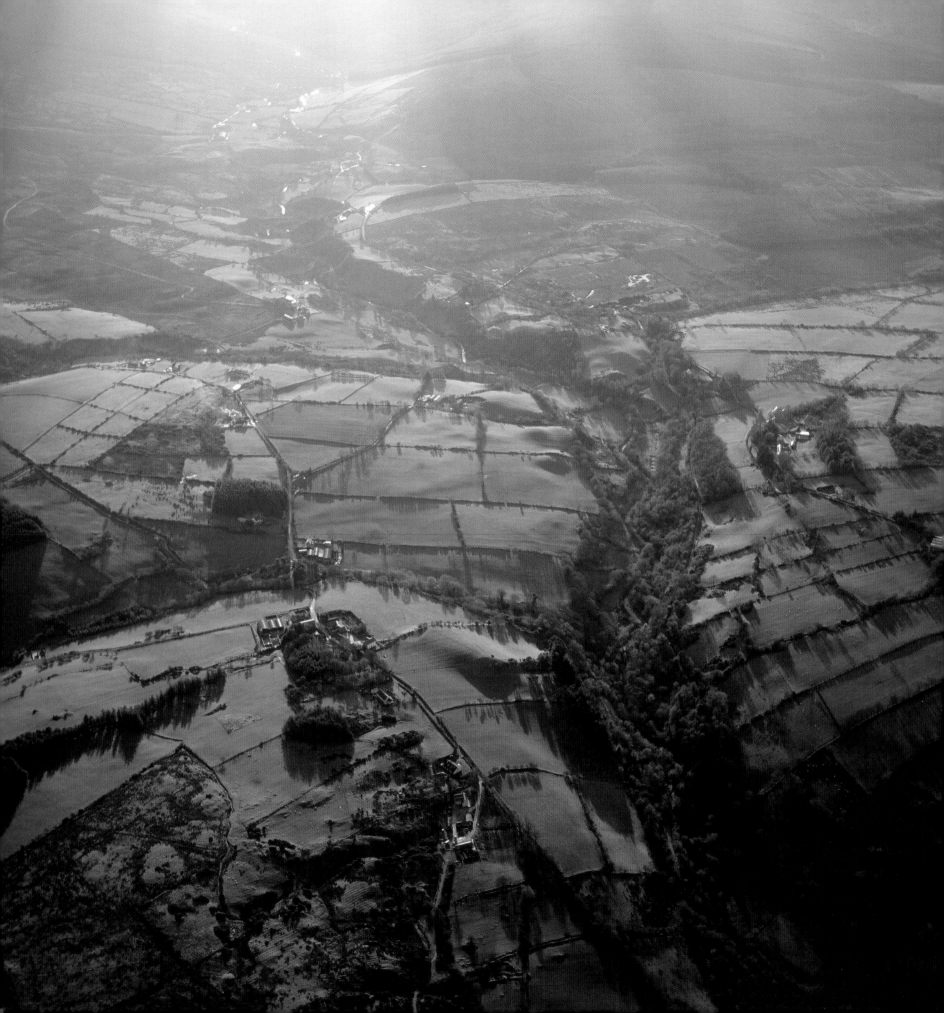

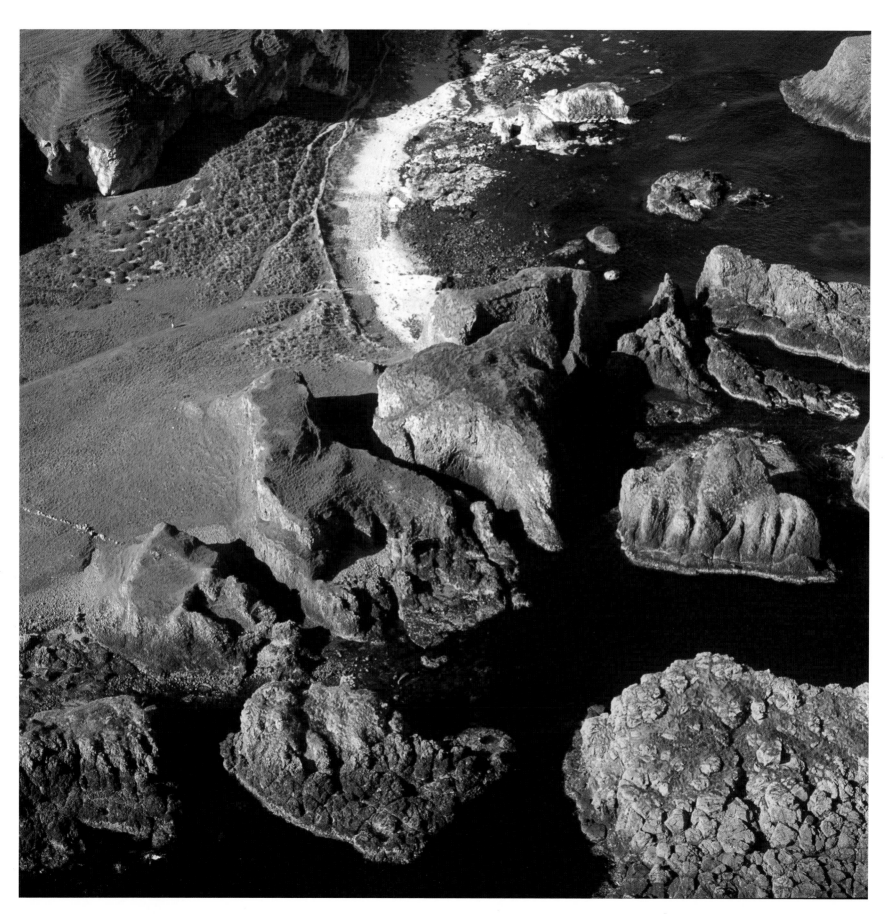

Above: Dundriff, near Ballintoy
Opposite: Glenshesk in the Glens of Antrim

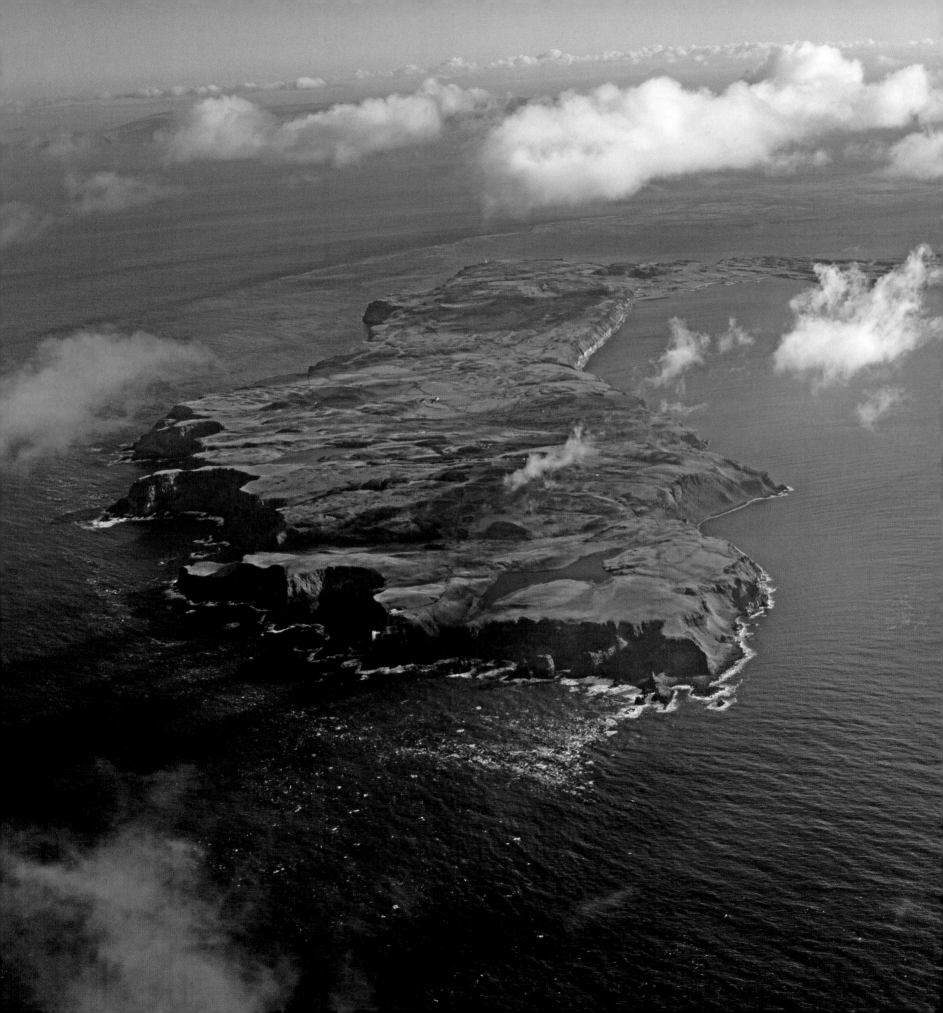

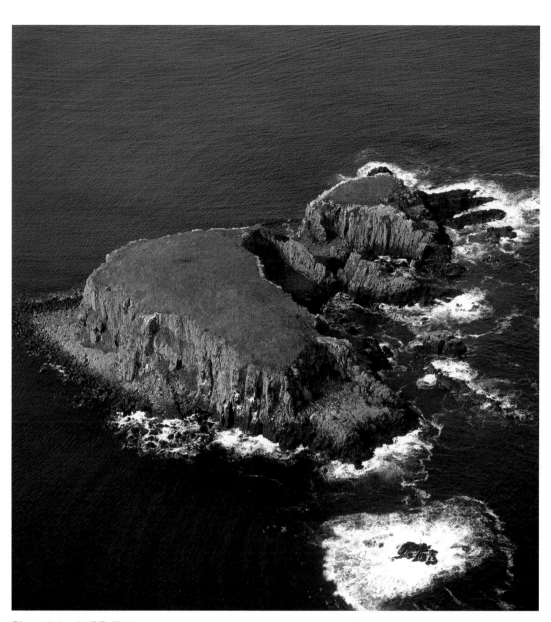

Sheep Island off Ballintoy

Rathlin Island off Ballycastle, County Antrim

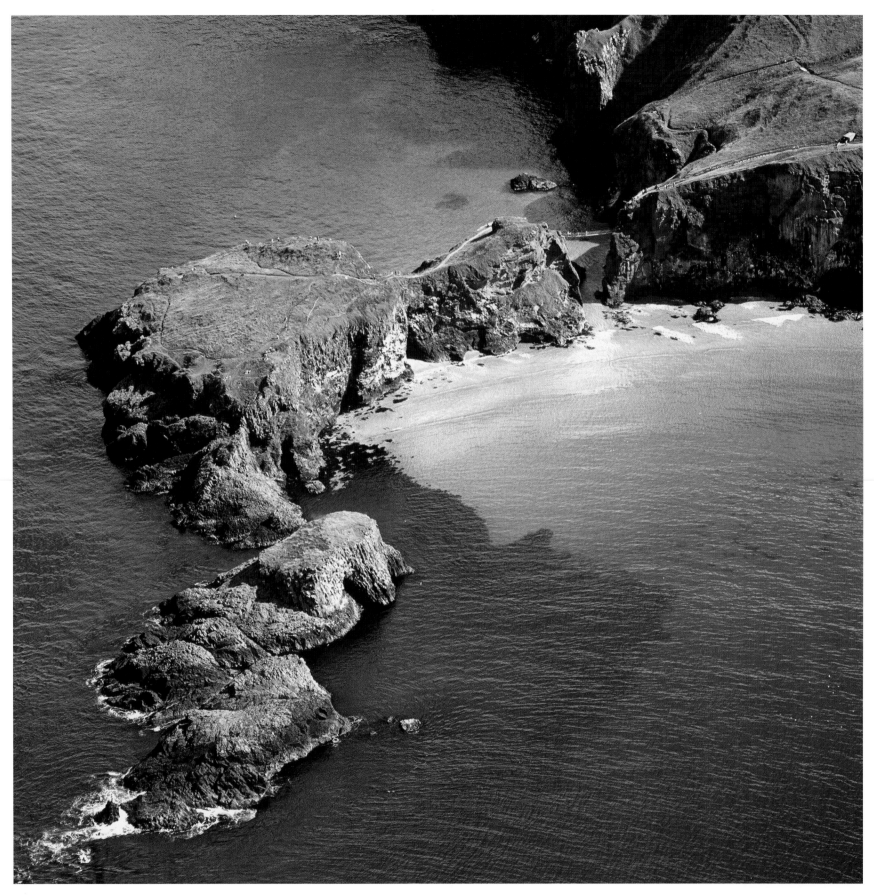

Above: Carrick-a-rede rope bridge
Opposite: Ballintoy Church

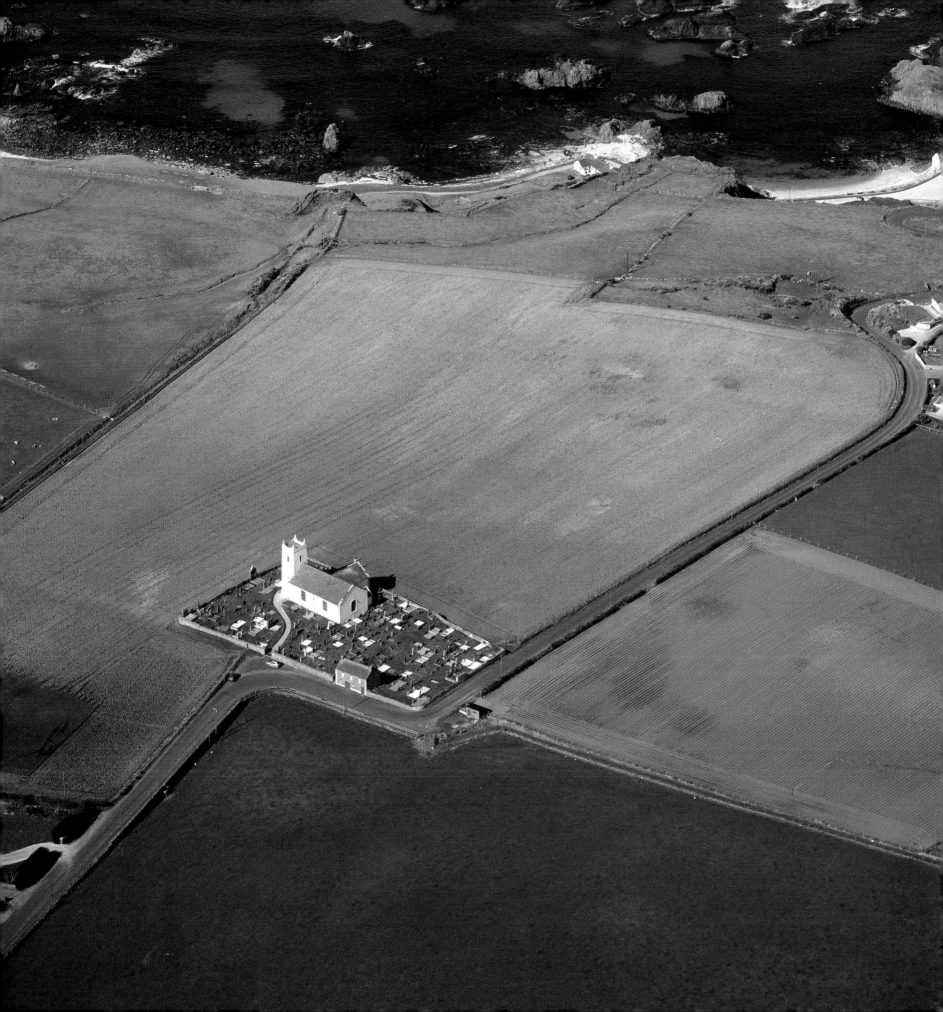

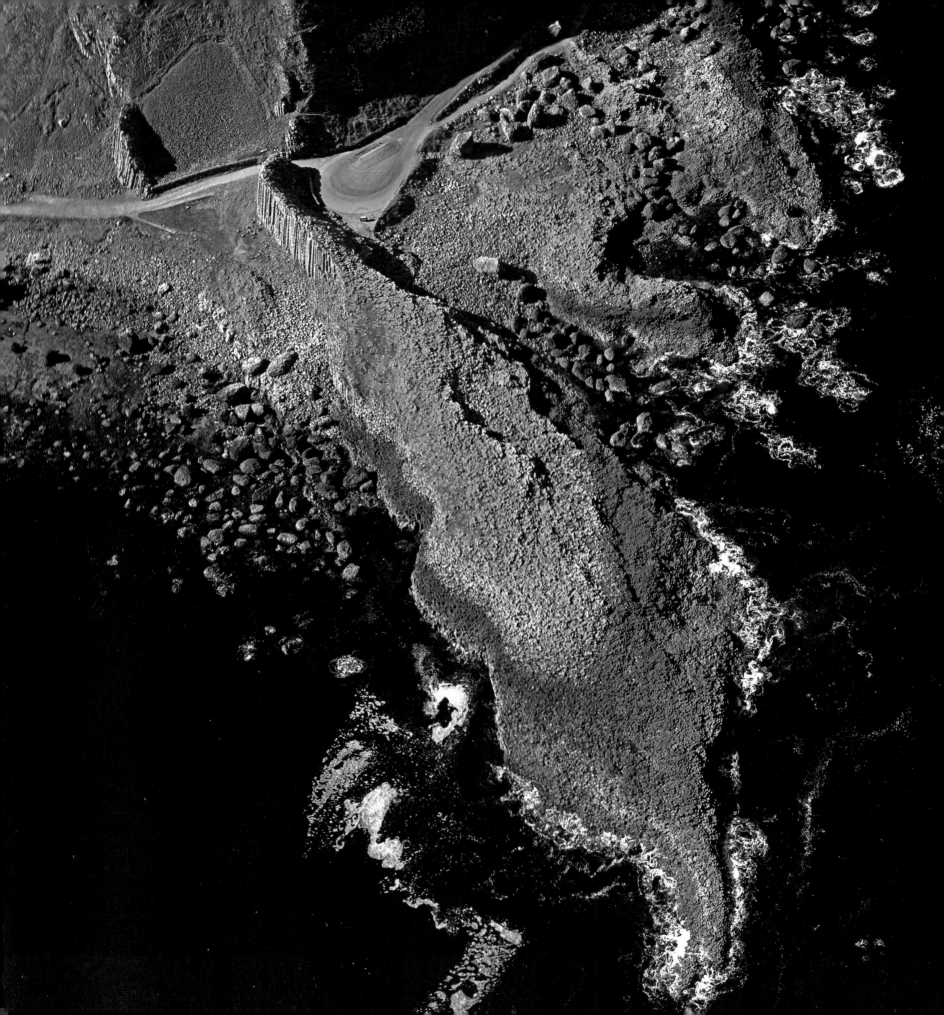

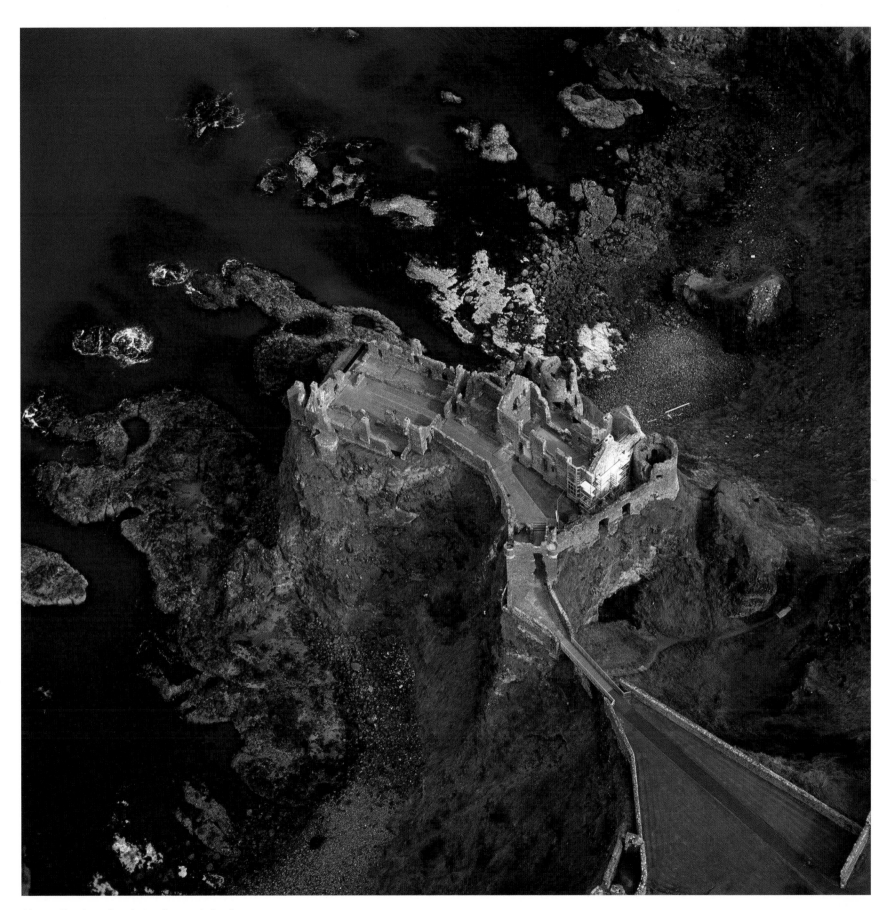

Above: Dunluce Castle on the north Antrim coast
Opposite: The Giant's Causeway

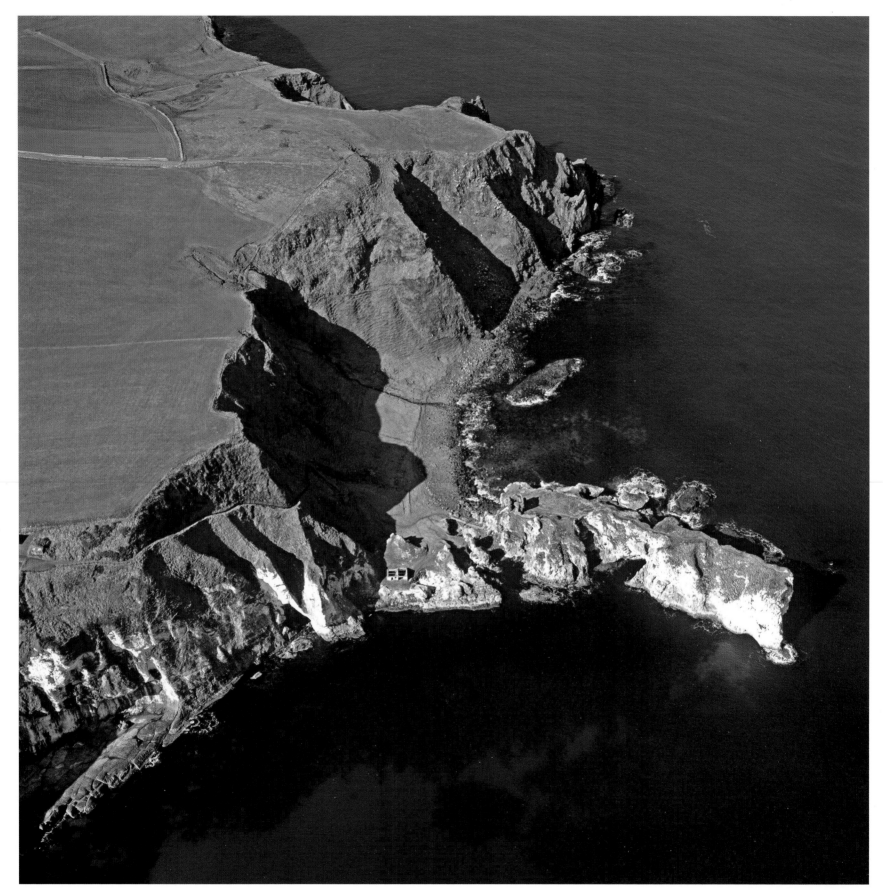

Above: Kinbane Head
Opposite: Portrush

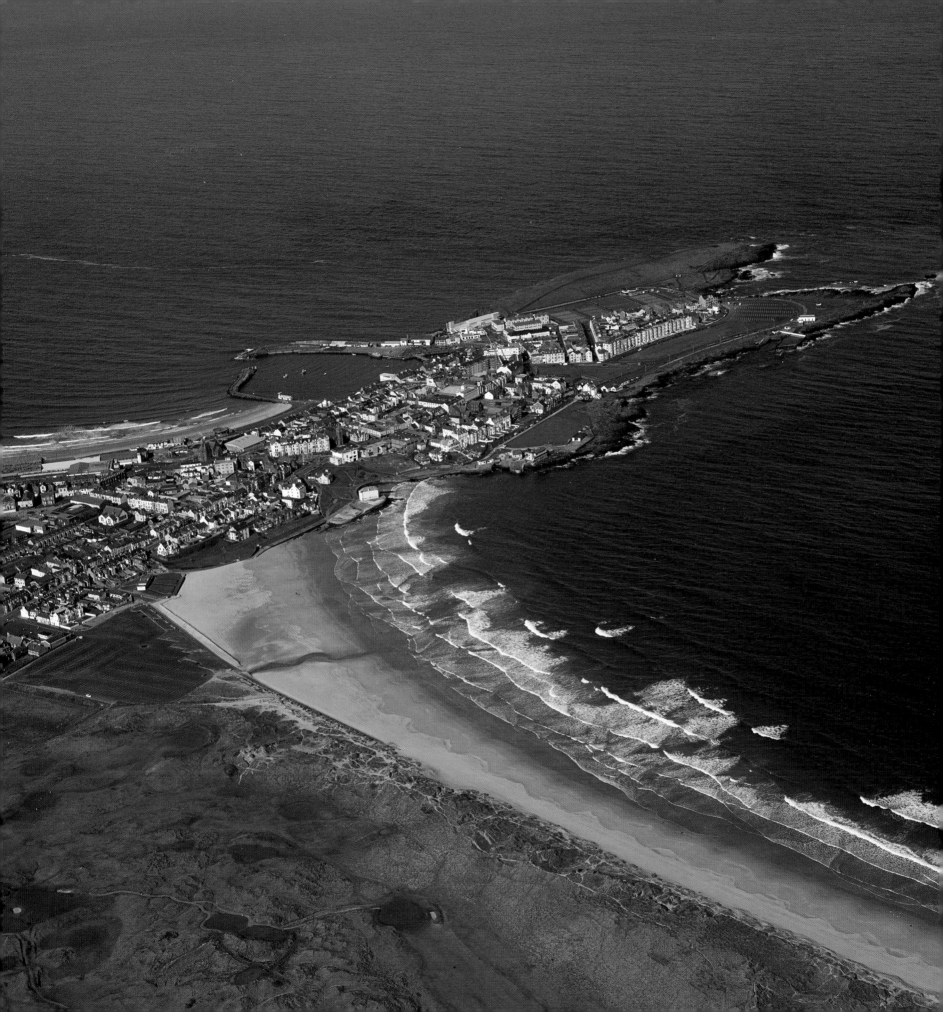

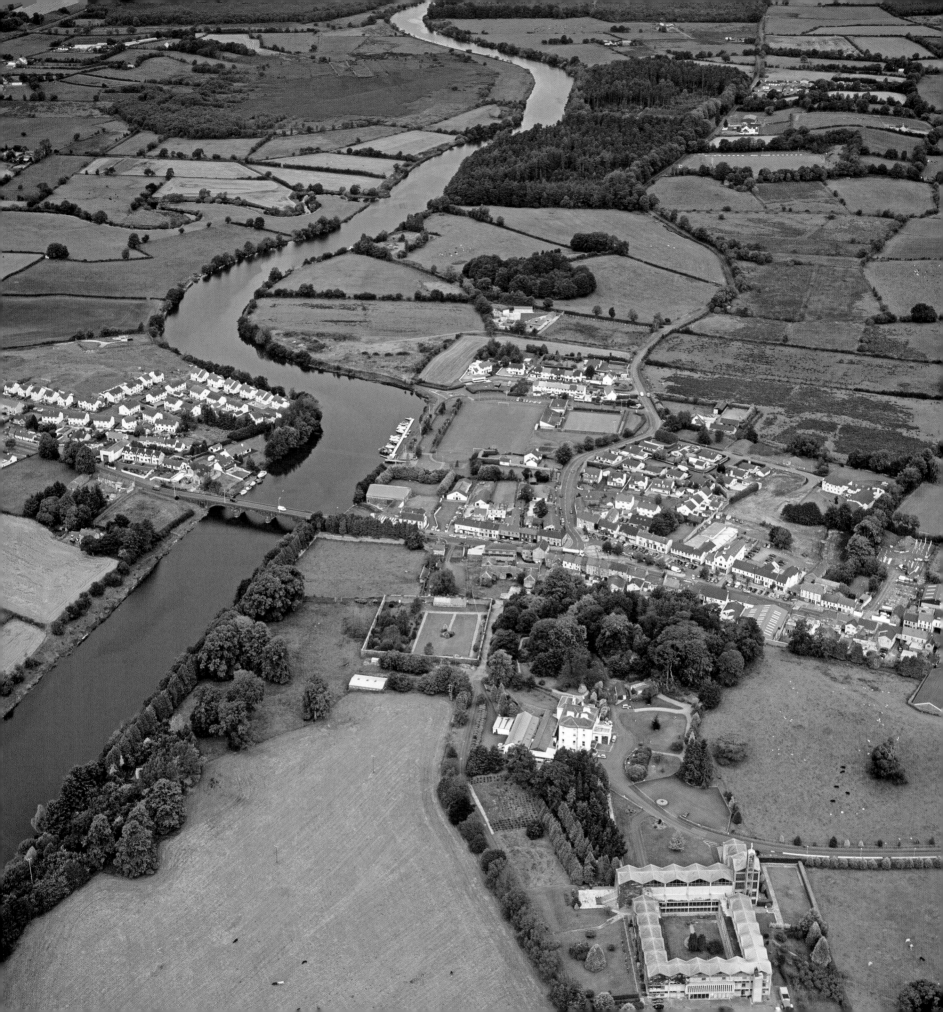

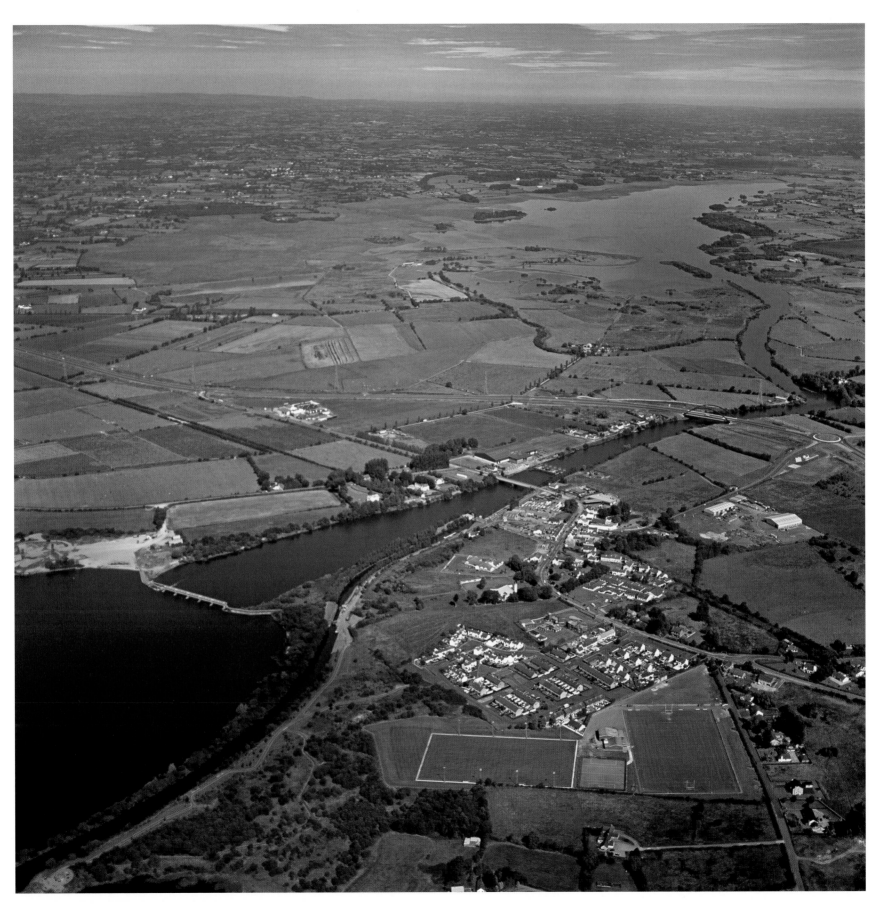

Above: The sluice gates outside Toome control the level of the River Bann
Opposite: Portglenone on the River Bann

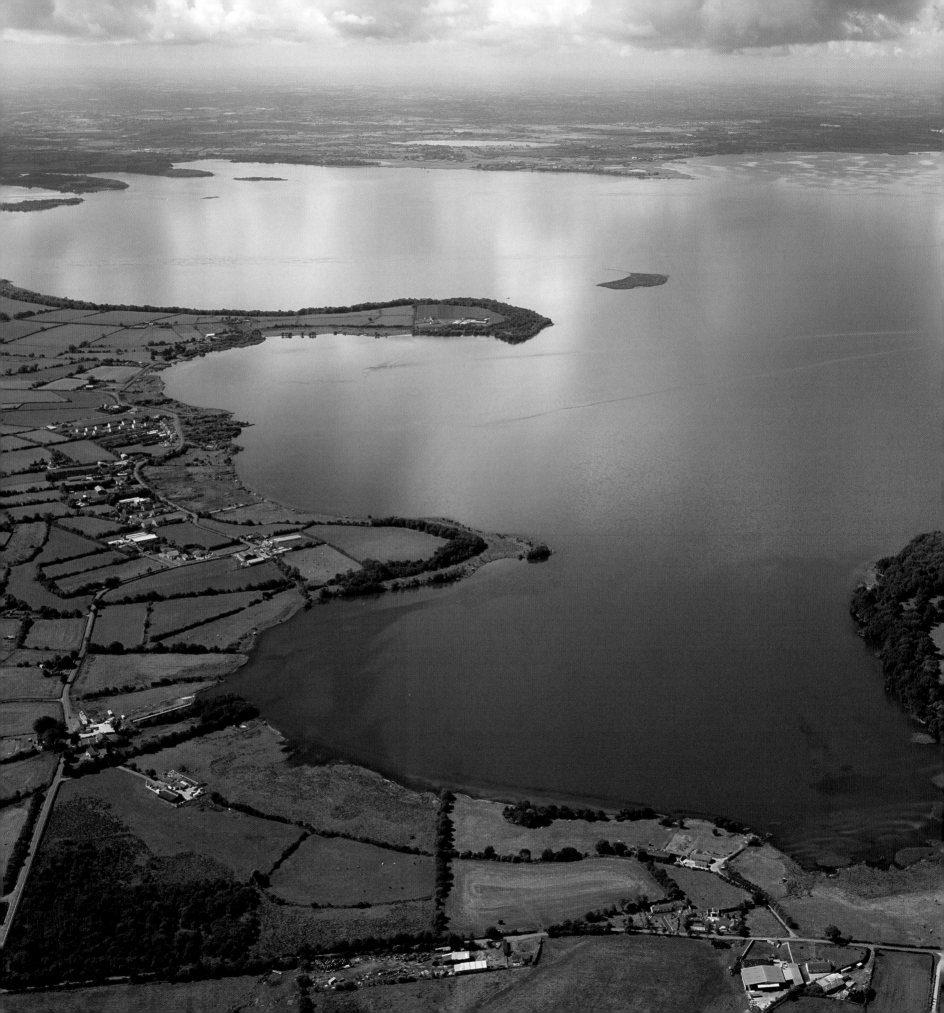

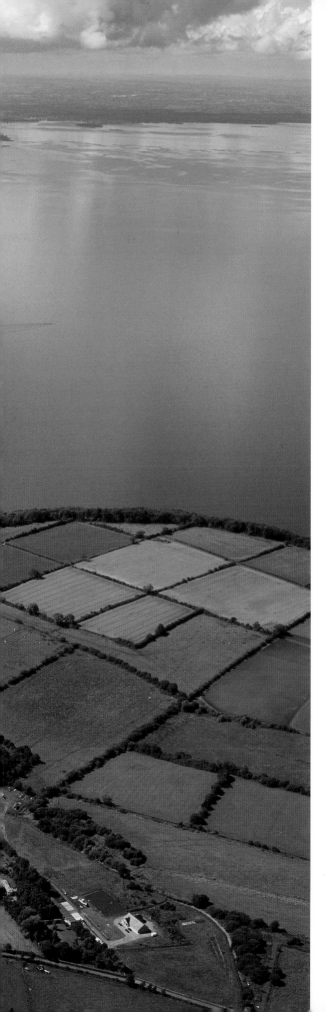

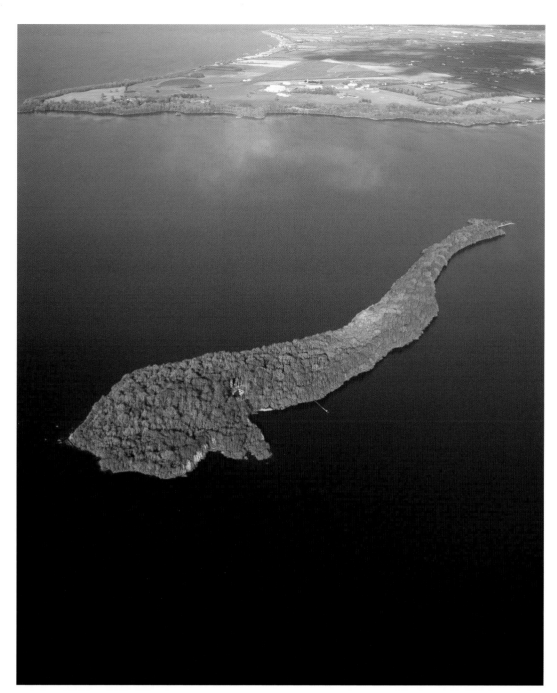

Ram's Island, Lough Neagh

Lough Neagh, near Toome

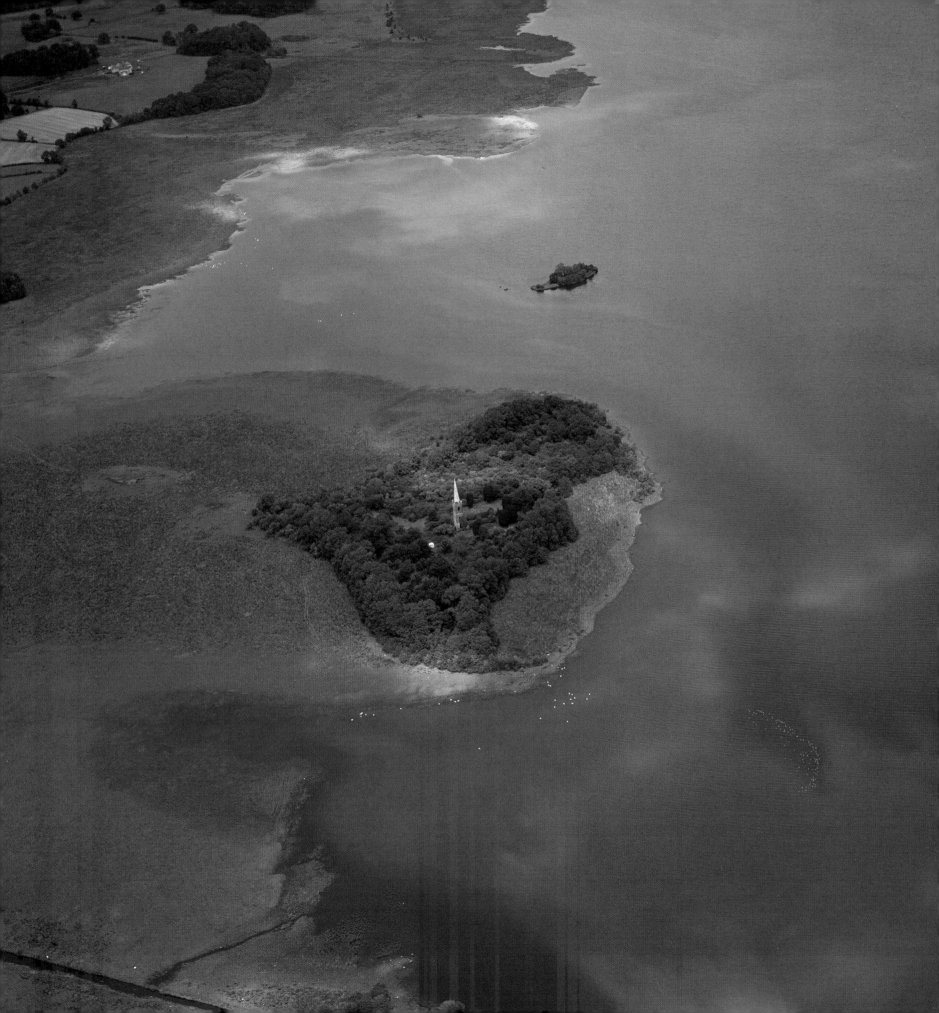

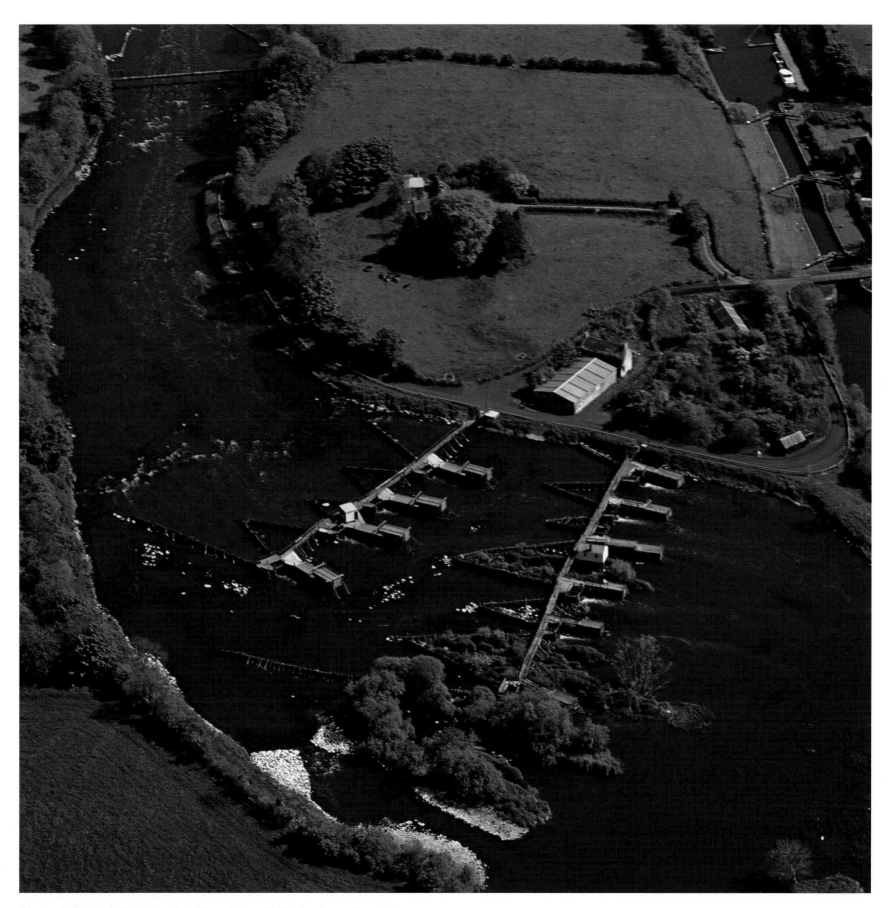

Above: Eel traps at Portna on the River Bann with the Locks on the right
Opposite: Church Island

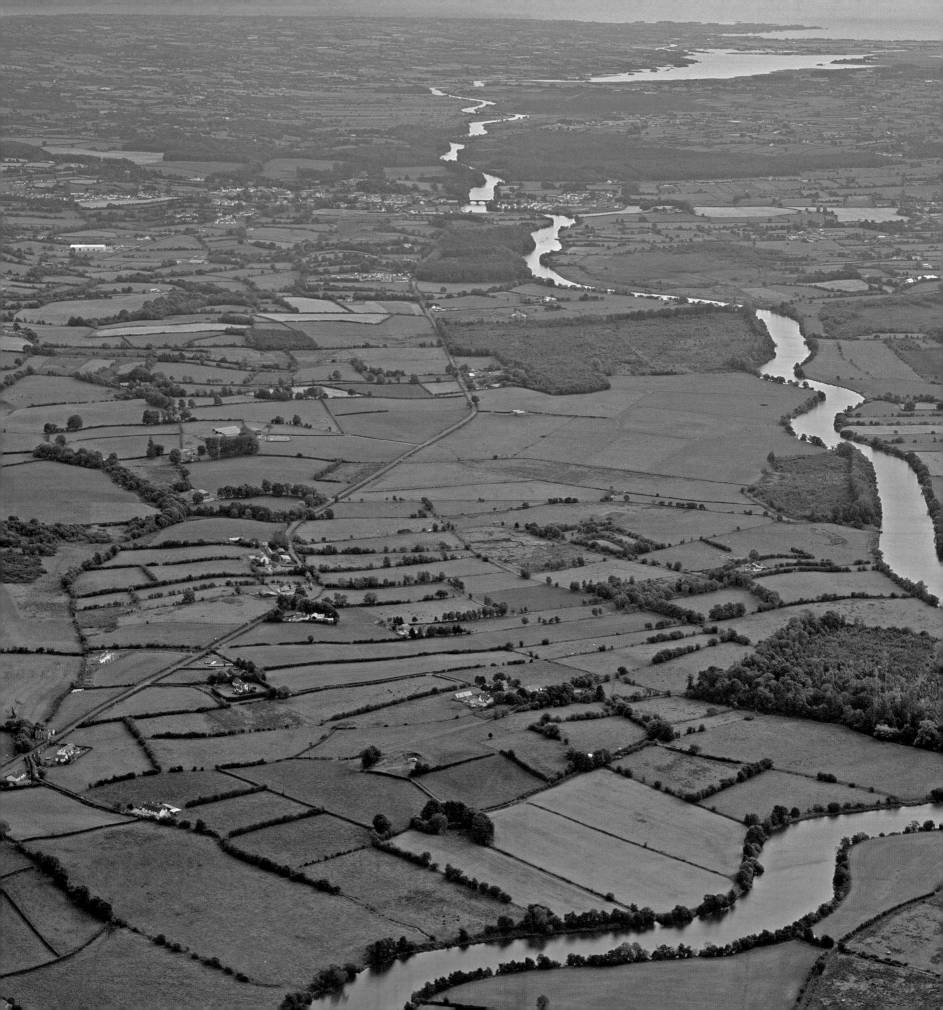

River Bann, County Londonderry, taken south of Kilrea

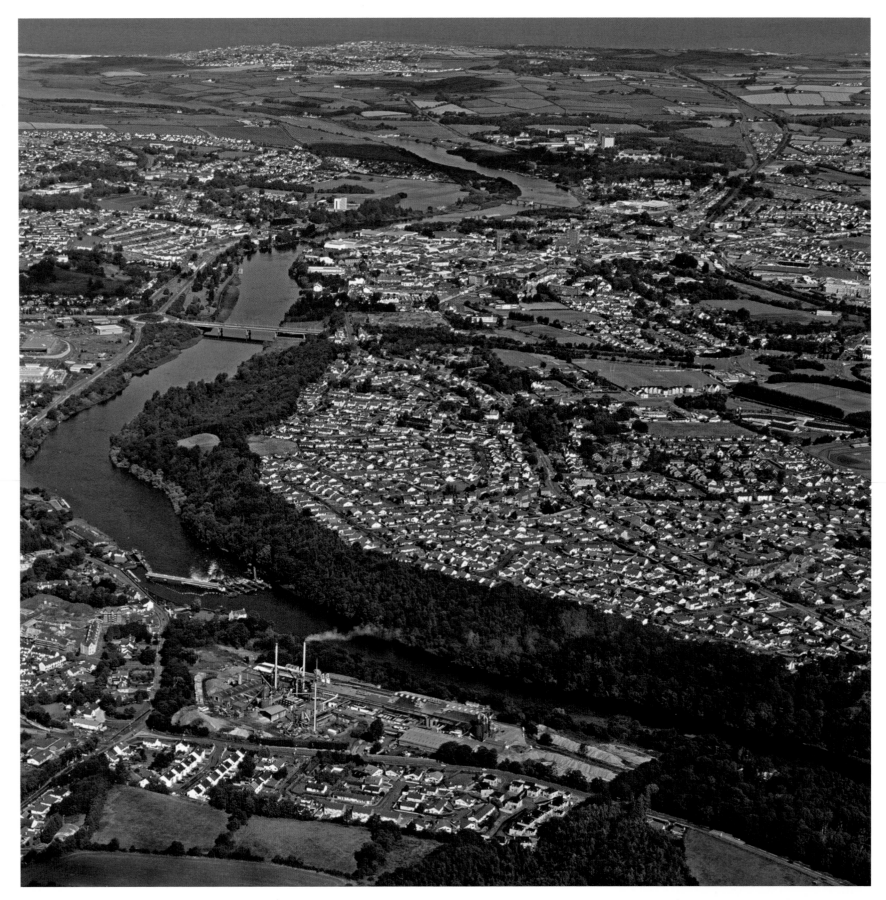

Above: Coleraine with Castleroe in the foreground
Opposite: Portstewart, County Londonderry

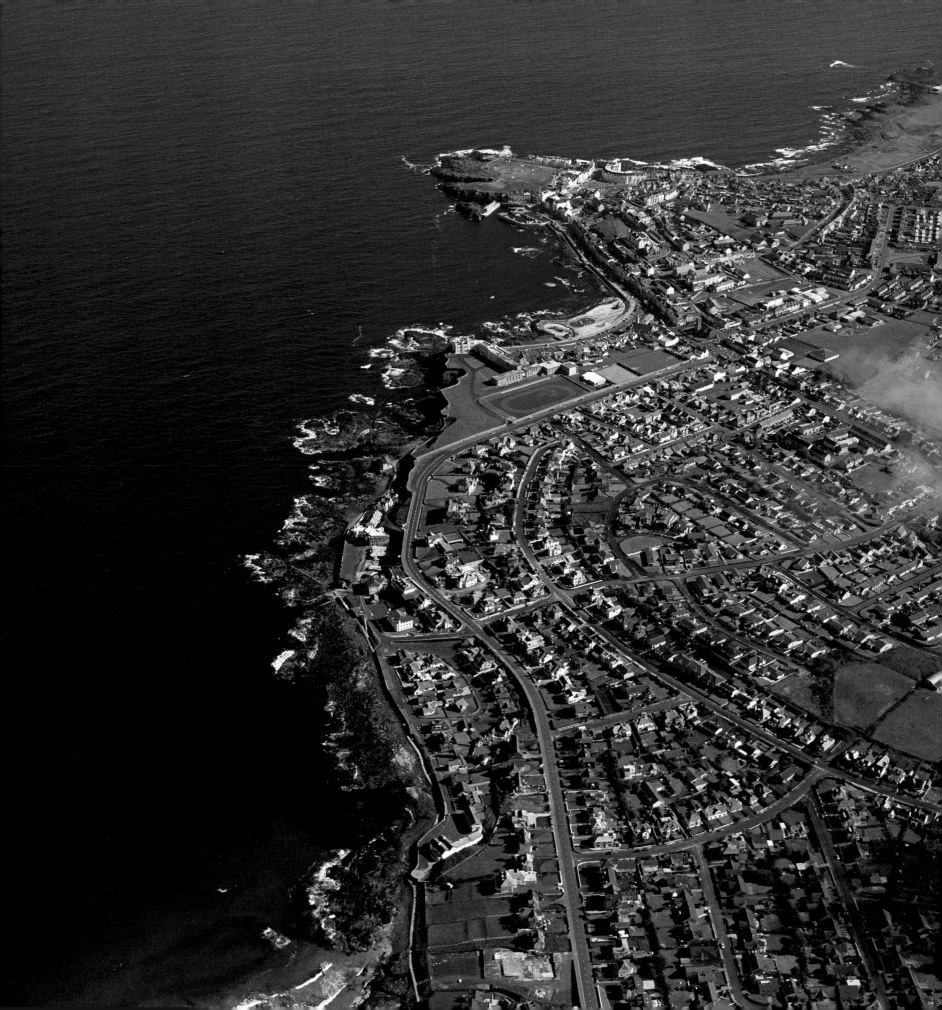

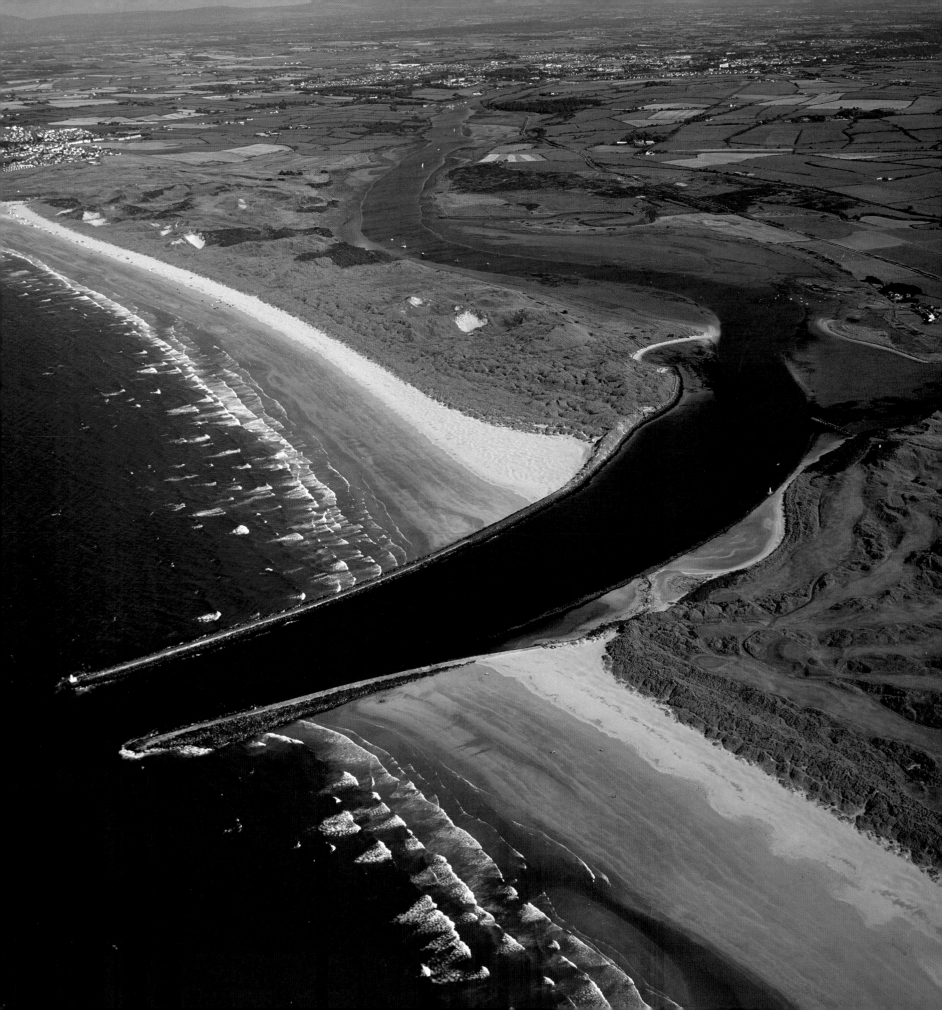

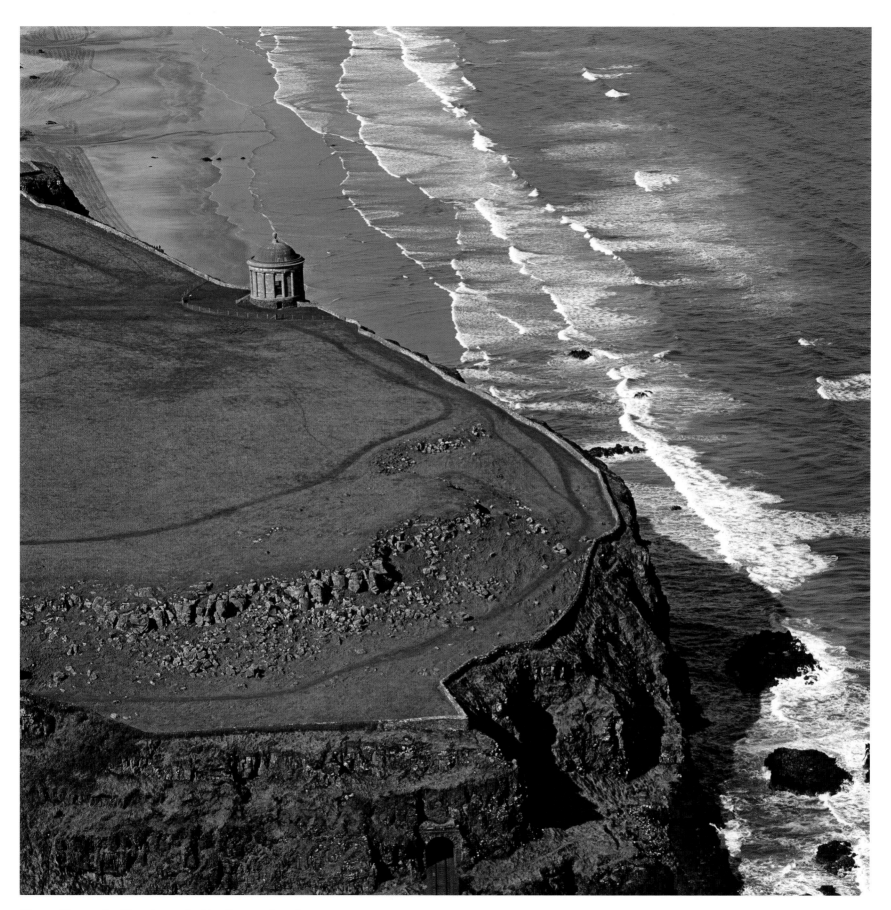

Above: Mussenden Temple overlooking Benone beach
Opposite: The River Bann enters the Atlantic at the Barmouth near Portstewart

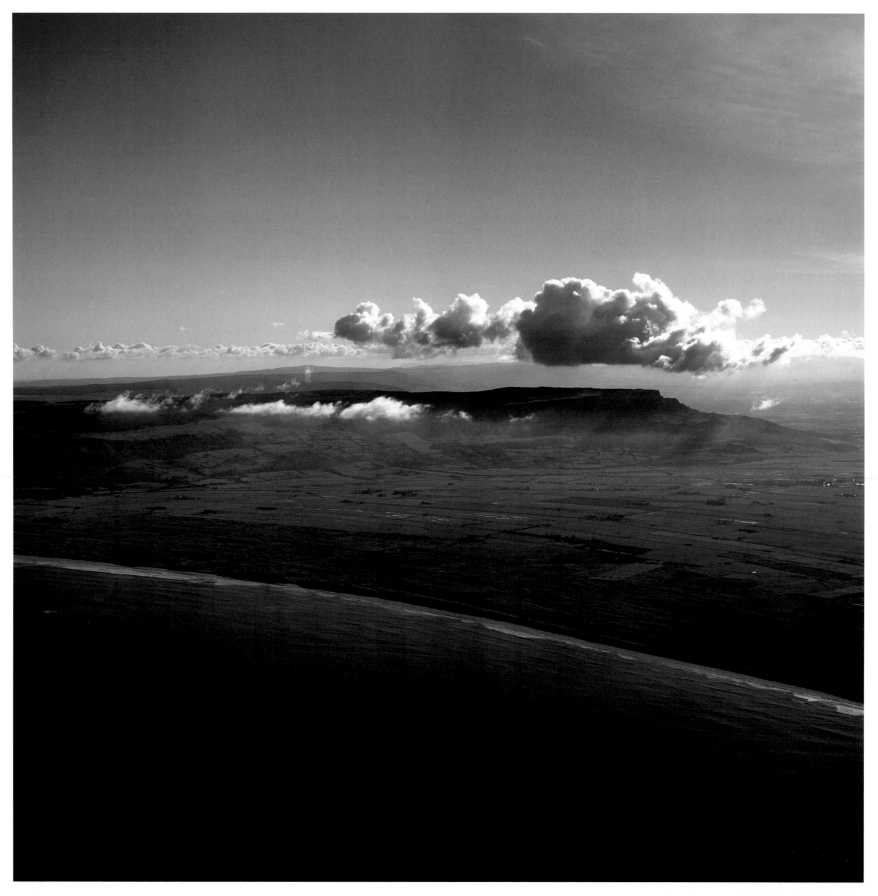

Above: Lough Foyle, looking towards Binevenagh

Opposite: The ferry running between Greencastle on the Inishowen Peninsula, County Donegal, and Magilligan Point, County Londonderry

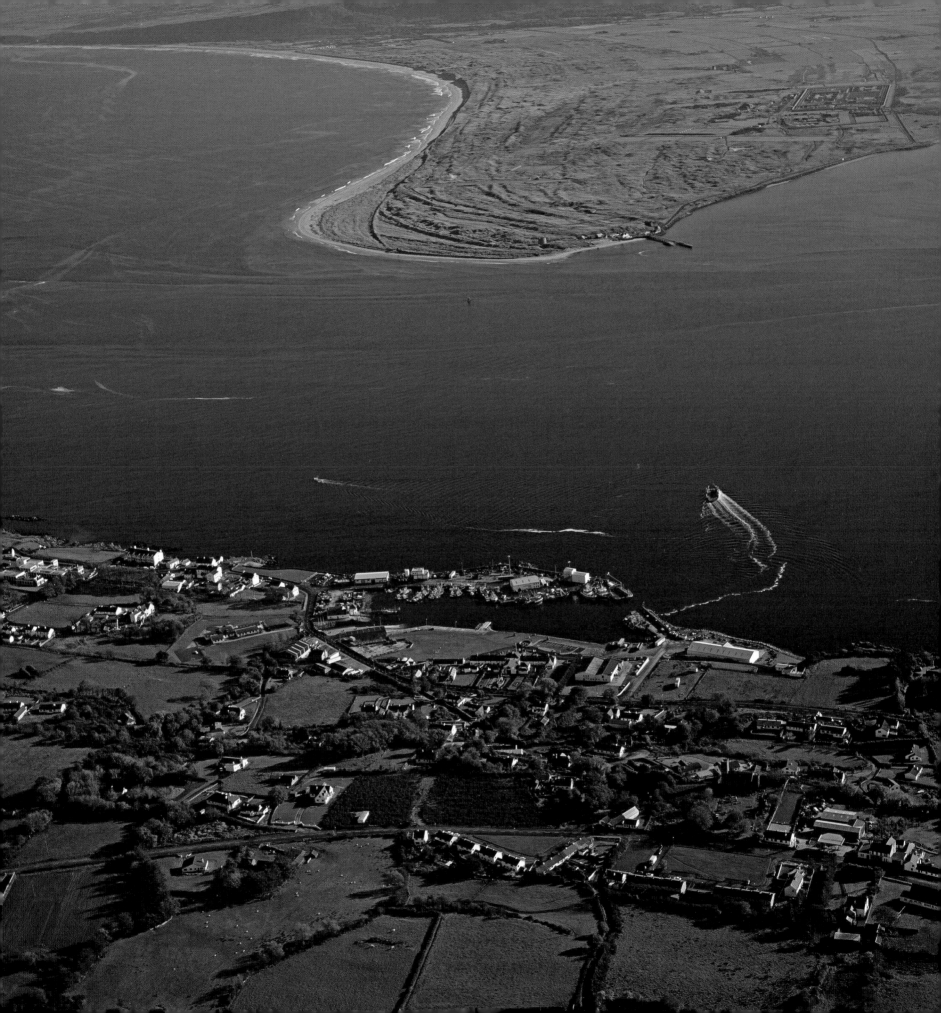

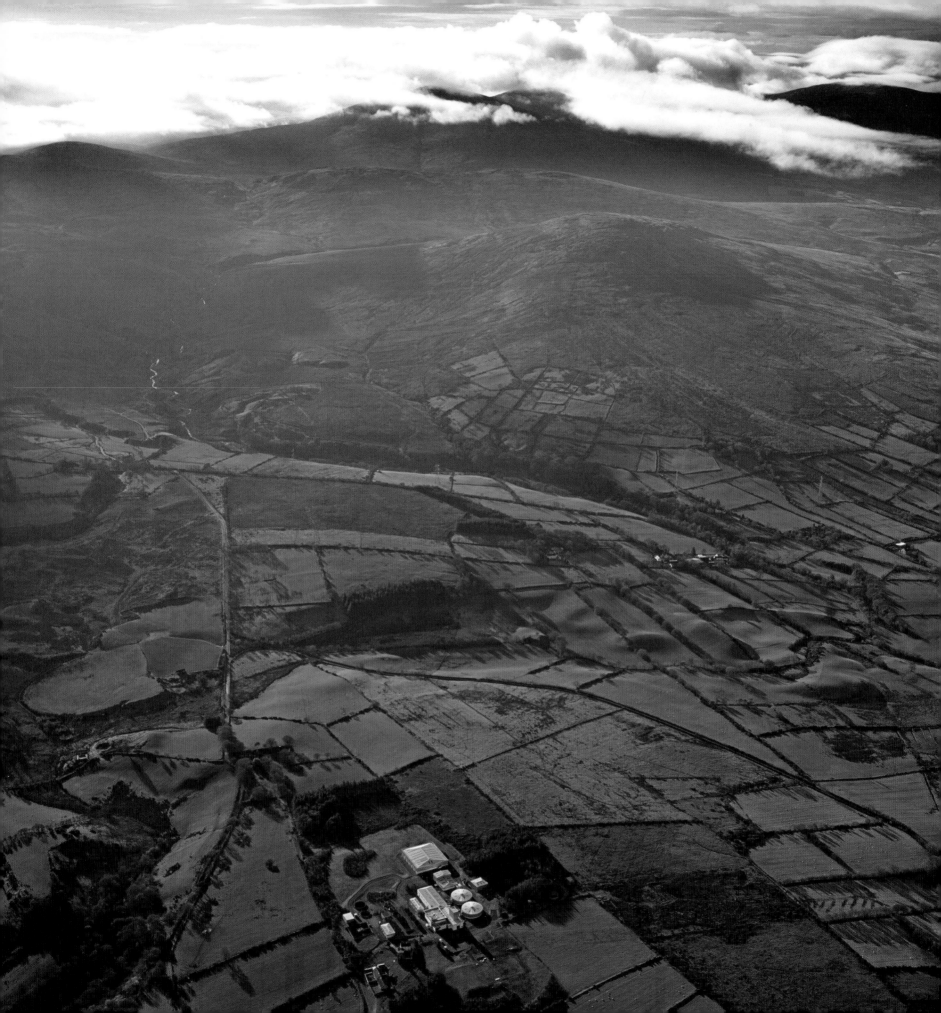

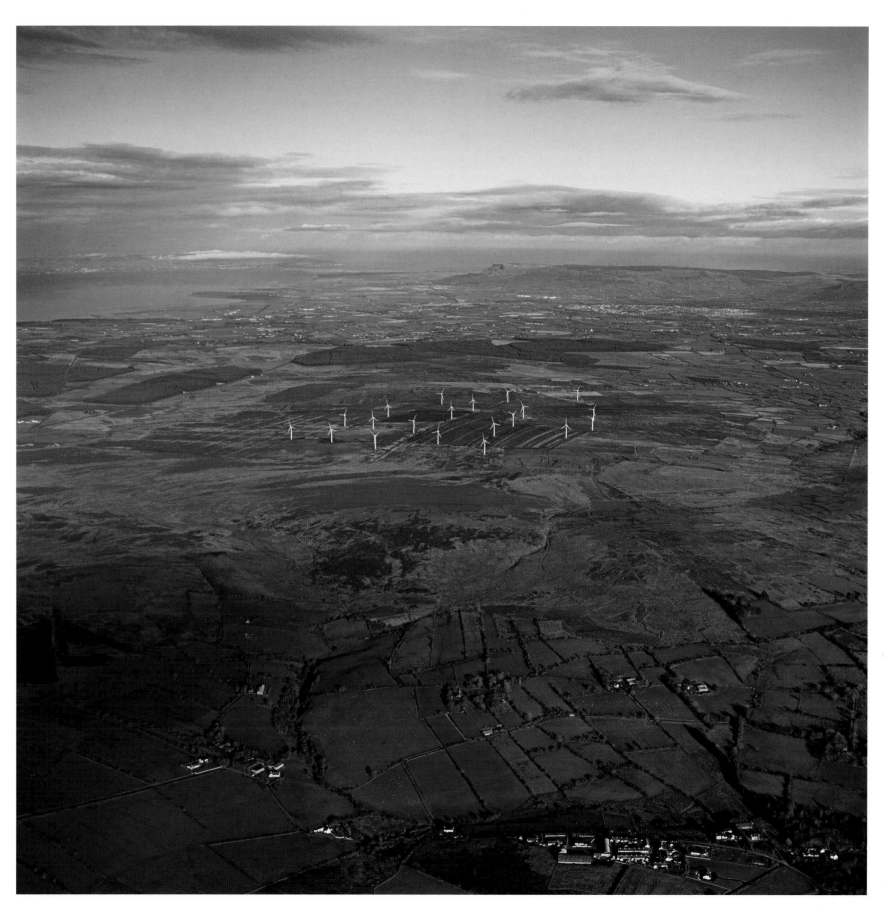

Above: Altahullion Wind Farm, near Dungiven in County Londonderry
Opposite: Mullaghash Mountain in the Sperrins, with Caugh water treatment works in the foreground

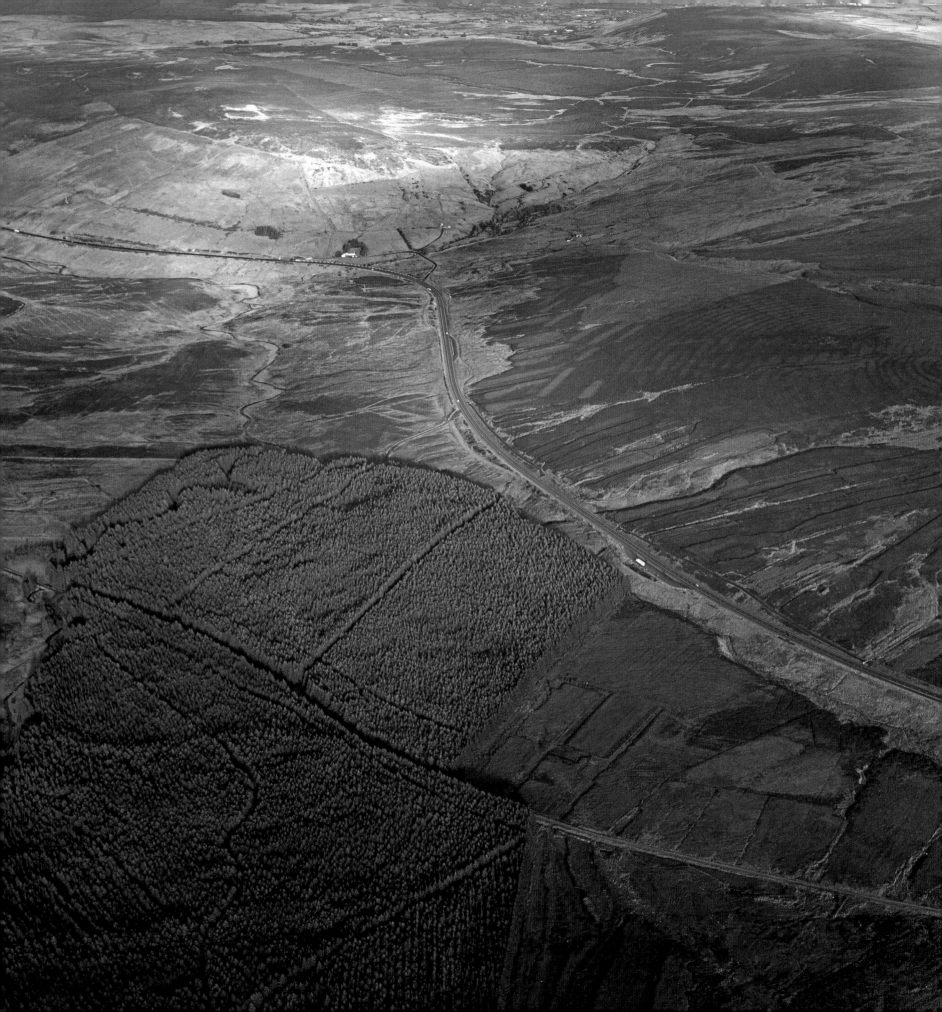

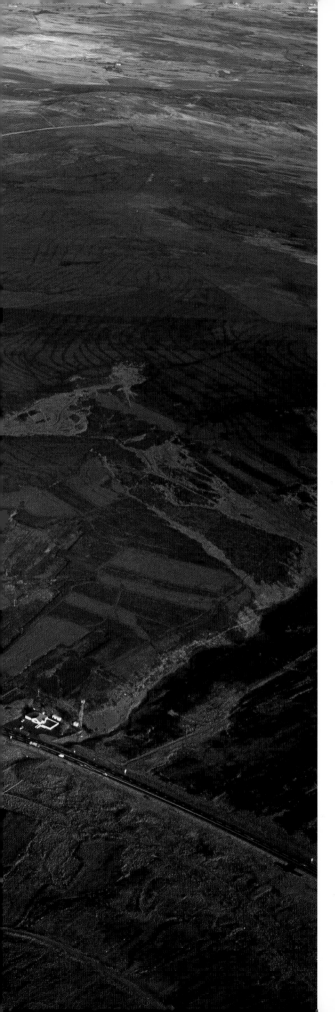

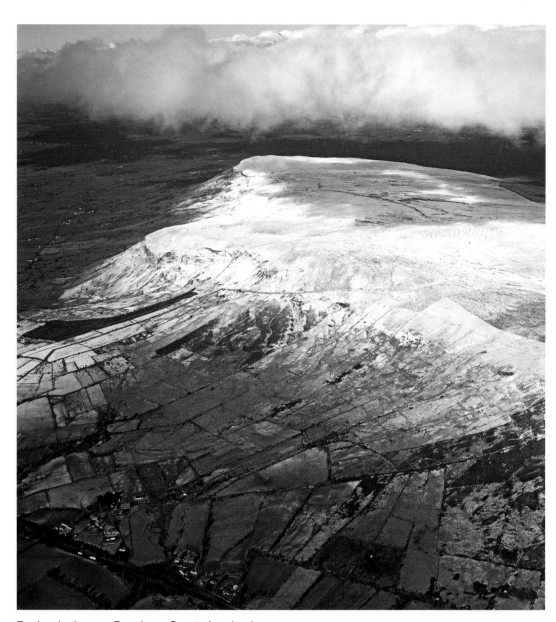

Benbradagh, near Dungiven, County Londonderry

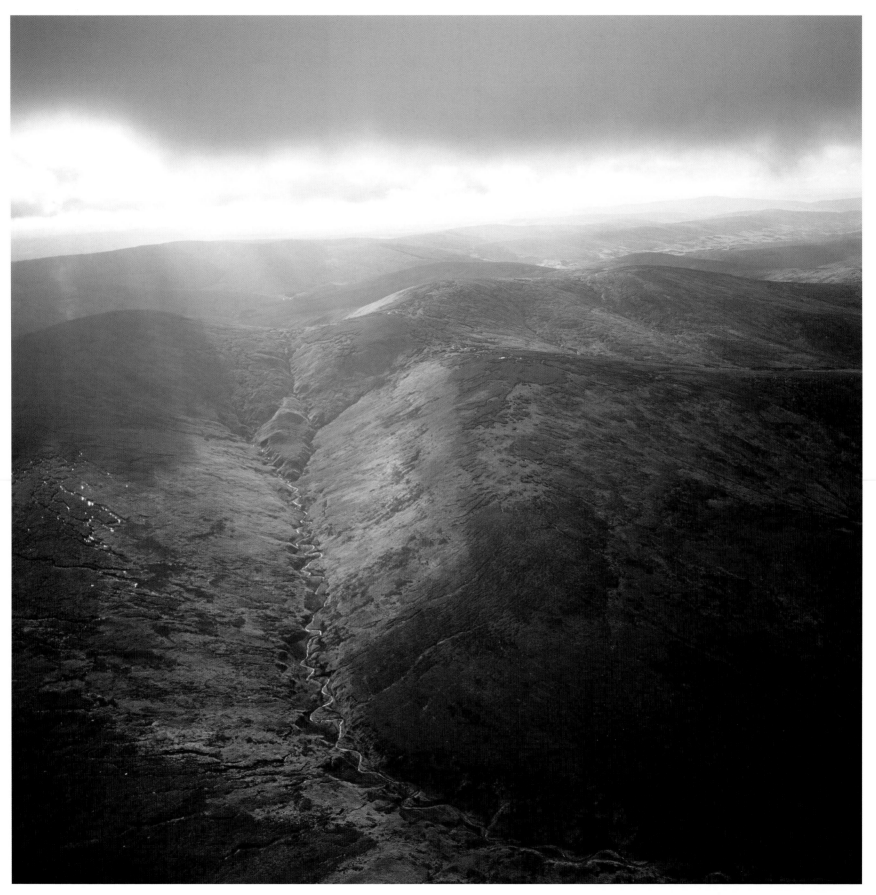

Above: The Sperrin Mountains, County Londonderry
Opposite: The River Foyle emerges from autumn mist at Derry

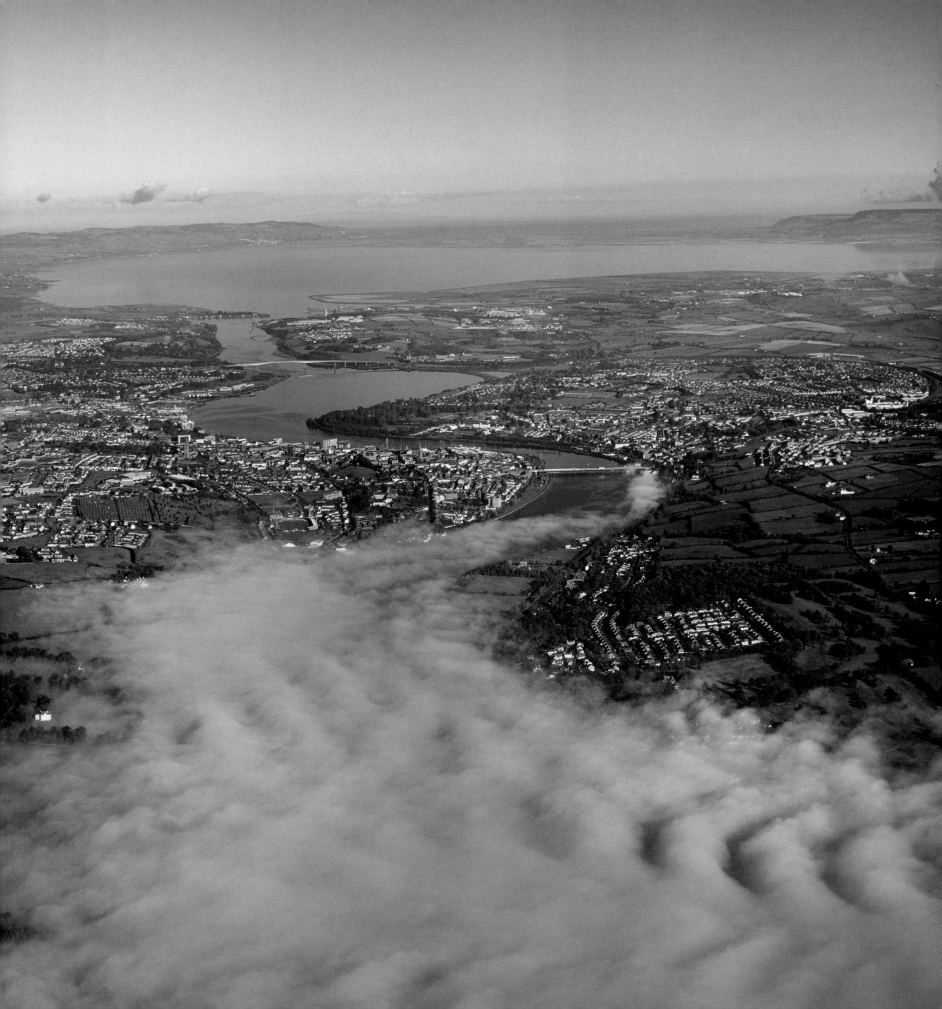

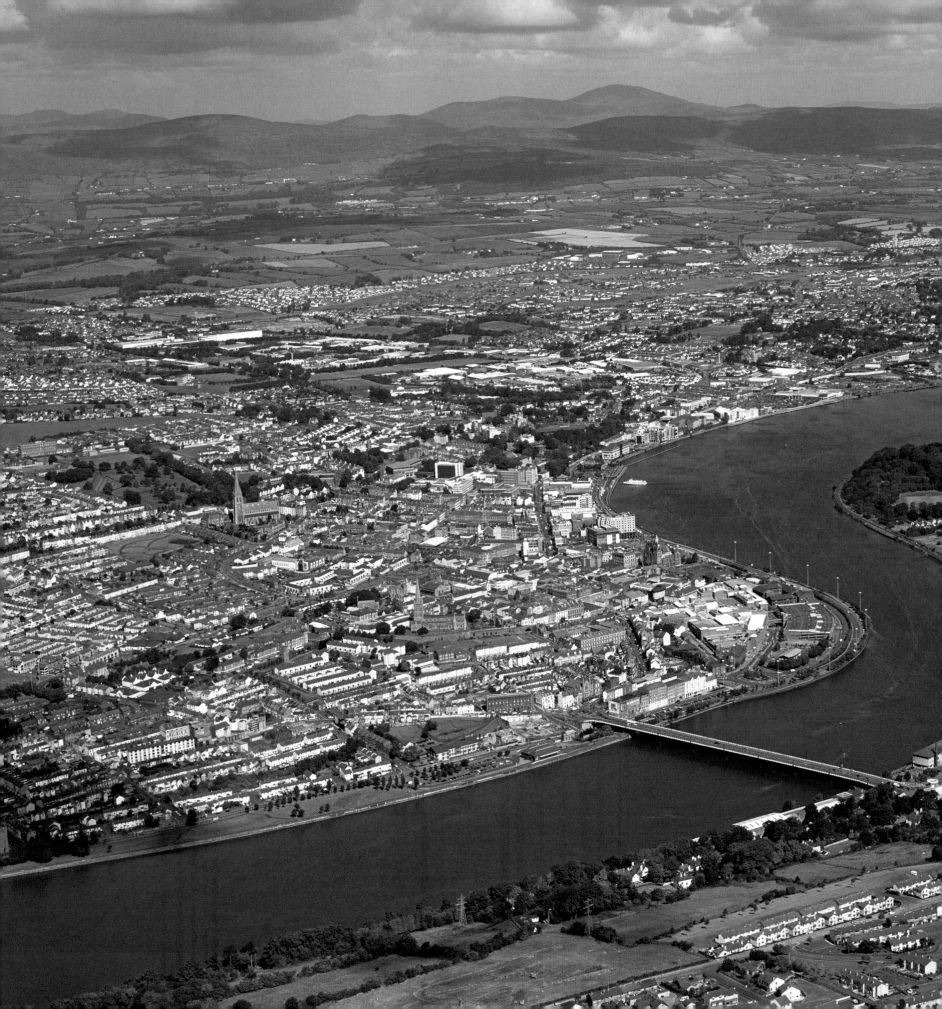

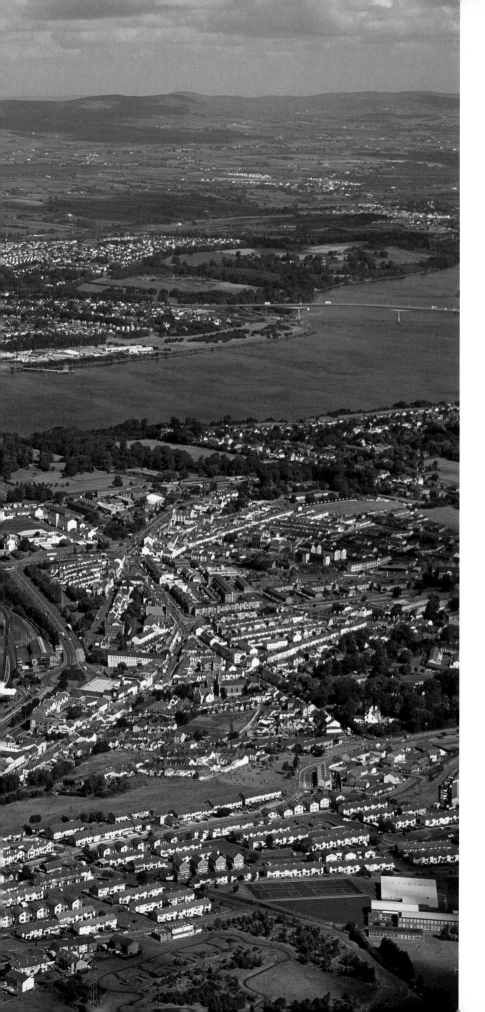

Derry city from the Waterside, with Governor's Bridge in the
foreground and Foyle Bridge downriver on the right

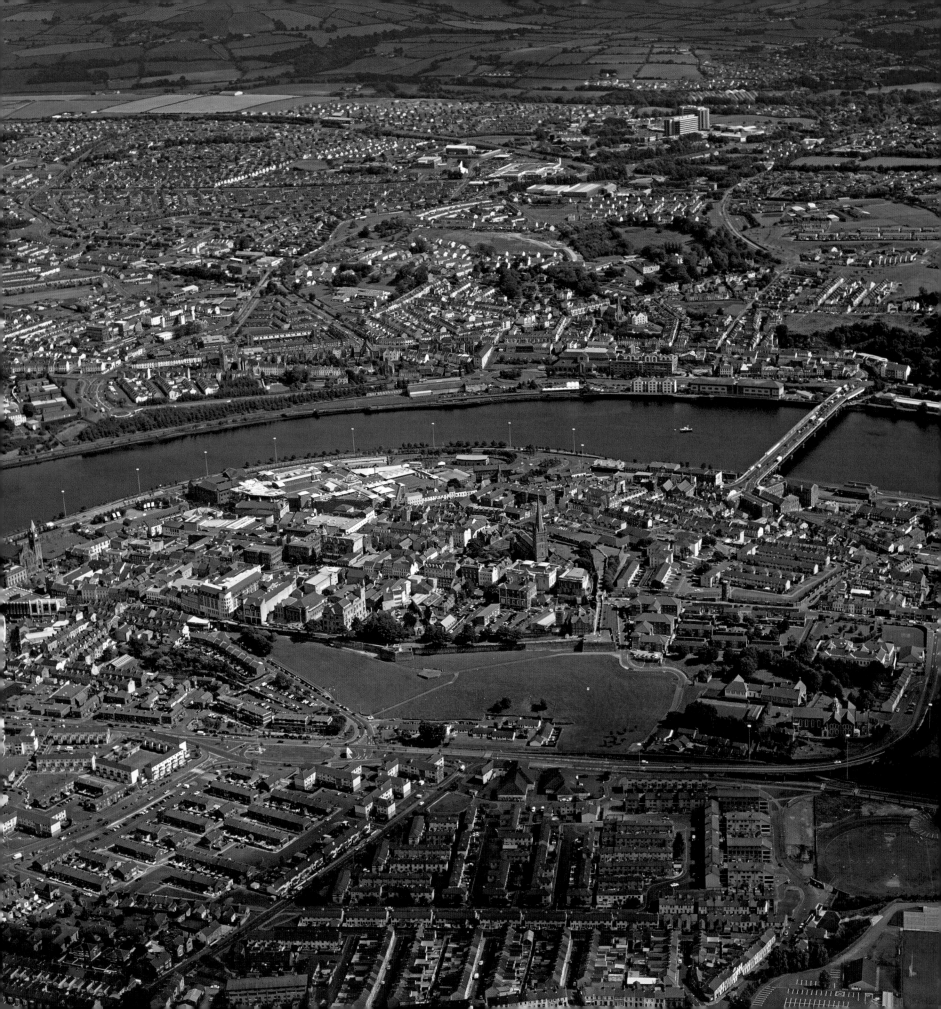

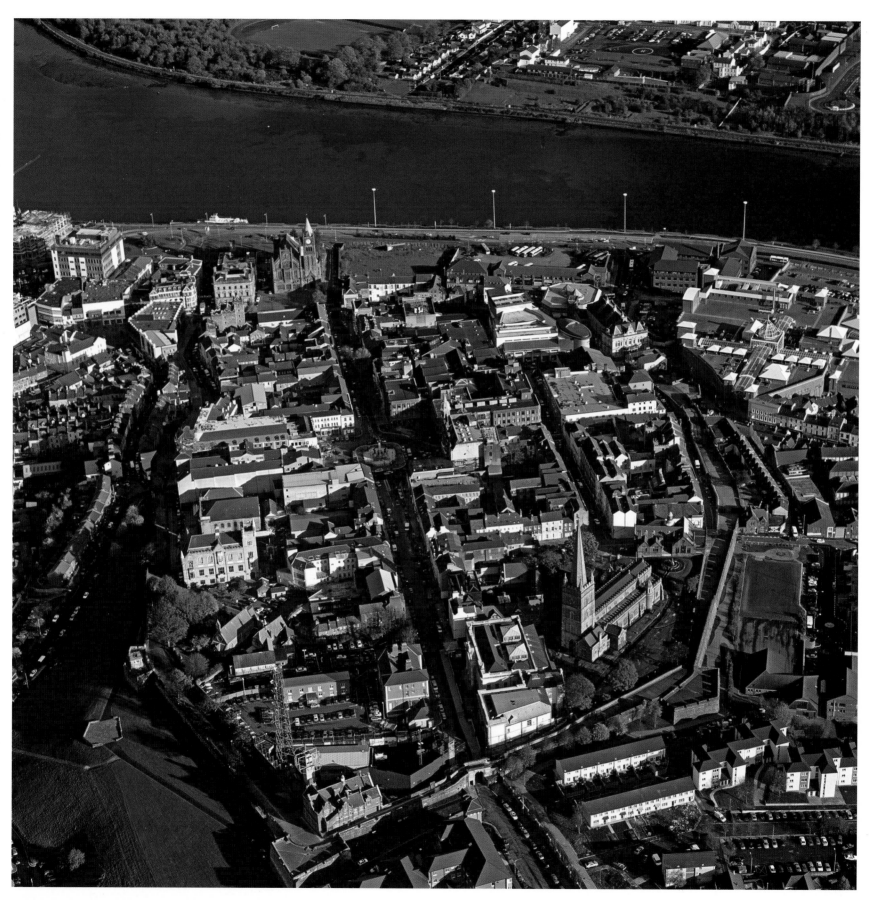

Above: St Columb's Cathedral inside the walls of Derry
Opposite: The two-level Governor's Bridge links the Waterside to Derry city centre

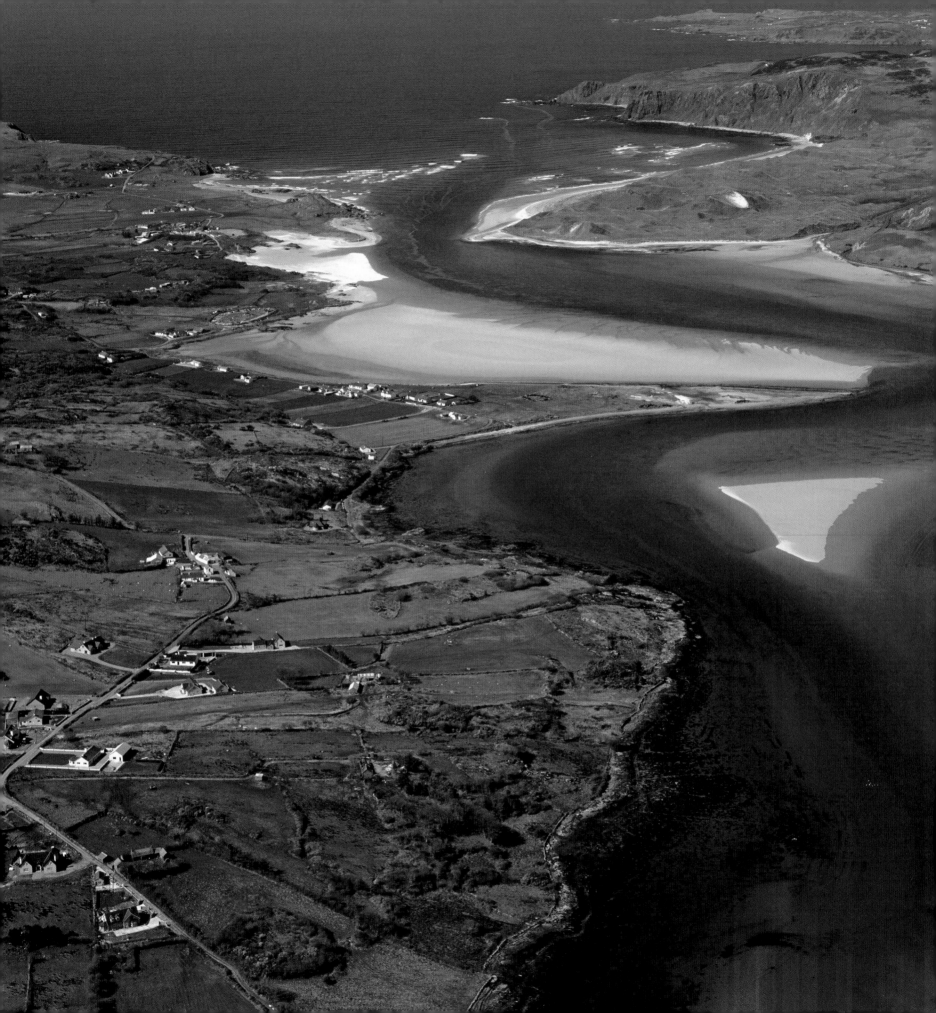

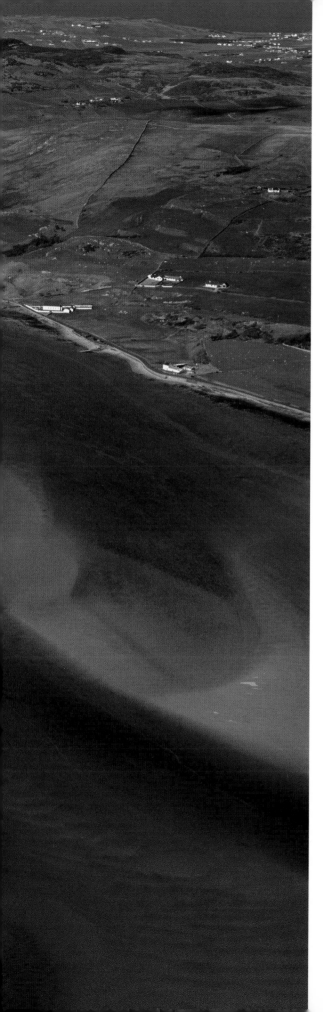

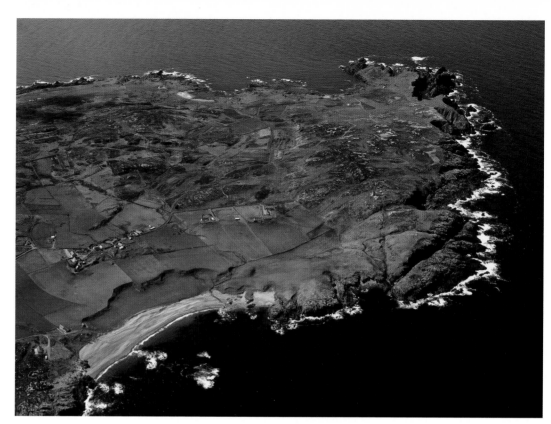

Malin Head at the top of the Inishowen Peninsula in County Donegal

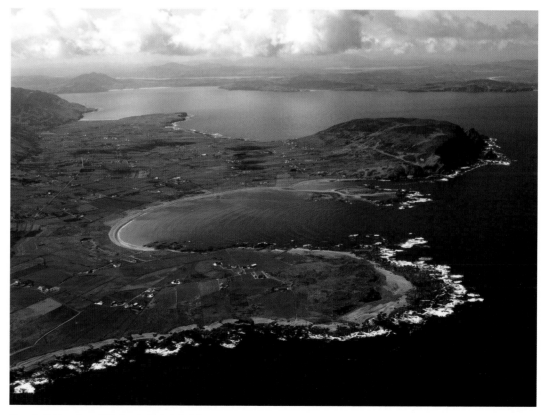

Dundaff Head and Tullagh Point, Inishowen

Trawbreaga Bay, Inishowen

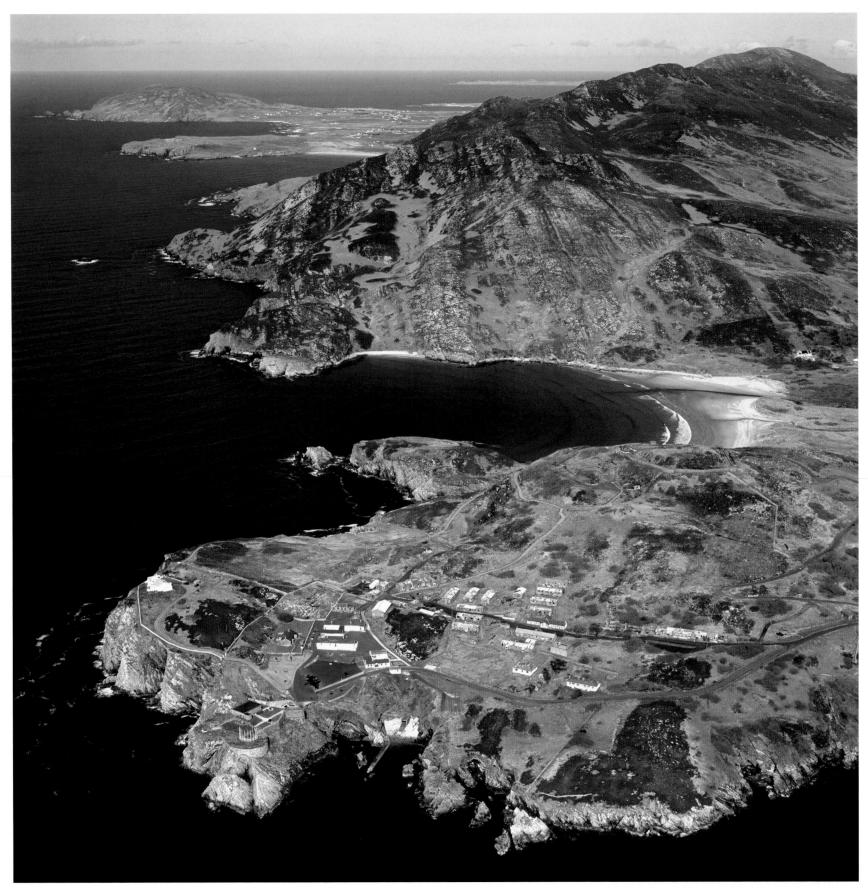

Above: Lenan Head on the shores of Lough Swilly, with Dunree Head and fort in the foreground
Opposite: The Bloody Foreland, the northwesternmost point of County Donegal

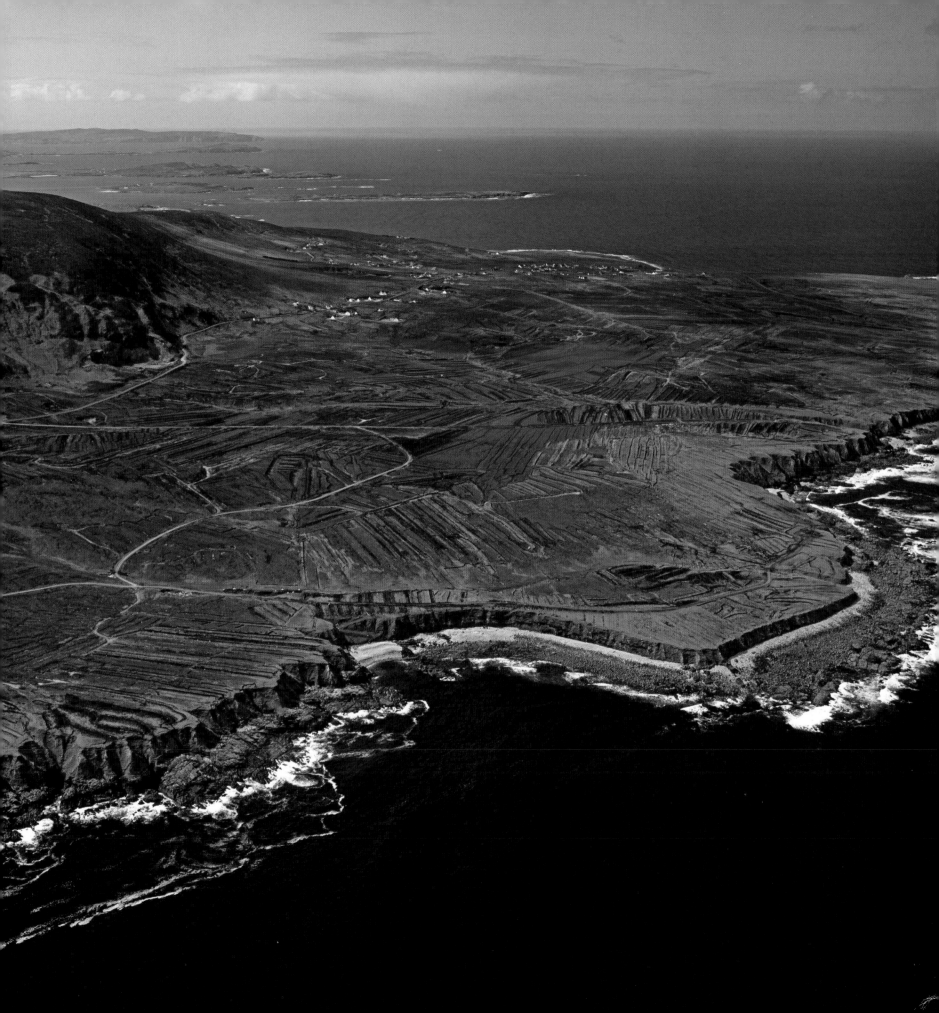

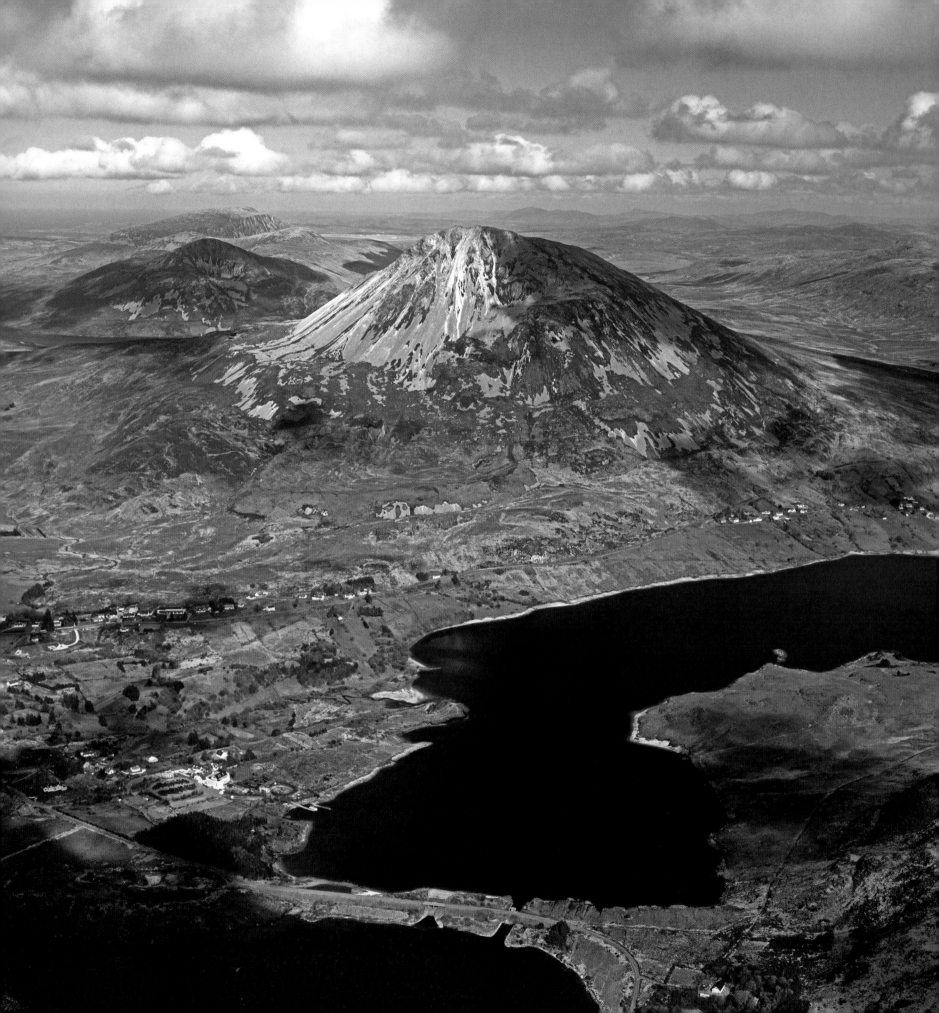

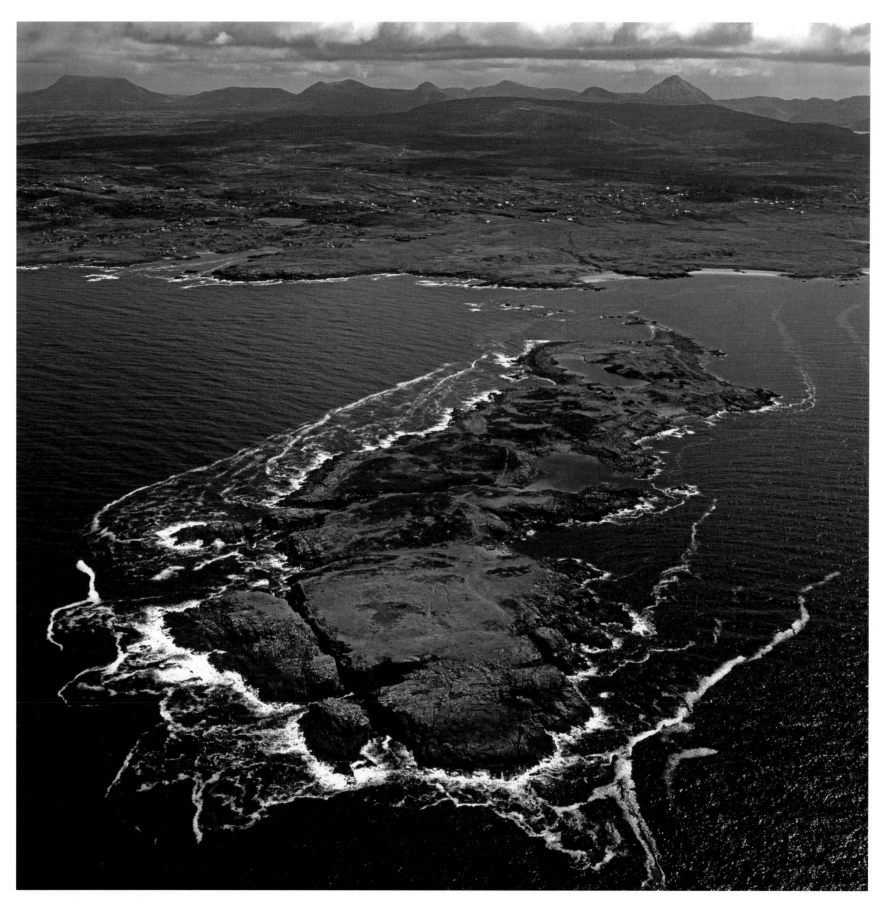

Above: Inishsirrer, looking towards the Derryveagh Mountains in County Donegal
Opposite: Mount Errigal, overlooking Lough Nacung

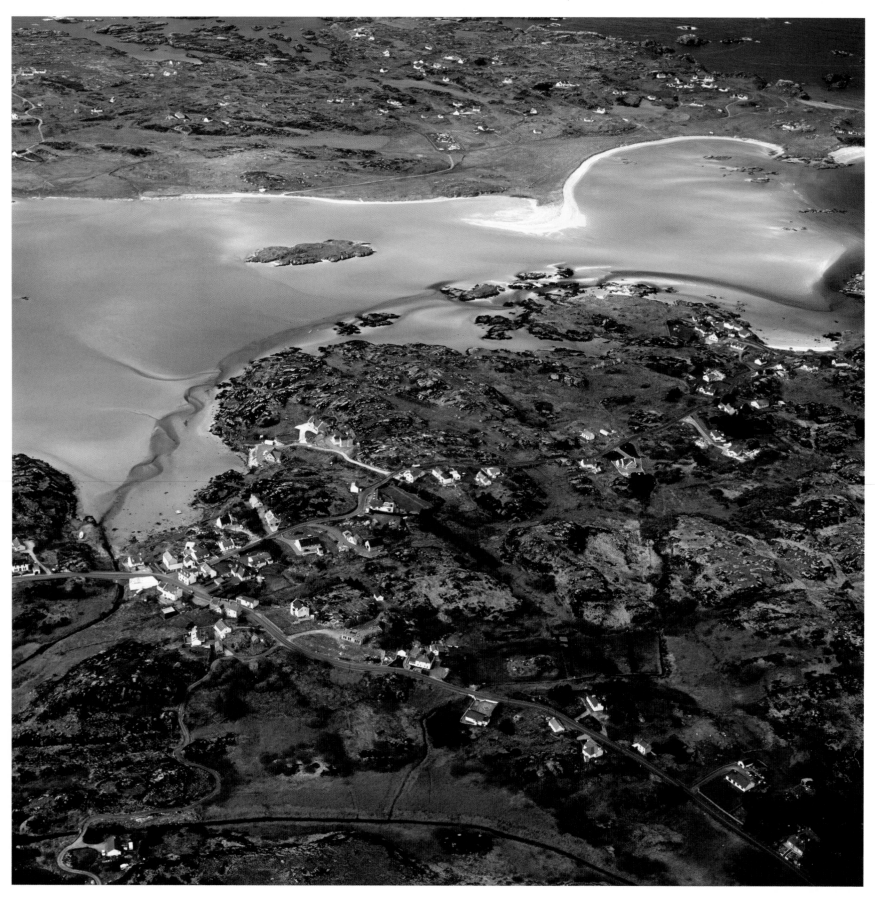

Above: Kincashla, County Donegal, with Cruit Island in the background
Opposite: The ferry running between Burtonport and Aran Island

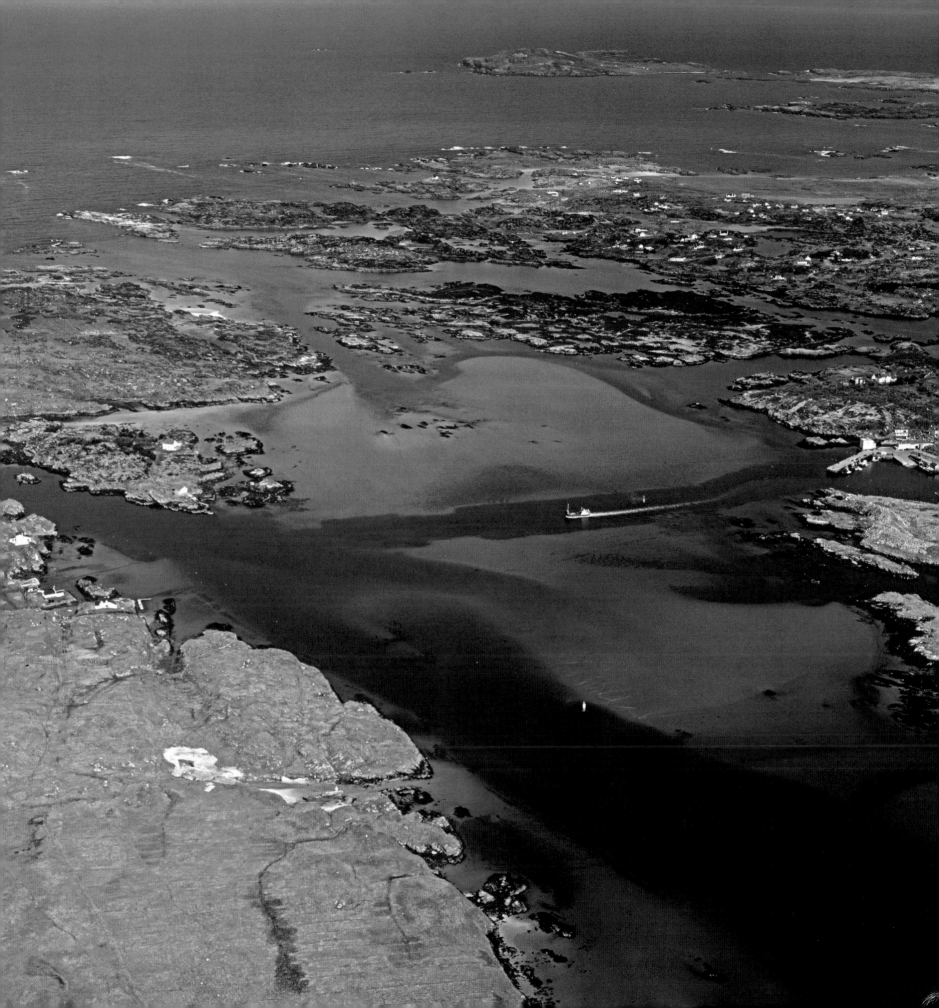

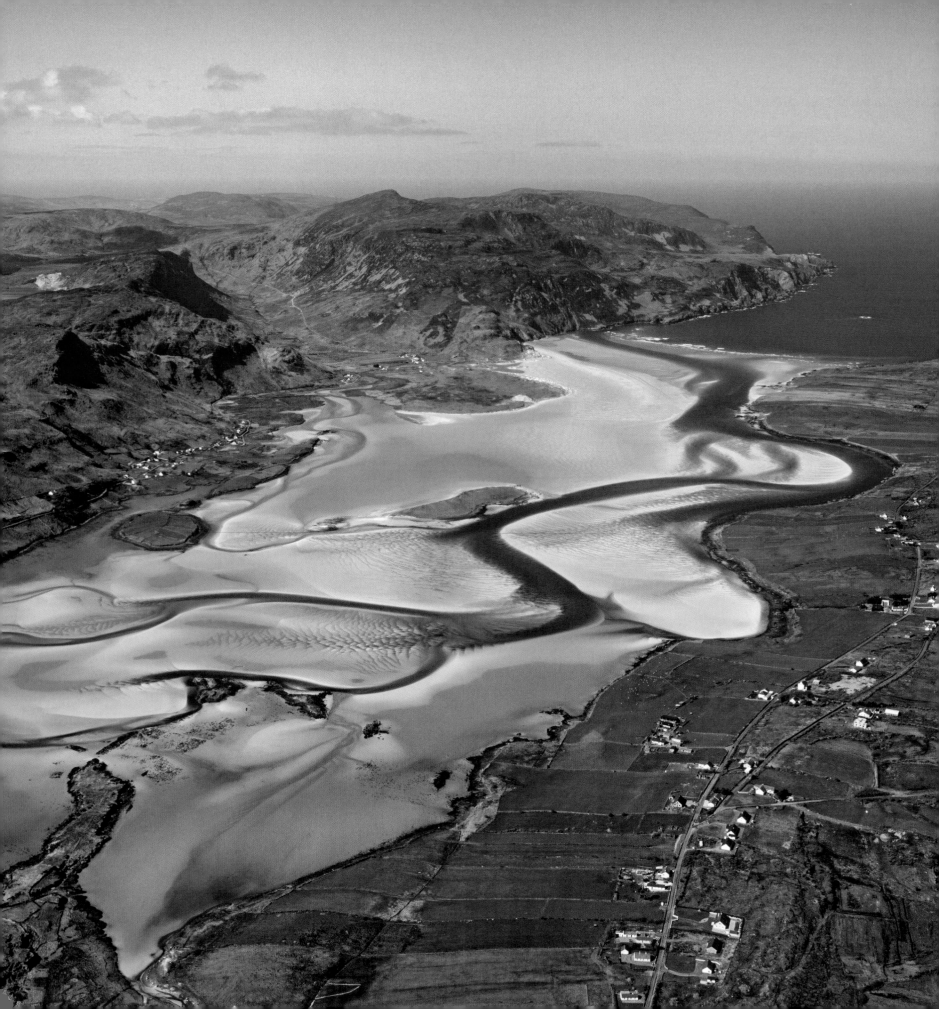

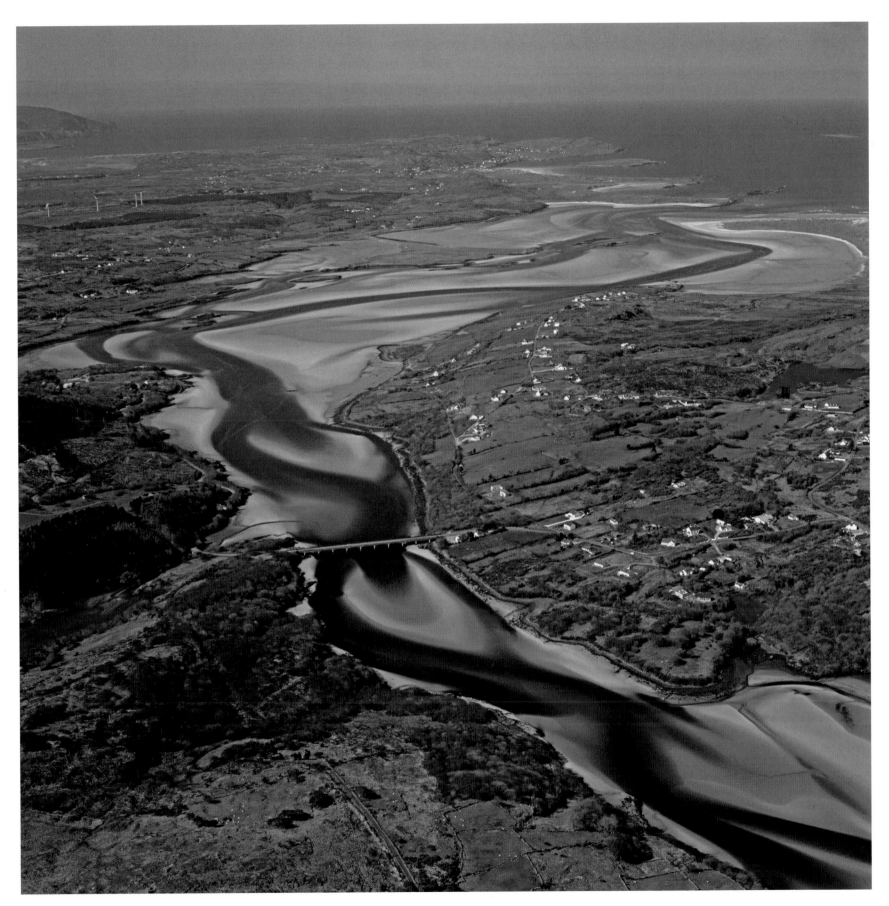

Above: Gweebarra River, west Donegal
Opposite: The River Brackey flowing through Ardara into the Atlantic

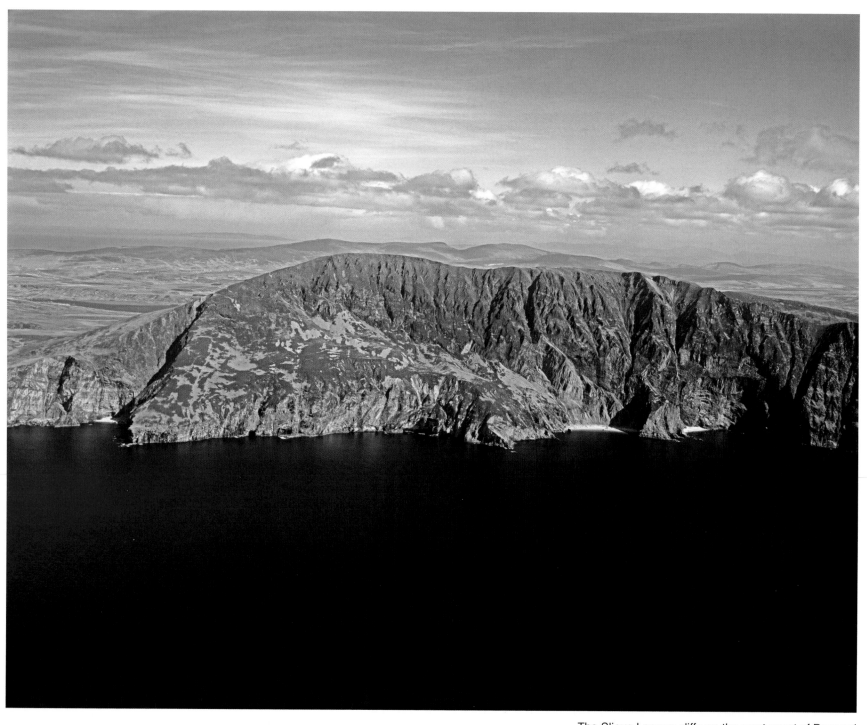

The Slieve League cliffs on the west coast of Donegal

Oyster farming in Donegal Bay

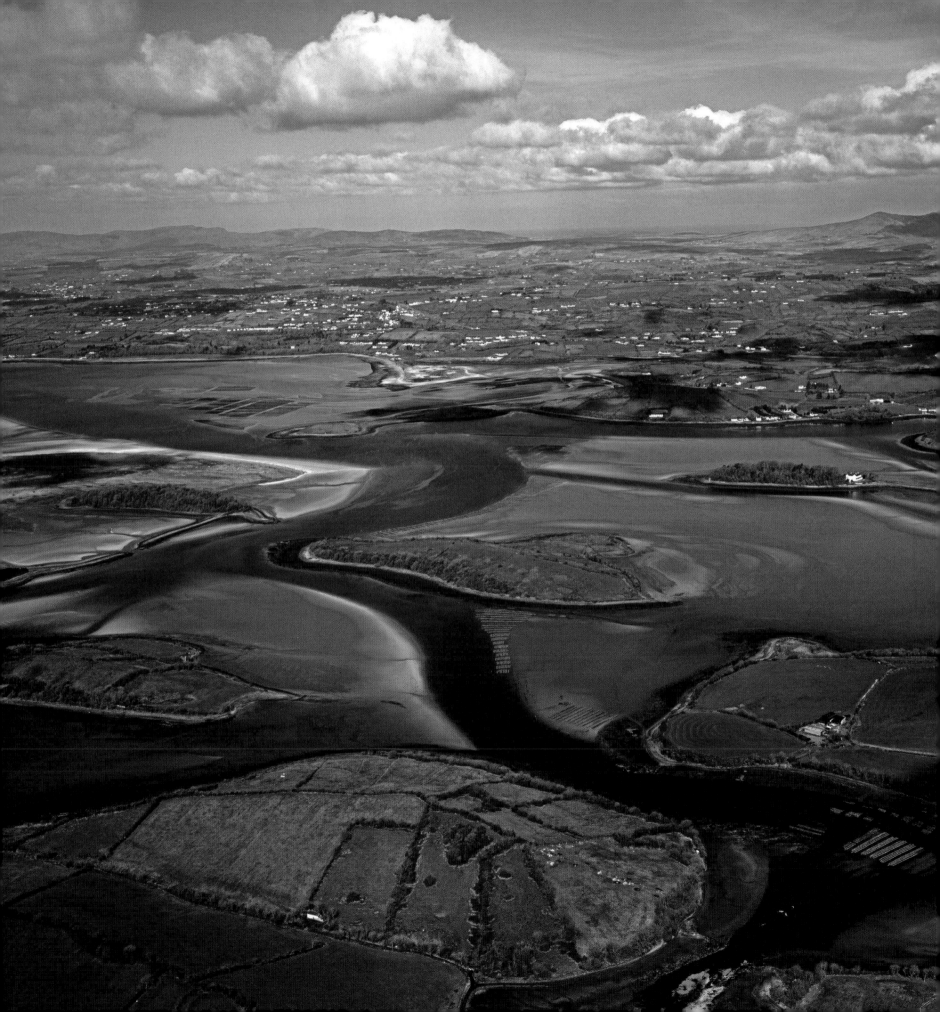

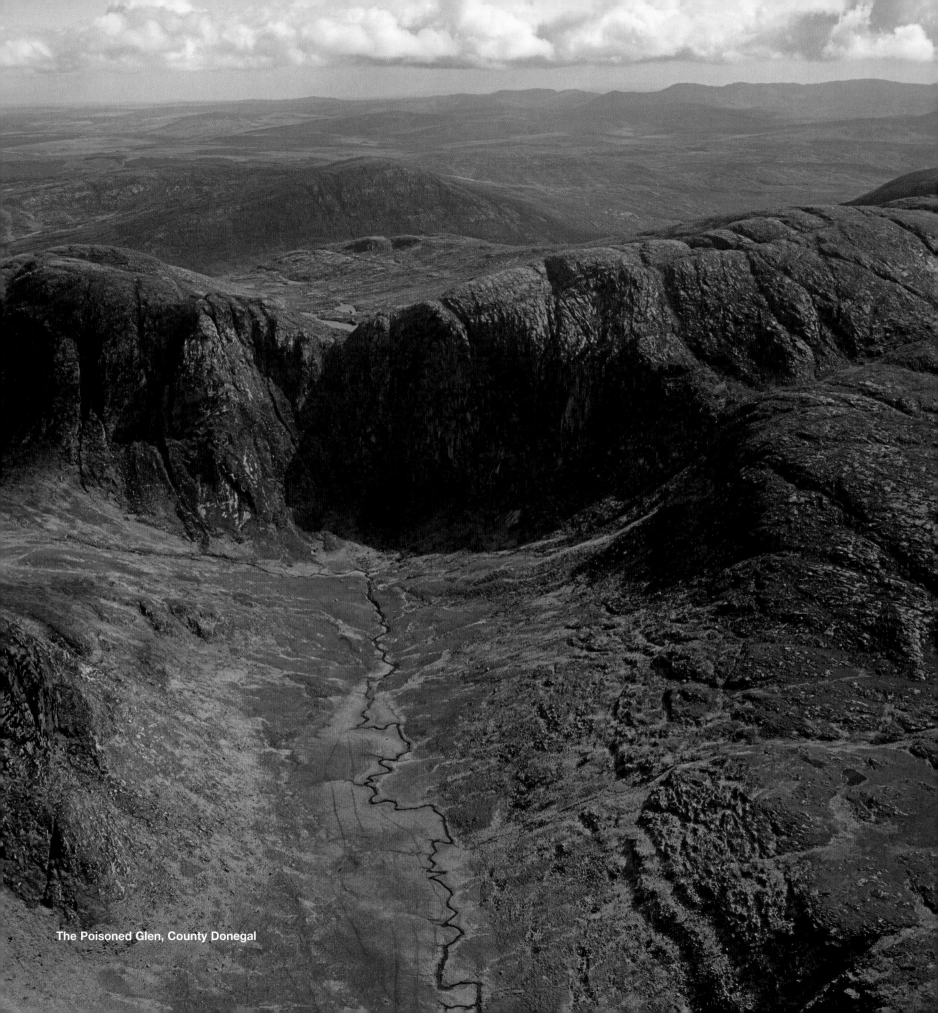

The Poisoned Glen, County Donegal

INDEX

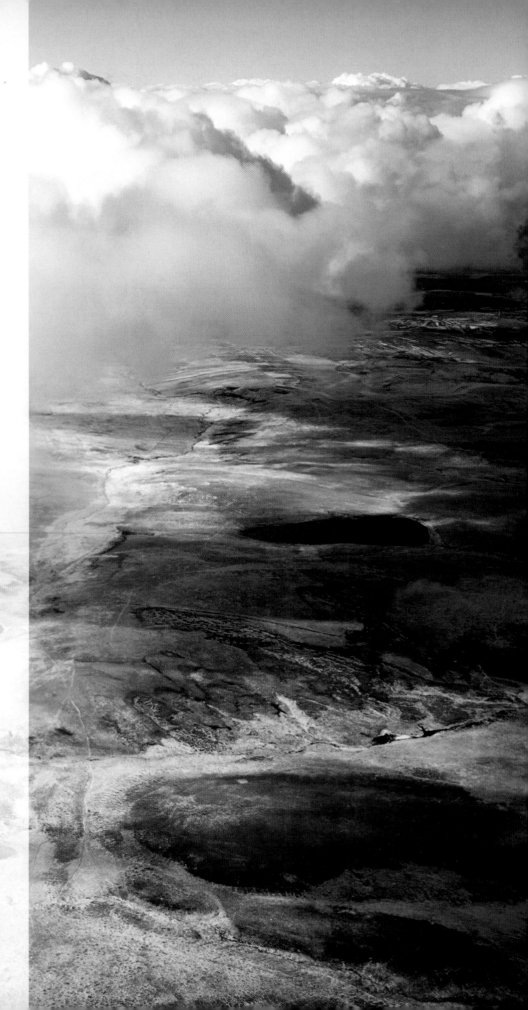

ACKNOWLEDGEMENTS

I wish to express my sincere thanks to those people who provide the essential back-up to my aerial photography. I get the pleasure and they do the work!

To my pilots, Tom Given and Bob Farmbrough, who provide skill, humour, patience and understanding in good measure. You need to have a thick skin and a sixth sense to chauffeur an aerial photographer. You get blamed if air traffic control is being unhelpful, you get blamed if the weather turns out bad, and you get blamed for not knowing what exactly is in the photographer's mind even though you cannot see what he sees because of the high engine cowling between the two of you.

And to my faithful and long-suffering staff. Ruth Mairs, who acts as general administrator and sorter-out of problems. She has a prodigious memory and I often use this, and her acute attention to detail, to dig me out of many holes of my own making. Patrick Orr, to whom is entrusted the processing of my precious films and who has never ruined one – yet! And Alex McClatchey, my computer expert, who can transform some unpromising looking images into works of art – or a least something saleable.

First published in 2008 by
Blackstaff Press
4c Heron Wharf
Sydenham Business Park
Belfast BT3 9LE

Typeset by IMD Typesetting & Design

Printed in Italy by Sedit

A CIP catalogue record for this book is available from the British Library.

ISBN 978-0-85640-818-2

www.blackstaffpress.com